TABLE OF CONTENTS

SUMMER 2022
VOLUME 2, NUMBER 4

EDITOR
LEON WIESELTIER

MANAGING EDITOR
CELESTE MARCUS

———

PUBLISHER
BILL REICHBLUM

———

JOURNAL DESIGN
WILLIAM VAN RODEN

WEB DESIGN
HOT BRAIN

Liberties is a publication of the Liberties Journal Foundation, a nonpartisan 501(c)(3) organization based in Washington, D.C. devoted to educating the general public about the history, current trends, and possibilities of culture and politics. The Foundation seeks to inform today's cultural and political leaders, deepen the understanding of citizens, and inspire the next generation to participate in the democratic process and public service.

Engage
To learn more please go to libertiesjournal.com

Subscribe
To subscribe or with any questions about your subscription, please go to libertiesjournal.com

ISBN 978-1-7357187-7-4
ISSN 2692-3904

———

EDITORIAL OFFICES
1604 New Hampshire Avenue NW
Washington, DC 20009

DIGITAL
@READLIBERTIES
LIBERTIESJOURNAL.COM

Liberties

OKSANA FOROSTYNA

Lviv: A Canary's Diary

February 20, Sunday

Yesterday, at home in Kyiv, we listened to Boris Johnson's speech and immediately bought tickets to Lviv. My husband Roman suggested a week ago that S, our three-and-a-half-year-old daughter, and I stay with my parents in Lviv, but I refused, despite the American and British embassies having already relocated there (and my mother begging us to come). A few days ago, the older daughter of my husband, a first-year student, left to join her mother who lives abroad.

Now it's time for us.

As I'm packing, S is running around, exclaiming "Let's go to Lviv, to Lviv!" An unusual enthusiasm, which I wouldn't

notice if she didn't also say: "I don't want him to kill us all!" "Who?" I ask. "Who's gonna kill us?" She doesn't answer, just keeps selecting which things I should pack. I'm astonished: she couldn't have heard anything like that from me or Roman, as we didn't discuss the situation in such a dramatic manner. Her kindergarten, maybe? They were preparing children to go to a shelter, and she might have overheard the older kids. During the last month schools and kindergartens in Kyiv and Lviv (I'm not sure about the other cities) taught children what to do in case of an air raid. We were all urged to prepare survival bags, or, if literally translated from Ukrainian, "an anxious backpack." There were dozens of how-to articles everywhere. Yet we didn't pack ours until now.

I keep telling myself that we will come back in a week, covered with shame. Another voice in my head tells me that we may never come back if the city is occupied or destroyed. We send a couple of boxes with clothes by post to pick up in Lviv later. We take all the documents, many toys, and almost all of S's clothes with us. What I learn instantly is that you look differently at your belongings when your home may be destroyed or vandalized. I take my diary, which I gave up after I started to write a book last year. I take my daughter's *vyshyvanka* (a Ukrainian folk embroidered shirt) for the same reason: I just hate to think anyone may touch it. I take three books: two old Polish books I recently purchased at the Internet flea market, and the first edition of Yuri Andrukhovych's novel *Perversion*. Not only is it my favorite book, I bought it at a very special moment of my life in 1997, so I guess it's my most precious possession, when it comes to material objects.

One of my duties as a fellow at a Central European think tank — the fellowship is named for Marcin Krol, the Polish philosopher and democratic activist — has been to contribute

to a weekly overview of security in the region. And so I've been explaining my anxiety by the fact that I have to read all the news. It's hard to draw a line between my intuition and my information overload. I notice my relief as soon as our train reaches the Ternopil region, officially western Ukraine, the area that is not of Russian interest according to the published maps of future invasion.

A canary in a coalmine:

No, the Russian invasion was not a surprise.

Ukrainians tend to say that we've been at this war for eight years, since 2014. That is true: even those not directly affected by the aggressions of the past eight years know someone who was. Almost every morning the war was mentioned in the news: someone was killed or wounded; even in the "quiet" period it was not really quiet. My husband later told me that his heart sank as he was closing our door, thinking of his friends who, in exactly the same way, closed the doors of their apartments in Donetsk eight years ago.

At the same time I never felt so much at home in my country as after Maidan. The paradox is that while parts of the country — Crimea and areas in the Donetsk and Luhansk regions — were occupied by Russians in 2014, the rest of the country was, as I experienced it, de-occupied; emancipated. I started my own small business, a publishing house, in 2015, since finally I knew that I wouldn't be persecuted by the tax administration, and that my business would not be raided, as happened before to many people I knew, especially when Kuchma and Yanukovych were our presidents. Of course, many others had businesses in the pre-Maidan years, but I was not as brave as them. In 2014 I applied to the State Security Service to use its archives because I realized that they are *my*

public service now, no longer just the former KGB, politicized and filled with Russian agents.

Then, in 2018, it changed for me, when my daughter was born. I became terrified by the images of all possible dangers and risks. I couldn't see a movie or read a book (except for some non-fiction) if they included a situation with a child in danger. Even fairy tales horrified me: how can any sane person let a child go into the woods alone?

Of course, I told myself, there were rational explanations for my outbreak of fear. First, the oxytocin storm, which is normal when you have a newborn on your hands. Second, all survival mechanisms are on. And finally, the family traumas in anamnesis: both of my maternal grandparents were orphans. My grandmother lost her mother when she was seven, growing up mostly with relatives who weren't particularly kind to her. Her painful memories were among the first stories I heard. And so I felt like I was five again, brimming with the fear of becoming an orphan. My grandfather, too, grew up in an orphanage, after his parents were killed by the Bolsheviks as "class enemies."

It didn't get better with time. I read so many books about the atrocities of the twentieth century. I wrote and edited articles about them, and here I was, helpless to say "no" to my daughter asking for a cookie because *how can you not give food to a child?* Five years earlier I put some effort into the Ukrainian edition of *Bringing Up Bébé* by Pamela Druckerman, an American journalist who moved to Paris and tried to raise her children in the French way, that is, giving them only healthy food and teaching them to eat gracefully. A big enthusiast of the book, I was sure that one day my own child would eat steamed broccoli, too. Now I realized that one needs to have had one's grandmother live through World War

9

Two in occupied Paris, not in occupied Kyiv as my grandma did (though she was a survivor of the famine in 1933), to have a gut tough enough to issue a firm "no" when a child asks for an unhealthy snack. Pamela Druckerman is Jewish, and so I speculate that this partly explains her struggle. Now, as I was preparing chicken meatballs for my not-that-French baby, I suddenly realized that I have myself become the proverbial Jewish mother from the jokes we used to tell. Except that they are not so funny anymore.

I have been living with these fears for more than three years. During the last month before the invasion, I was totally freaked out for seemingly no reason. And so with the first bombings I felt a kind of relief, and I began to calm down. As in a horror movie, the part after the monster is visible is not as scary as the suspense at the beginning.

Something like this had happened before. I knew that something was coming before the Maidan revolution. I wasn't afraid, I just avoided making big plans. During the three months of Maidan I was extremely lucky: I didn't suffer a bruise, though I was in the thick of things. Like a canary in a coalmine, I feel the danger before the explosion.

February 22, Tuesday
As expected, Putin signed the decrees of "independence" of the occupied territories of the Donetsk and Luhansk regions. Shchastia (a town on our side of the frontline) was shelled. It has begun.

February 23, Wednesday
It seems that everyone I overhear while taking my walks with S comes from elsewhere. On a playground on the neighboring street, I met a woman from Vyshhorod, near Kyiv. She

rents an apartment in a building of the same type as ours —
they call it "Polish luxe," meaning very nice and comfortable
interwar Constructivist buildings, with thick walls, relatively
wide stairs, sometimes marble panels in the hall, and solid,
deep cellars. She asked me where the local bomb shelter is. I
told her to use the basement, they are good for this purpose
in our neighborhoods. And I realized that basements in these
buildings are so well equipped as shelters because the people of
that era expected a war. That never occurred to me when I was
growing up here.

Later I noticed a sign that said "Shelter" in our own hall.

February 24, Thursday
I wake up as my mom was talking on the phone with my
in-laws. Kyiv and its surroundings were attacked from the air.
The Russians invaded. Roman's parents are coming to be with
us. Or rather they are trying to come. All roads from Kyiv are
jammed with cars, and the lines for fuel are huge.

Later I go to a pharmacy and do some grocery shopping.
There are no signs of panic on Lviv's streets, except perhaps
the long lines at the ATMs and at every pharmacy. It's
unusually quiet for this area: we live seven minutes from a
big crossroads and a farmer's market. I notice that there are
fewer cars. Some shelves in the grocery store (bread, flour,
sugar, and so on) are already empty. That's understandable,
I say to myself: we live in an old residential area, there are a
lot of elderly people here, and they are not used to Internet
shopping. And they remember the Soviet shortages of, well,
everything.

I also went downtown. Most of the shops are closed. That
makes sense: who needs boutique clothes today? I noticed
some people in military uniform with rifles.

I spent most of the day writing emails and texting. Friends from all over are worried.

A tale of two cities:

I moved to Kyiv from Lviv in 2011. Before that I spent thirty-three years here. Most of my friends left Lviv earlier, some of them when I was still a student. They graduated hastily from university and moved on. I'm not sure how much I belong here. Still, all this time I've been registered in Lviv and my income taxes go to the Lviv city budget. I once had an apartment here (I sold it in 2019). My mother was born here.

But my grandmother came from Kyiv in 1947, the period called "the second Soviets" (the first Soviet came in 1939, after Stalin and Hitler invaded Poland). She left starved and ruined Kyiv, where she didn't have any means to live with her sister, who moved earlier. In other words, she came to save herself and her daughter (my aunt). The population of Lviv changed almost completely after World War II. Many Poles, who had been the majority, were killed or forcibly deported to Russian camps, and so were Ukrainians. Almost all the city's Jews — they knew it as Lemberg — were killed by Nazis during the Holocaust. After Yalta, Lviv became a part of the Soviet Union, and few Poles stayed in the city. Russians, Ukrainians, and Jews came from the USSR. They somewhat derisively called those Ukrainians and Poles who had stayed "the locals." Their children, and often their grandchildren, did the same. My grandmother used the word in that way. My mother pronounced it mostly with respect, as she considered "the locals" to be kinder than the people she knew at home; but pronounced in a different tone the word was a pejorative. "The locals" in turn called the newcomers "liberators" — *vyzvolyteli* in Ukrainian, or *osvoboditeli* in Russian (the latter was used to add a little acidity to the sardonic usage).

Were we "liberators"? Technically, we were. We spoke Russian while my grandparents were alive. We lived as the majority of Soviet people did, an extended family in one apartment. Both my mother and I went to Russian schools. We lived in the city center, that is, the quarter of the city built before 1939. My grandfather was a captain in the Red Army and an invalid of the Great War who came to Lviv in 1947.

And yet we were not like typical Russians, not at all. My grandmother never had a job in Lviv, and she lived completely immersed in the world of relatives and family, never embedded in any Soviet social structure. My grandfather once held some power in his hands: he distributed "liberated" apartments (empty after their owners were either killed, or deported, or left for Poland or the West, the luckiest ones). As he had never known anything but an orphanage, a military training, and the Red Army, my grandfather believed that a person may be happy with only a bed and a nightstand, and so he stayed in a shared apartment (*kommunalka*) and refused to get a four-bedroom place for himself. It was only when he married Grandma that she made him apply for a modest one-room apartment. Nor did he avail himself of any of the opportunities for corruption, except for a bottle of vodka as a present after the paperwork was done. Soon he ended up on the bottom of the Soviet bureaucracy's food chain, and most of his life he worked at a factory. Moreover, he was not Russian but Chuvash, the Turkic ethnicity in the region of the Volga River. The most interesting thing about the Chuvash is that their language is the closest to the dead language of the Khazars, a Turkic people who are said to have adopted Judaism in the Middle Ages. Anyway, my grandfather struggled with Russian grammar until his death. My father, born near Lviv, grew up in the Dnipropetrovsk region, and came to Lviv as a

student. So maybe we were not real "liberators," but neither were we "locals."

The real "liberators" were mostly part of the machinery of repression in a rebellious region, where the underground Ukrainian resistance operated until the late 1950s. (Strangely, I never heard of the *banderivtsi*, the anti-Soviet partisans, before I went to school at the age of seven, which means that in our family they were not considered a menace.) Unlike in other Ukrainian cities, Russophones here were not Ukrainians who had to switch to Russian, but ethnic Russians, since they were regarded by the authorities as more reliable politically, and dominated the army and the KGB. Even the Russian language was different in Lviv: it was proper Russian, without a Ukrainian accent. And the KGB staff was as large in Lviv as it was in Kyiv, the capital of the Soviet republic, a city almost three times larger. The closeness of the Western border (the territory of the enemies — yes, socialist Poland too) explained the extensive presence of the military. Thus the lines between the castes were more visible in Lviv (as in the other cities occupied by Soviets after the war) than in the east.

My grandmother missed Kyiv, but she never came back. My history with Kyiv had one more twist: my father started to work in Kyiv, and my mother joined him soon after I became a student. We started to live in two cities: me in Lviv with my grandparents, and my parents in Kyiv. Mom hated it, and that was understandable. It was not a hospitable place back then. They came back to Lviv in late 1998. That was their first experience of living apart from my grandparents, and they switched to Ukrainian there, a rather non-conformist move for Kyiv in those years. I meanwhile switched to Ukrainian in university, so it was all very natural when they were back.

I decided to move after I realized that I was spending more

and more time in Kyiv and enjoying it a lot, that I had exhausted Lviv, that most of my friends were in Kyiv. I wasn't bitter. I left determined to be happy, and I was, just as I had once been in Lviv. My 33 became a new 19. I had a happy farewell to Lviv and a happy arrival in Kyiv. I found a place in an old building in Podil, the nicest neighborhood in the city, just a few blocks from the riverbank. My windows faced the emerald rococo dome of the Andriivska church (and a red flag directly in front of me, as I lived next door to a Communist party headquarters). The Maidan was a short walk away, which was a strategic advantage during the revolution. I spent the next eight years in that apartment. My future husband moved in, and later we bought a new place, also in Podil, after our child was born.

While I lived in Kyiv I didn't like to come back to Lviv. I did so, just a few times a year, mostly for an annual book fair (I worked in publishing), and sometimes for Christmas or Easter, certainly far less often that most of my friends did. At some point I realized that the obstacle was physical: I felt suffocated in Lviv, as if I had only one lung. The thought that I might one day have to return to Lviv (if I lost my job, say) was my nightmare. Yet something changed last year, in March 2021. I came for longer, more than a week, to work with the Cultural Strategy Institute, a think tank for which I serve on the supervisory board. Though the institute is a relatively new municipal body, for its institutional memory and its people it is a sort of sequel to the Dzyga Art Association, where I worked twenty years earlier, and which provided the best professional experience of my life. Dzyga organized festivals, rock concerts, and exhibitions, a sort of production company with an asymmetrical focus on being good in art rather in business. It also opened clubs and cafes, and its venues were safe spaces for artists, journalists, academics, and students like us.

This time I came to Lviv with my daughter, who brought long and slow walks to my life: you can't walk fast with a two-year old. For the first time in years, I had occasion to meditate on the blurred surfaces of the old Habsburg-era buildings, on all the backyards, on the hypnotic topography of the city. Another novelty: I began to think obsessively about people who had lived there before World War II. Not that I wasn't aware of them all those years. I just didn't have much empathy for them. In Kyiv I once started to write a book of essays partly about that. I even entertained the possibility I might come back to Lviv someday. I didn't tell anyone.

February 25, Friday
I woke up in the middle of the night because of a strange noise — the airplanes, I guess. The distant sound is familiar, and not: it was as if I had heard the planes before, but in a dream, not in reality. I understood the planes were most likely Ukranian. I think that the afterlife may sound like that.

Then we heard the air raid sirens. I held the sleeping S tight.

Roman's parents are still on their way: they drove all day but could only make it to Ternopil, and they stayed there for a night. They arrive, finally, in the afternoon, exhausted.

Roman is busy renting and arranging everything necessary in the apartment for the refugees. His friend gave him a substantial sum of money for that purpose on her way to Poland. She threw a pack of cash over the heads of the crowd at the railway station. He reported that the people at the station were weeping and gnashing their teeth.

February 26, Saturday
I texted Andriy, my daughter's godfather, to check on him. (He stayed in Kyiv.) I found him on his way to his hometown for

conscription: the military mobilization is not digitized. His home is high in the Carpathian Mountains.

Andriy is an old friend and a *kum*. *Kum* is a family you choose yourself. The official title "godparents" means that they should provide spiritual guidance for a child of their friends. I recently realized that our bloodlands made the title special also for another reason: godparents have the responsibility to care for a child if the parents should die. That signifies an enormous degree of trust, and the ties are so important that they gave a name for the Ukrainian practice of nepotism — *kumivstvo*.

Andriy is seven years younger than me. I got to know him when he was a student at Ukrainian Catholic University in Lviv, and I had just started to write articles in English. I wrote a piece about the heroes of the Orange Revolution, and he was one of them. In 2004, as an observer at the second round of the presidential election in some distant village in the Odessa region, he hid himself under the wheels of the truck when local authorities tried to steal the box with the votes. When he confronted the local authorities, they tried to ignore him; he figured that they wouldn't dare drive over his body and kill him, and it worked. He came to Maidan directly from there and spent the entirety of the revolution in the square. Graduating with a masters in theology, he moved to Kyiv to work in an organization providing assistance for people with HIV. Sometimes I stayed at his place when I was in Kyiv. For years Andriy has been providing me with guidance in several areas, above all in music (he is also an extraordinary DJ) and spirituality. He has a special talent for explaining the Bible in the style of a stand-up comedian, using the vocabulary of a street pusher. He looks like another hedonistic Kyiv hipster, and few know that he is a devoted Christian, living what he preaches.

Most universities in Ukraine have military classes for male (and sometimes female) students, so they can get a rank with graduation. Ukrainian Catholic University does not have any. Andriy is a private now. I saw him at Maidan and in many other situations, I know how selfless he is, so now I'm desperately worried about him. When I asked him to be my *kum*, I made him promise that one day it will be he who introduces my daughter to her first joint. He *must* keep that promise.

February 27, Sunday

In Hostomel, Russian bombings destroyed AN-225, the famous gigantic airplane known as "Mriya." It wouldn't matter so much if "Mriya" had not had its special moment last August, during the thirtieth anniversary of Ukrainian independence, when my daughter became fascinated by it as it flew over our home during the rehearsal for the parade and then over the parade itself. Since that day, she has called every airplane "Mriya." Not long afterwards Roman took her to the Aviation Museum, and it looked like she found her new passion. We haven't told her that it is gone, of course.

"Mriya" means "dream" or "aspiration."

February 28, Monday

It is snowing, and the trees in the huge backyard that we share with the nearby buildings are all white. You can barely make them out through the wet snowy lace. In the morning someone plays the Ukrainian anthem on a trumpet, we can't see exactly where, maybe on his balcony. We open our balcony door and applaud him as he finishes, as do some other neighbors whom we do not see.

Lida, my old friend and colleague at the Cultural Strategy Institute, called. We worked together at Dzyga: she was there from the beginning, in charge of finances, and I came later and

did press and promotion. Her mother died shortly before the invasion. Contrary to Ukrainian tradition, she didn't wait and instead let refugees live in her mother's apartment immediately, and gave away most of her belongings to those who need them now.

Lida is just back from the cemetery, visiting the grave on the ninth day after her mother's death, in accordance with Ukrainian tradition. She couldn't buy candles there, as is the custom; the gravediggers were busy preparing Molotov cocktails for territorial defense.

March 1, Tuesday
The Russians hit the TV tower in Kyiv. Five people were killed, and some were injured who were just passing by. The shells damaged the broadcasting facilities nearby and also the territory of Babyn Yar, which is right there. The tower stands.

March 2, Wednesday
It seems like everyone I know is volunteering. I joined Lida to help pack necessities for the territorial defense and the refugees; she had volunteered there the day before. It turns out that the hub is managed by the daughter of a well-known Lviv architect and political activist, one of the members of the Lviv Student Fraternity in the late 1980s. Lida was also a member. In those days the "brothers" organized anti-Soviet student strikes, including the major hunger strike in Kyiv in 1990 that led to the resignation of the prime minister in the still-Soviet republic. (It was the first Maidan.) The head of the fraternity, the late Marek Ivashchyshyn, shortly thereafter founded the Dzyga Art Association. Both Marek and most of the other "brothers" never stopped being politically active, no matter what they did professionally.

I can't help noticing that today I see the same people I knew from my work at Dzyga. The network becomes visible with every political crisis: when Georgy Gongadze was killed and the Russians used the political crisis to assert control over our president Kuchma, and when Marek and Yaroslav Rushchyshyn, another former student leader, founded an opposition newspaper and were persecuted by the brother of Victor Medvedchuk, Putin's *kum*, during the Orange revolution, and then during the Maidan revolution. (Medvedchuk was the director head of Putin's presidential office in the early 2000s and is now under arrest for state treason. His younger brother Serhiy was the head of tax administration in Lviv, an institution that was weaponized for political repression.)

And now their teenage children are packing the medicines, the clothes, and the food for the war with the same enemy. Will it end with their generation?

March 3, Thursday

We saw our trumpeter: he went out and played the anthem between the two neighboring yards.

I came back home in the evening to have an online PEN discussion with the historian Marci Shore, who knows so much about Ukraine. I was covering for the wonderful Ukrainian philosopher Volodymyr Yermolenko, who was evacuating his family from Brovary, a town near Kyiv.

Today we mostly sorted out thermal underwear and packed it for the people in Kharkiv. It is much easier to do manual labor than intellectual work. That was the same problem during Maidan. Being a rational thinker, I tried to create added value amid the turbulence, to do what I do best. Anyway, I'm never sure I do the right thing.

March 4, Friday

I stay home today: S is very nervous when I'm away, despite the two sets of grandparents. There is a lot of drama when I get back. She sleeps badly.

In the city center the sculptures in the UNESCO heritage area are wrapped in special protective materials. Some of them, such as a crucified Christ from the medieval Armenian church and a seated Christ from one of the domes, are hidden in shelters. The famous Renaissance market square and the nearby quarter have already survived several wars, as has the rest of the city. Even after World War II the damage was minor, nothing comparable to Kyiv or Warsaw. Over the last two decades the city fulfilled the dream that was in the air in the early 2000s, which I felt when I would cross the deserted square in the evening on my way home from the gallery. Lviv became the new Krakow, full of tourists (before Covid), with a bar in every hole in the wall.

It is full of other kinds of newcomers now. It is easy to spot them: they are usually waiting for someone. Do they think I'm one of them when we look at each other nervously? I, too, also wear warm comfortable winter clothes when a simple coat would be more appropriate. I, too, keep looking around as if I had never before noticed the strange mascarons on a nineteenth-century facade. But I'm not like these new arrivals: I came in peace to the city I know.

March 6, Sunday

In her sleep my child says, "Home!"

She is needy for my attention, demanding that I "read" a tourist guide of Stockholm that I brought from there in 2005. I promise her that we would go to Stockholm when she is a little older. She asks questions about every picture, and we make

21

plans: we will see the Royal Palace, we will meet the Queen and the King, we will run in a park. Nothing is more important these days than spending time with her.

I've been to Stockholm once, and I fell in love forever. Ever since that visit I used to say that I will go there to die. Today I received an invitation to spend some time in Gothenburg, a fine opportunity for Ukrainian editors in need. Well, I'm not in need, at least for now; I'm quite comfortable. I have no right to take a place that others may desperately be seeking. And I don't want to go anywhere without Roman. Besides, the prospect of going to Sweden is not as attractive these days. If I really need to go there — if, say, Lviv is occupied — it is very possible that I will never come back. The idea of dying in Sweden is still attractive, but I would prefer to do it on my own terms.

March 7, Monday
I've written a short piece called "Postwar" for *Krytyka*, the journal I used to work at, about how the West has been mesmerized by toxic Russian narratives for decades, about how disgusting are the attempts to justify Russia's "great culture," as if that is the most important thing right now. At first I thought that my piece was too harsh. Then I read the statement of German PEN, which was concerned mostly with the fate of Russian writers and made an equivalence between "poorly equipped Russian soldiers" and Ukrainians under attack, since both were "Putin's victims." No, my piece wasn't too harsh.

The infotainment of our days: a woman at Darnytsia, an old working-class area in Kyiv, knocked off a Russian scouting drone with a jar of preserved tomatoes. She was out on her balcony for a smoke, and this was what she thought to do when she saw a drone and panicked. Some may say it's an

urban myth, but I can easily imagine such a woman: she might be one of the women I met many times in the printing shop at Darnytsia, where I discussed the paper and the bindings with them. They could easily do what the woman in Darnytsia did.

I notice the announcements on every pharmacy door I pass: "No iodides available." The Russians have occupied Chernobyl and are holding personnel as hostages; there was a fire at the captured nuclear plant in Energodar, the biggest in Europe. The possible consequences may be far worse than the Chernobyl catastrophe in 1986. No wonder people bought out everything that might protect them. After Chernobyl they gave us kids antistruminum, small sweet pills of potassium iodide. Like almost everything in Soviet schools, it was obligatory: from time to time a school nurse would deliver it to the classroom at the beginning of a lesson.

Recently I remembered that we moved into the apartment in which we now live three days before the Chernobyl catastrophe, on April 23, 1986. I was in the first grade, and I don't remember exactly when we learned about the explosion. I'm sure that my parents understood how serious it was from some of the "hostile voices," that is, from Radio Liberty, the BBC, or the Voice of America. My father brought a Geiger counter. It stood on a windowsill for some time, but soon my parents were so annoyed by its sound that they just put it away in the basement. Lviv was lucky again in 1986, not affected by radiation, but Kyiv was heavily affected. I don't really remember people coming from Kyiv and Prypyat those days, though I knew they were trying to escape. Only later I learned how difficult it was to leave Kyiv. People fainted in lines to get a train westward. Exactly like now. I don't remember anyone using the word "refugees" back then, but we were aware that many people from Prypyat found their new home in Lviv.

I was eight, and my own fears were a consequence mainly of books and movies: as with many Soviet "technical intelligen-tsia" — people involved in what is called R&D in the West — my parents liked science fiction and I was caught up with their interests. In the Soviet Union science fiction was a loophole in Soviet censorship, but probably a slightly different pool of authors than people in the West read. Ray Bradbury, Herbert Wells, Arthur Clarke (until some point), and Clifford Simak had been translated and published in the Soviet Union, but I doubt that I know a single name of the writers whom Americans of my generation preferred. Stanisław Lem, who grew up in Lviv, and had to leave for Poland after the Soviet occupation, was hugely popular. As we didn't have real news in 1986, but only indoctrination programs, my idea of the catastrophe that we faced was embroidered out of the plots of man-made apocalypse in science fiction. Yet the idea of a nuclear apocalypse had one more source in my case: oddly, I loved the Soviet "international news" TV program, which was in fact propaganda speeches about how mad Ronald Reagan was and how the USSR was striving for peace. I was the only one in the family who watched it, terrified that Reagan might start a nuclear war at any moment (as they said he might). In school corridors I saw older kids running in gas masks. Happily I was spared that experience, thanks to Gorbachev.

Chernobyl marked a huge shift in Soviet consciousness, as Soviet people realized that they themselves may cause nuclear catastrophe, and not the capitalist demons overseas. Many years later I read that it was also the beginning of the end for the USSR; people learned that there are things more dangerous and powerful than the KGB. My interest in science fiction faded with *glasnost* and *perestroika*: it turned out that reality itself had almost infinite resources for miracles. Westerners

often underestimate the isolation in which Soviet people lived. (The situation was very different in "socialist" Central Europe.) Back then no aliens from distant planets could compete with the newly opened Western world. In fact, we were the aliens.

March 8, Tuesday
I saw a person I've known for ages. Yurko is also my neighbor. He had a Kyiv period too, and now lives with his family and children at his old home, the grand neoclassical four-story apartment building that we see from our windows. The building is quite unusual for Lviv: its palatial design would fit Paris. When I was a child, everyone called it the "professors' house." Yurko's father, who is now ninety-six years old, is a member of the Academy of Science, a distinguished achievement, and the honorary director of the Physico-Mechanical Institute, where my parents once worked and started dating. Yurko tells me that until recently his old father went to work, having taken a break only due to Covid. Yurko himself walks with a cane: he badly injured his popliteal ligaments five months ago, and this keeps him in Lviv. As he spent two years in the military in the Donbass war, he is one of "the first-call reservists." "They told me to come back when the knees are fine," he says. In the 1990s Yurko was one of the first Internet-providers in Lviv and more broadly in Ukraine. His company made the first websites for almost everyone I knew. He was also the ultimate party guy, making cocktail shots of his own recipe and usually the last man standing.

I received a long email from my editor at the *European Review of Books*, a new magazine for which I've been working on a review of a new book by Yaroslav Hrytsak, a historian and public intellectual whom I've known for years. (He lives in Lviv.) This task was a real joy from the start, but now it gets

tricky: as I write about Ukrainian history, Ukrainian history starts to run amok. Now I discuss the ending of the review with my editor. The previous ending is outdated already. The article is supposed to appear in May. Our history will be different in May. But how different?

March 9, Wednesday
I texted with my *kum*. He finished his training and is "fully deployed." I can't ask where he is and he can't say. I promised to keep a bottle of cognac for him. (I was referring to a Ukrainian brandy that we prefer. It's imprecise to call it cognac, but we do.) We agreed to drink it on a bench at Podil as we did after Maidan.

An acquaintance of mine, a Belarussian poet who moved to Ukraine many years ago, and his wife, a Ukrainian poet, wrote on Facebook that they are stuck in occupied Bucha. He quoted a Russian occupier who told a group of women and children: "Well, Ukrainian tribe, are you dying out? No one is gonna rescue you from here." They didn't let them leave.

We celebrated the New Year together once, in 2012. It was my first New Year's party in Kyiv. I was happy then, and even happier that night. We danced to a remix of a Soviet children's song with a refrain that was changed to "Lu-ka-shen-ka!" I had many hopes for the upcoming year.

Our host that night went to Donetsk in 2014 and was arrested as a "spy" by the separatists. He spent forty-eight days in the Donetsk concentration camp known as Izolyatsia, interrogated by the Russian FSB. (A book about Izolatsia by Stanislav Aseyev recently appeared in English.) I guess it was then that he (or his kidnappers) deleted the photos from that New Year's party from his Google drive, the ones that he shared with us back then.

March 10, Thursday
I take S for a walk in the park near our home. There is also an amusement park there, obviously not functioning now. Many of the carousels are the same ones I used to ride decades ago. It is cold, even colder than it was in winter, and we are almost alone there. S likes the small stadium where I ice-skated with my mother when I was six. S keeps herself busy cleaning the seats with her mittens, when a David Lynch-ish thing happens: an elderly man who had been pacing along the stadium suddenly stops after having walked three hundred feet and starts to step backwards, slowly, almost like a moonwalk. He traces his entire way backwards and then hides in one of the stadium facilities.

It is almost the city center here, but it is absolutely quiet. It could be any other cold spring day in a deserted park: no signs of war. Like a time capsule.

March 12, Saturday
The air raid sirens wake us up again very early this morning. We all have a special app for air raids on our smartphones now, and the sound is awful. S is afraid, and Roman makes up a story for her, about a small brave bear who travels to Baryshivka, a village near the summer house of his parents. Baryshivka was bombed yeaterday. Roman's parents talk to the neighbor who looks after their cat, urging him to use their food storage in the house. Their village is cut off from food supplies for now. We all fall asleep soon, but S has a bad dream. I feel her shiver.

March 15, Tuesday
A sunny day. It smells of March, but not as it was last year. The fragrance is of the past, when I was a teenager. I believe this is because fewer people are using their cars now: the price of fuel has risen, business has slowed down, and the air has become

again as it was when we were poor. The old city center is almost a cup, a lowland, partly open and partly encircled by hills. All its smells are more intense, as I learned after moving to windy Kyiv.

People sit in cafes, but no one is relaxed. I took a photo of the wall of the yard we went to with S a year ago. The same playground, the same wall, a different March.

March 17, Thursday

I meet a friend of a friend for coffee: a lovely American-Israeli journalist. Almost everybody around us in the café speaks English. She asks me if she could hug me when I have to go, and we laugh about how quickly we have all forgotten about Covid.

March 18, Friday

Russian missiles hit Lviv for the first time, the facilities near the airport. It's a sunny and cold day.

I think to myself that from now on I can never think of Lviv as my own special experience. Any Lviv story is now overshadowed by the thousands of stories of those who found shelter here.

March 23, Wednesday

We meet with Lida and Vlodko Kaufman and discuss our plans for a big exhibition of contemporary Ukrainian art to be shown in Lithuania, Poland, and maybe France and Austria — a retrospective of a kind, mixing old and new.

Kaufman was one of the founders of Dzyga back in 1993. When I started to work there in 1998, I was overwhelmed by my proximity to a living legend, though as a journalist I had written about his work earlier. Already at that point he was

celebrated by the writers I admired. Later I was deeply honored to write commentaries for his various projects. He would bring a pile of trash to the gallery and announce that it would become his new installation, or he would show some new paintings, or he would try to explain the idea of a performance. As I would produce a text about it, he would exclaim: "Oh, that's what I mean!" A stranger overhearing us would have thought that we were mad. What Kaufman taught me in the process was priceless: he managed to explain the few seconds of ecstasy he lives through during a performance, the elusive magic that an artist may capture if he or she is very lucky. He prepared me to recognize and to welcome those moments of selflessness that nothing in the world may give us but art. I would never have written my first (and last) novel if not for him.

And now we discuss how to present Ukrainian artists to the public in Europe, when that public is finally ready to look more closely at what was under its nose all this time. I must admit that in retrospect I'm a little bitter: even as I enjoyed my work in Dzyga, I was not able to grasp how valuable the art, the music, and the people were back then. But as the world became global for us too, and I've seen a bit here and there, I realize that what was happening in Ukrainian culture back then was unique. And almost no one mentioned it. Kaufman talks about how Malevich and Archipenko were appropriated by Russians, and about their roots in Ukrainian contexts, and about the many more artists still unknown to the world, a whole invisible universe that survived the oppressions and the occupations of the past. As he speaks I wonder whether I know how to tell the world a story about the magic that I remember myself.

Roman's parents left for Vinnytsia, their native city. No air raids today.

March 24, Thursday
We go to a playground with S, the one we used to go to last year. But it is full of people now, mostly newcomers it seems. On our way home S asks, "Where is my home?" She is tired, and probably is asking how long it would take to get home, but it sounded desperate.

March 26, Saturday
I was coming back from a coffee with Elliot, a journalist for *Time*, when the air raid siren went off. It feels different in the city center, where we hear the voice urging us to get to shelters. The wind rose, almost a storm. The touristy horse-and-carriage passed by in a hurry. It is a strange combination, an air raid siren and a cabbie in Habsburg-era costume, his carriage decorated with gilded patterns.

I hear an explosion, then another, when I go up the street not far from home. The distant explosions catch me on the top of the hill, and I see the thick black smoke quickly covering half of the sky behind the familiar hill on the far side of town. I call Roman: he has taken our girl for a walk and the blast was even more distant on their side of the hill. On my way I meet Yurko coming back home with his kid, both totally cool.

The rockets hit the oil depot on the other side of the city, less than a mile from my godmother. She said their windows were intact, but the fires were raging and the black smoke was everywhere.

March 28, Monday
Our trumpeter performs again in the backyard.

We have a long walk with S to Stryiskyi park, a beautiful nineteenth-century park with dramatic ravines, a pond with

swans, pseudo-Romantic ruins, springs, and a greenhouse. One of the few prewar Polish monuments that survived the war is here, a monument to Jan Kilinski, a hero of Kościuszko's anti-Russian uprising. The whole park was named after Kilinski when it was established, but everyone called it "Stryiskyj" even before Soviets, and the old name prevailed. My mom used to take me there when I was S's age. We lived close by then, and we live close by now, just on the other side of it. When I was little I didn't know how unique our street was, with its upward spiral of remarkable early twentieth-century buildings. I also didn't realize how unusual the street on our way to the park is, a dark ravine between two high slopes with the buildings over our heads.

How does a landscape determine who we are? The back of our building faces the hill. Not only does it confer upon us the privilege of a huge green backyard with fruit trees, which were once my overgrown magical woods when I was little; these days it also provides us with a sense of safety. We never go to our basement shelter, the hill protects us, as if we can hide from the bombings in the folds of the landscape.

You can't explain Lviv until you explain the landscape. First, the river. The Poltva once gave life to the city, but it was buried beneath its streets in the nineteenth century. Now it is the municipal sewer system. The central prospect and Lviv Opera House stand on what was once the mainstream. Our building stands on the bank of what used to be one of the Poltva's tributaries, now a busy and noisy street. The pedestrian and transport arteries of the city repeat the course of the underground river. We somehow feel the streams under our streets: even S spins in her sleep to adjust to the flow of the underground river.

We connect the dots of the familiar locations when we

see them from the top of the neighboring hill, especially now, when the trees are not green yet. In a few weeks, when the foliage is thick, we will use our inner Google maps. Mine is especially rich with pins these days. I can point to a building with a kitchen full of smoke and Taschen albums where I was happy in 1996, sitting with my new friends, both dead now. Or to a building where a boy lived with whom I was hopelessly in love in 1992, and the nearby yard where we used to try our first cigarettes with my friend, who left for New York. In my private chronology, different blocks are different worlds. But a single missile can wipe away all the nuances of these worlds, and turn the whole terrain, crowded with miniature scenes and characters as in an illuminated manuscript, into a mash of ruins.

A landscape also means a lot for an army. If I'm not mistaken, it is one of the primary considerations of military thinking: "take the heights." The landscape is what they see on their maps, but it is different from mine, which is dotted not with targets but with memories.

S is busy with her ice cream when we run into Yaroslav Hrytsak, whose book I'm reviewing, taking a walk in the company of other people from Kyiv whom I know, including my colleague from the Soros Foundation. I am unexpectedly happy to see them all, and when they leave I realized why. These days our life in Lviv, filled with foreigners and high ranking guests, is dream-like, in that you meet people where they are not supposed to be. Only it's war, not your brain, that oddly reshuffles them.

March 29, Tuesday
I woke last night terrified for no reason, and soon the air raid siren went off. S woke up too and she snuggled me.

We had two more air raids today, one of them as soon as we went for a walk with S. On our way back I made up a story about monsters we must hide from. I don't know how else to explain to my daughter why we must stay at home. I also realize how fortunate we are: we are not hiding in a shelter. I'm making a chocolate pie during an air raid, and recalling many texts that were written by frightened people like me: on the curbs of wars, on the safe side of catastrophes.

April 1, Friday

We went with Lida to Genyk Ravsky's exhibition at the Dzyga Gallery, one of my favorite places in the world. We noted that it's been a quarter of a century since its opening. Dzyga is a part of the former Dominican monastery. The narrow medieval street, called Virmenska for the Armenians who lived there for centuries, ends at the gallery's doors, but the gallery hall is a prolongation of the street, just under the arch, which was painted black twenty-five years ago. The scene is usually full of people sitting in the gallery café.

Genyk Ravsky is one of the first artists who was involved in Dzyga. I remember him from the old days in a leather jacket and long hair, looking like one of the rock musicians who loved his paintings (he played also, but I was too young to witness it). Genyk used to mix pop art with classical images, to put jeans on the characters of the *Iliad*. I guess it was a mark of those times and that milieu. Now he is in Territorial Defense. Lida would later send me a photo of him in the gallery when he managed a day off: in a military uniform, with unusually short hair.

There are many photos along the stairs to the second floor, where our office once was. All the photos are black-and-white and all are by Vilya, the eccentric photographer

33

who died fourteen years ago, one of the regulars of the old Soviet underground scene — not glamorous at all, like his photographs. He was already quite old when our nightclub in the basement of the Lviv Puppet Theater had its heyday. He was so poor that sometimes he didn't have film in his camera, though he pretended to take photos anyway. But his photos preserved the era for us. Here is Junko, the rock musician. He was roughly my age, now dead. Frankly, he always had a kind of a mark on him: both a mark of genius and of death. I remember he had a small volume of Rimbaud in his backpack when I first saw him, and he also looked like Rimbaud. I mentioned this in my novel. When I saw him for the last time, at Maidan on the day after the shootings in the government quarter, and learned that he escaped the massacre, I felt immense relief: if he survived that, he would live. He died soon after. Listening to the songs that his band played in the late 1990s, I marvel at how original and progressive they managed to be, a galaxy away from the mainstream music industry. If Junko and his band had lived in London or even in Bristol, they would have become global stars. I see also the ghosts of many other musicians, writers, and bohemian types, and of course of Marek himself, a father figure for them even if they didn't know it. All of them are gone now. I reflect that Lida and I are among the few survivors, and it has nothing to do with the bombings. Some people die because their environment is too harsh and unresponsive, because they don't feel that they are needed.

Our club was in the basement, and this accurately reflected the status of Ukrainian culture at that time, even when the state was nominally "ours." The people in the photos were mostly marginal for their own TV and media, even in Lviv. My perfectly Ukrainian first editor, a nice guy, approved my pieces

about Dzyga and Ukrainian rock musicians without much enthusiasm, encouraging me instead to get interviews with the Russian actors who were regularly touring in Lviv.

Now most Ukrainians spend time in basements of another kind — the opposite of the basements of my youth, the workshops of musicians and sculptors, cafes and clubs. Why do I feel that there is a connection?

April 3, Sunday

I noticed that Lviv used to annoy me when my mind was all about the future, but now I have surprisingly intense flash-backs, an urge to visit the sites of my student years. When planning, and thinking about the future, is not an option, the past dominates the mind. As one door shuts, another opens.

April 5, Tuesday

Olesya Ostrovska-Lyuta, the director of Art Arsenal, the huge national art center in Kyiv, wrote a Facebook post that perfectly captures what I feel these days. Olesya calls herself a bureaucrat, but in fact she is one of the most profound intel-lectuals I know. She is my age, also from Lviv, but she left early and graduated university in Kyiv. She wrote that after the first shock of the war her mind was crowded with reminiscences:

> These visions come one after another. I'm kind of wallowing in them, telling them to family and friends. I enjoy recalling small details, rolling a memory of an air temperature or light in my head.
>
> Maybe that's exactly what happens to an old person, when she slowly departs from reality, immersing herself in her own vanished world instead. Maybe that's how

our mind reacts to a boundary experience, which in my case is the shocking reality of war and the risk of death, and in the case of old age is an approaching transition to nothingness. And so you feel as if you are swimming in a soft fog of your own stories, there is just you and the world that has passed by, and thus has lost its acuteness, has become amicable, like a grayish anesthetic substance. Maybe this is how we cope when approaching the frontier of the unknown.

We stay late at a playground, it is dark when we leave. We leave almost simultaneously with another parent, who is obviously not from Lviv, and I wish him a good night. Again I feel like I'm cheating: because of my shabby winter clothes in April (a cold April, but still) they may think that I am one of them, that like them I return to a rented apartment with uncomfortably high ceilings, strange smells, and a chilling uncertainty. Whereas I'm coming back to the apartment I grew up in.

April 14, Thursday

I take S to a meeting with my colleagues in the Institute for Culture Strategy to discuss the exhibition we are planning. We put up a name already: "Ukraine. Unmuted." S causes only minor damage at the office.

Then we go to a playground at the top of the steep street on the hill of the Citadel. Just above us is one of the Citadel towers, now turned into a five-star hotel. Most of the people descending the metal stairs from the hotel and down the street speak English.

An elderly man with a small, cute dog starts a conversation with a janitor. The two seem to know each other. The older

guy speaks Russian, trying to switch to Ukrainian. He gives some intangible impression of wealth, as some people do: it was easier to spot in our part of the world when imported clothes were a sign of privilege, but I can detect it even now, when the same brands are worn everywhere. They discuss the area, and the man with the dog turns out to be immersed in his memories: he points to the fancy hotel and says, "That used to be a Torture Tower. When we were kids we found bones here all the time."

I know what he means. The Citadel was a concentration camp, Stalag 328, during World War II, mostly for prisoners of war. About 140,000 of them died there.

Built in the 1850s as Austrian fortifications, the four towers and cantonments for the garrison were supposed to protect the city. The idea came after the Austrian army used the hills to batter the Polish uprising in Lviv in 1848. In Soviet times the territory of the Citadel was closed, but some of my classmates boasted that they had explored its bunkers. There were some military facilities there, and, they said, the KGB too. (The headquarters of the KGB was on the opposite side of the hill, on my street.) Since my school was just in front of another slope of the Citadel hill, I stared at the other death tower during my boring classes. Most of my classmates lived nearby: in Soviet times children attended the school nearest to where they lived. This was the Russian school, meaning that instruction was in the Russian language, quite natural for the city center. The elderly guy likely went there, too. It is possible that he brought his children there, and that I knew them.

Our school was a sort of citadel as well. It used to be an unofficial *obkom* school, meaning that the children of the local Communist authorities went there. It was renowned for its

math teachers, who were so good that their students could enter elite Moscow universities. (They didn't help my math skills any.) We were isolated from the roiling political and cultural Ukrainian life just a few blocks from our building. I remember that the teachers were once concerned for our safety because a huge anti-Soviet rally was taking place in the city center.

I don't quite remember when the Citadel was opened to the public, certainly sometime in the late 1980s or early 1990s. For a while my dad had an office in the former Austrian cantonment. When I was fifteen, I went there with friends. Though it's in the heart of the city, encircled by nineteenth-century streets from every side, it was a separate world, like a summer camp. The view from the ground of that death tower, then abandoned, was breathtaking.

Today I watch a group of teenagers cross the playground, heading up to that place. The girls wear heavy makeup, exactly as I did when I was their age. I overhear them talking about the war. They will hide from it there, as we used to hide from the challenges our parents faced and the 10,000% inflation of 1993.

We follow them. As we walk, I tell S that I spent a lot of time here when I was little. "Were you little, mommy?" she asks skeptically. "And I was once big," she says firmly. "Will you be little, mommy?"

"I will." I'm proud of myself, the mother of a natural born Buddhist.

April 25, Monday
A heavy rain catches us on our way home. My daughter is happy, jumping into every puddle. The rain is brushing the blossoms off the trees when an air raid starts. And immediately the blinding sun shines. The air raid siren yowls. I look back

and see a huge rainbow across the sky. In a universe such as this, no one should judge anybody for dancing at a funeral.

May 1, Sunday
I'm 44 today. Eleven years ago on this day I was buying the first bottle of brandy as early as 11 am. It was for a traditional morning rock concert in the inner yard of the city hall, organized by Dzyga. A long line early in the morning for a rock concert on the first Sunday of May: this was another mark of the city. It was also my farewell; I would leave for Kyiv soon afterward, and I mostly remember that May as endless walks and drinks with my friends. Today I use the opportunity to walk alone and take some of my old routes.

Two days ago Kyiv was hit with missiles again, including a residential building not far from our home. It's too early to go back.

Every Monday morning I finalize the weekly overview of the news from Ukraine. I sort out the dispatches about attacks, about the killed, the tortured, and the raped, to include all that is important for the security of the Central European region. I do it cold-bloodedly. But I may burst into tears seeing sun streaks on a familiar roof, or young grass in an abandoned lot, or a splash of audacious green in a backyard behind the narrow front door.

I think again about how a landscape shapes you: it's easier to believe that the world is full of miracles when you know that a dirty, dark, and uninviting entrance may hide a magic garden behind it. A person accustomed to walking in a flat city gets a particular idea of time, her time is linear, as block after block is left behind, becoming the past. But keeping several hills in your sight simultaneously, several distant areas at once, makes it easier to connect different eras in one's mind — to

39

feel the past, which is never dead, and not even past.

About thirty years ago, every day on my way to school and back, I passed by the Citadel, the KGB, and the notorious prison on Łącki, now the Museum-Memorial of Victims of the Occupation Regimes. At that time I did not know that during "the first Soviets" in 1939–1941 it was the NKVD prison where up to a thousand people were tortured and killed. Polish girl scouts were raped there in the way young girls, almost children, have now been raped in Bucha, Borodyanka, and Irpin. Unlike the Russian soldiers near Kyiv, the Soviets came back. Maybe some of those soldiers picked up their grandchildren at my school. Anyway, they owned the city because of what was done in 1939, and then in 1944, and then later. But the city in its turn owned their children and grandchildren, at least the many of them who became hippies and underground artists. The city owned those who came here during the urbanization of the 1960s: unlike most peasants who switched to Russian as they moved to a city, in Lviv they were sticking to Ukrainian, and eventually turned it into a stronghold of the Ukrainian movement.

I need this city even after I die. I need it to lie on the abandoned concrete slabs, warmed by the sun, at Citadel hill, just as I did in 1993. I need it to hang out in the Jesuit gardens, the beloved park of little Stanisław Lem, just as I did in 1995 with the grandchildren of those who pushed his family out of the city. I need it to listen to music and poetry under the walls of the Dominican monastery as the sun still shines, because it is June, the enchanted June of 1997. I wish I could somehow do that before I become little again.

ROBERT KAGAN

War and the Liberal Hegemony

Why did the United States intervene in the Second World War? The question is rarely asked because the answers seem so obvious: Hitler, Pearl Harbor, and what more needs to be said? To most Americans, World War II was the quintessential "war of necessity." As the late Charles Krauthammer once put it, "wars of choice," among which he included Vietnam and the first Gulf War, are "fought for reasons of principle, ideology, geopolitics or sometimes pure humanitarianism," whereas a "war of necessity" is a "life-or-death struggle in which the safety and security of the homeland are at stake." If World War II is remembered as the "good war," the idea that it was "necessary"

is a big part of the reason why. The enemies were uniquely wicked and aggressive; Americans were attacked first; they had no choice but to fight.

This perception of World War II has had a paradoxical effect on the broader American foreign policy debate. On the one hand, writers of an anti-interventionist bent rightly perceive that the war's reputation as "necessary" and therefore "good" has encouraged Americans to believe that other wars can be "necessary" and therefore "good," too. (Krauthammer believed the "war on terror" was also one of "necessity," and Richard Haass put the Gulf War in the "necessary" category, and in 1965 even David Halberstam and *The New York Times* editorial page believed that American intervention in Vietnam was necessary.) On the other hand, anti-interventionists are not alone in believing that, even if World War II was necessary, the circumstances were unique and therefore irrelevant to subsequent foreign policy discussions. There will never be another Hitler, and the idea that a foreign great power (as opposed to a terrorist group) might launch a direct attack on the United States seems far-fetched even today. World War II thus stands apart, bracketed from further relevance, as perhaps the only widely agreed "necessary" foreign war and therefore the only "good" foreign war that the United States has ever fought.

But what if even America's intervention in World War II was not "necessary," as most Americans would define the term? What if it, too, was a "choice" that Americans made, based on calculations not so different from those that produced the later wars of choice in Iraq, the Balkans, and Vietnam?

Those many Americans who opposed American involvement in Europe and Asia in the late 1930s and early 1940s certainly did not believe the war was necessary. This was not because they were ignorant of the potential risks posed by Hitler and the Japanese Empire. The America First Committee, a group that combined corporate elites such as the chairman of Sears Roebuck with scions of the eastern establishment such as Joseph Kennedy and Chester Bowles, launched itself in September 1940, three months *after* the unexpected conquest of France by the German blitzkrieg. Its founders understood the implications of France's defeat. They not only believed but predicted that Britain would be the next to fall, leaving the United States without a single meaningful ally in the European theater. (The bestselling author Anne Morrow Lindbergh wondered whether it was "courage" or "stupidity" that made the British fight on.)

With Japan on the march on the Asian continent — Japanese forces, having conquered much of China, invaded Indochina three weeks after the Committee's founding — Americans in the fall of 1940 faced the real possibility of a world in which Europe and East Asia, along with the Eastern Atlantic, the Mediterranean, and the Western Pacific, could soon be dominated trio of militaristic dictatorships (Mussolini's Italy being the third.) *This* was the moment — arguably the nadir of the future Allies' fortunes — when the America First movement took its stand against further American aid to the victims and prospective victims of Nazi and Japanese aggression. Just a few weeks earlier, after the British evacuation at Dunkirk, Winston Churchill gave his famous "we shall fight on the beaches" speech, with its concluding prayer, mingled with reproach, that, "in God's good time, the New World, with all its power and might," would come "to the rescue and the liberation of the old." That was precisely what

the American First movement aimed to prevent.

The anti-interventionists' main practical argument was that even in those direst of international circumstances, American security was not immediately or even prospectively threatened. By virtue of its wealth, its strength, and, above all, its geography, the United States was effectively invulnerable to foreign attack. Those who held this view were not benighted cranks, nor even the well-respected men and women who led the America Fist movement. It was conventional wisdom among the nation's leading foreign policy and military experts in the late 1930s. Respected analysts such as George Fielding Eliot concluded, after "a detailed consideration of America's strategic position and military requirements," that American security was not in danger from any European power so long as it maintained an adequate navy. This was also the view of self-described "realists" of the day, a new breed of professional foreign policy and military experts who prided themselves on what Eliot called "realistic thinking," the "banishment of altruism and sentiment" from their analysis, and "single-minded attention to the national interests." Yale's Nicholas Spykman, one of the founders of the school of "classical realism," argued that with "the European neighbors of the United States ... three thousand miles away" and the Atlantic Ocean still "reassuringly" in between, America's "frontiers" were secure. So long as the United States maintained a strong navy capable of protecting its shores and so long as bombers' cruising radius remained less than four thousand miles, the Atlantic and Pacific would remain "the chief elements in the defense of the United States."

Hanson Baldwin, the military editor of *The New York Times*, explained in detail what an attack on the United States would require:

Under fire from bomb and gun, soldiers and heavy equipment would have to be transshipped to small boats from the transports anchored offshore. Then the small boats would have to make a landing through the surf. Once on the hostile beach, the enemy would have to struggle to get their tanks and field pieces off ramp-bowed landing boats onto the beach under shells and machine-gun fire, their only support, their carrier-based aviation, and the guns of their warships.

This proved a prescient description of the D-Day landing in 1944, but at the time Baldwin meant to show how unlikely it was that a foreign power would or even could launch an invasion of the United States. In the same spirit Senator Robert A. Taft, no one's idea of a yahoo, argued that no foreign power "would be stupid enough" to try to land "troops in the United States from across thousands of miles of ocean." A Council on Foreign Relations study group in February 1940 concluded that "no one believes that an actual military threat to this country exists, even if Britain and France were to be conquered by Germany." Although some, such as Spykman, began to change their minds after the fall of France, most did not. Herbert Hoover denied that American security depended on the outcome of the war in Europe. The victor, if it was Germany, was not going to turn around and "attack 130,000,000 people 3000 miles overseas, who have a capacity of 10,000,000 soldiers and 25,000 aircraft."

Not only was a foreign attack on the United States physically unlikely if not impossible, the anti-interventionists argued, but it was also avoidable if Americans simply attended to their own affairs and stayed out of the other great powers' business. Neither Germany nor Japan had any reason to risk

bringing the United States into the war. And the United States had no reason to stand in the way of nations seeking to expand their territory and spheres of influence. Most Americans agreed that the United States had no vital interests in Europe or Asia. At least that had been the dominant assumption of American policymakers throughout the 1920s and Franklin Roosevelt's first term.

After the Pearl Harbor attack and the subsequent declaration of war by Germany, many of the anti-interventionists did not change their views. War had come to the United States not because Tokyo and Berlin had sought it, but because Franklin Roosevelt, departing from the policies of his predecessor Herbert Hoover, had interjected the United States into distant quarrels. While the great majority of Americans regarded Pearl Harbor as a treacherous act of "infamy," the anti-interventionists made themselves unpopular by insisting, in the words of Arthur Vandenberg, that the United States had "asked for it." The Roosevelt administration's "dogmatic diplomatic attitudes" had driven the Japanese "needlessly into hostilities." After all, as Hoover put it, if the United States insisted on "putting pins in rattlesnakes," it should expect to get bitten.

The anti-interventionists' arguments were not as weak as they are often portrayed. In retrospect it is clear that the Japanese would have preferred not to go to war with the United States, certainly not in 1941 but perhaps ever. Japanese military leaders did not even believe they could win a war with the United States absent divine intervention or a failure of American will. As the anti-interventionists pointed out, the Japanese would not have attacked Pearl Harbor had the Roosevelt administration not attempted to use its economic and diplomatic influence to try to block or slow Japanese expansion on the Asian mainland (and had Roosevelt not

decided to place the U.S. Pacific Fleet there as a supposed deterrent).

And if Japan had not attacked when it did, Hitler would not have declared war on the United States when he did. In 1941 Hitler was actually trying to avoid pulling the Americans fully into the Atlantic war, despite Roosevelt's deliberately provocative and aggressive expansion of the U.S. Navy's role. There is some evidence that Hitler may have intended to go to war with the United States eventually. In 1941, while preparing for the invasion of the Soviet Union in June, he had ordered plans for constructing a "big battleship navy," likely for use against the United States. But such thoughts were shelved when the initial invasion of the Soviet Union bogged down and settled into a war of attrition.

With the war a stalemate with Britain in the west and Russia in the east, any German assault on the United States was likely years off and left the United States plenty of time to watch and to prepare. Even staunch pro-interventionists such as Henry Luce acknowledged, as late as February 1941, that no one could "say honestly that as a pure matter of defense — defense of our homeland — it is necessary to get into or be in this war." Even if "the entire world came under the organized domination of evil tyrants," it was "quite possible" that the United States "could make itself such a tough nut to crack that not all the tyrants in the world would care to come against us." If Americans did enter the war, Luce argued, as he hoped they would, it would not be because the war was "necessary" as a matter of "survival."

The anti-interventionists were also right to point out that American policy had turned against Germany and Japan well before the latter were in any position even to think about an attack on the United States. The critical event in that

regard, the fall of France, did not occur until the summer of 1940. Prior to that, most observers regarded it as impossible that French forces, dug in behind their Maginot Line, could possibly be overrun by an as-yet largely untested German military. Yet Roosevelt began bringing American influence to bear against Germany as early as 1937, after Japan's full-scale invasion of China but before Hitler had committed any act of aggression at all, when he labeled Germany, Italy, and Japan "bandit" nations that needed to be isolated and quarantined like a disease. Thereafter he worked to modify the neutrality legislation that had prevented him from helping Britain and others; he enacted an increasing array of economic sanctions against Japan; and he brought the U.S. Navy into the Battle of the Atlantic as a belligerent in all but name. Were these steps necessary to the defense of the American homeland? Certainly not in any immediate sense. If anything, as the anti-interventionists argued, they brought the threat of war closer, a possibility of which Roosevelt was aware and which gave him no pause.

Why, then, did Americans start sticking pins in rattlesnakes in the late 1930s, increasing the risk of war, before any direct threat to American security had materialized? The answer had more to do with belief and ideology than with raw assessments of German and Japanese military capabilities. Roosevelt and many other Americans concluded that the Nazi regime was dangerous well before it had committed any act of external aggression. As Hugh Wilson, the one-time American ambassador to Berlin, observed, fears about Germany's course began immediately after Hitler's ascension to the chancellorship in 1933. That year

brought early signs of the coming persecution of Jews as well as celebrations of book-burning in the squares of German cities and towns, which people in the West found disturbing.

But it was the infamous "night of the long knives" in 1934 that shocked the liberal world. As Ambassador Wilson noted, the Nazi's murderous purge "profoundly" affected the "attitude toward Germany of every man of politics in Europe and of most of them in our own country. The temper of Europe toward Germany changed from indignation and exasperation to fear and horror." The fears grew as the Nazis consolidated control and began the systematic persecution of Jews and other minorities. For many American observers, the turning point came in the fall of 1938 after the mass persecution and killing of Jews in what became known as *Kristallnacht*. Even more than the Munich settlement six weeks earlier, which Roosevelt privately condemned but publicly praised, *Kristallnacht* convinced Roosevelt and others that, as the historian John A. Thompson has put it, the Nazi regime could never be "incorporated into a stable, norm-governed European order." That perception shaped American policies going forward as Hitler rearmed and began working more aggressively to overturn the Versailles settlement, but its origins preceded those efforts.

Not only could such a regime never become part of a stable liberal peace, but in the eyes of many Americans, especially liberals, the very nature of the regime guaranteed conflict. Most liberals believed that because Germany and Japan were "totalitarian" states, they would never cease their struggle against democracy and liberalism at home and abroad. As the critic Lewis Mumford put it, the fascists could not co-exist with "the ever-rising, ever-recurrent forces of civilization." Their "propulsive system of beliefs" would drive them onward

49

until the world was "made over in the fascist image." In 1937 the American diplomat George Messersmith insisted that what was occurring was a "basic clash of ideologies" and that the dictators were embarked on "a long road" that must end in an attack on the United States. Roosevelt spoke for many when he divided the world neatly along ideological lines, insisting that unlike nations "devoted to the democratic ideal ...autocracy in world affairs endangers peace."

These theories echoed Americans' ideological preferences going back to the founding era, but they were, nevertheless, only theories. As a practical matter, Germany and Japan might not ever find the circumstances propitious for launching an attack on a United States that was, indeed, substantially invulnerable. In his State of the Union address in January 1939 — months before Germany's invasion of Poland — Roosevelt barely talked about national security per se. He talked about belief and principle. "There comes a time in the affairs of men," he told Americans, "when they must prepare to defend, not their homes alone, but the tenets of faith and humanity on which their churches, their governments and their very civilization are founded. The defense of religion, of democracy and of good faith among nations is all the same fight. To save one we must now make up our minds to save all." Roosevelt's most arresting image was not of a German invasion or massive bombing raid, but of a democratic America isolated in a world of dictatorships. In a speech at the University of Virginia following the fall of France, he warned Americans that they were at risk of becoming a "lone island" in a world dominated by the "philosophy of force," "a people lodged in prison, handcuffed, hungry, and fed through the bars from day to day by the contemptuous, unpitying masters of other continents." Among other concerns, Roosevelt and others worried that the

United States could not long survive as an open, free-market, democratic society in such a world, that confronting the dictatorships over the long term would require a controlled economy and limits on individual freedoms. This was also just a theory — did free market capitalism and individual liberties die during the long Cold War? — but it reflected a timeless American anxiety. It was just another way that American policy was shaped more by matters of belief and ideology than by tangible measures of threat. Roosevelt and other Americans believed that preserving American democracy — the ultimate American "interest" — required a global balance of power that favored liberalism.

The nascent school of foreign policy realism was appalled at the "giddy" moralism and emotionalism that, in Beard's words, prevented Americans from dealing "with the world as it is." Hugh Wilson, a senior member of the "realist" camp at the State Department in the 1930s, observed of Americans in general that "our most certain reaction to the stimulus of a piece of news from a foreign land is to judge it 'good' or 'bad,' 'righteous' or 'unjust'... we instantly assess it by a moral evaluation based on our own standards." This moralistic approach had "poison[ed] our relations with Japan," and with the Nazis as well. The historian and critic C. Hartley Grattan complained that such "powerful currents of emotion and opinion" had led Americans to "throw cold reason out of the window."

For the realists and other anti-interventionists, accepting the world "as it is" meant accommodating historical shifts in the global balance of power, not fighting them. In one of the seminal works of realist thought, *The Twenty Years' Crisis,*

published in 1939, the British diplomat and intellectual E. H. Carr defended Neville Chamberlain's concessions to Hitler at Munich on the grounds that the "change in the European equilibrium of forces," that is, the growth of German power, made it "inevitable that Czechoslovakia should lose part of its territory and eventually her independence." The American diplomat George F. Kennan, then serving in Prague, agreed that Czechoslovakia was "after all, a central European state," and its "fortunes must in the long run lie with — and not against — the dominant forces in this area." Carr argued that if dissatisfied "have-not" powers such as Germany were bent on changing the existing system, "the responsibility for seeing that these changes take place ... in an orderly way" rested as much on the defenders of the existing order as on its challengers. Americans, of all people, should respect "the right of an able and virile nation to expand," Charles Lindbergh argued. As for Japan, the journalist Herbert Bayard Swope, winner of the first Pulitzer Prize, maintained that "sixty-three million people living on rocky islands" had "the right to exist," and if their existence required expansion, "then why forbid Japanese expansion to follow natural lines?"

To do so was more than a mistake, the anti-interventionists believed. It was immoral and contrary to American traditions and principles. Americans' refusal to accept the world "as it is" amounted to a form of imperialism. Even if the United States managed to defeat Hitler "after many years" of brutal war, Taft warned, it would just be the start of an open-ended American commitment to European peace and security. American forces "would have to police Europe or maintain the balance of power there by force of arms." If Roosevelt's commitment to the Atlantic Charter was to be taken seriously, the historian Howard K. Beale ominously observed, then the "victorious

Anglo-Americans" were not just going to have to "maintain democracy by armed force on the Continent of Europe and then 'police' that Continent." They were also going to have to establish and defend the "four freedoms all over the world." This would require "an Anglo-American navy large enough to establish 'freedom of the seas'... on all the oceans of the world." For Beale and other anti-interventionists, this was a prescription for "unadulterated imperialism." The famous Christian pacifist A. J. Muste worried that "we shall be the next nation to seek world-domination — in other words, to do what we condemn Hitler for trying to do." The Germans, Beale argued, would probably regard "Anglo-American 'policing'" much as Germany's victims in Europe now regarded German occupation: they might even call it "slavery." Beale did not want to see "a German imperialism" replaced by an "Anglo-American world imperialism." He did not want the United States to "dominate the world."

The vast majority of Americans, of course, would have denied any such intention. They saw their actions in purely defensive terms. They preferred to believe they were responding to an unprovoked attack from Japan and an equally unprovoked declaration of war by Germany. Once these were dealt with, once the aggressors had been defeated, most Americans likely assumed their nation would return to something like normalcy again. Indeed, in what would become a central paradox in American foreign policy going forward, most Americans probably thought that they were fighting a war precisely so that they might return to the relative passivity of the interwar years or the decades before World War I. A few internationalists talked about shouldering global "responsibilities," and that may have sounded like a good thing to some, but few Americans believed they were engaging in a massive

reshaping of the world, exerting hegemony, imposing a liberal order, or even establishing the United States at the center of world affairs.

But whether they understood it that way or not, the United States was imposing its preferences on a resistant world. Americans were engaged in hegemonic behavior, perhaps not on behalf of themselves, but on behalf of liberalism, which to their opponents amounted to the same thing. Whatever else Germany and Japan were doing, and however unpleasant their methods, they were attempting to break free of the restraints of an Anglo-American world order they had no part in establishing, which did not serve their interests as they perceived them but, on the contrary, was created specifically to constrain them. The Versailles settlement, which the United States had played a central role in shaping, had made Germany a "have-not" power, and the Washington Naval treaty, with its Nine-Power agreement on East Asia, had attempted to clamp a lid on Japanese expansion on the Asian mainland. The Germans and Japanese were thereby denied an empire and the regional sphere of interest that the other great powers enjoyed. And now, as Germany and Japan attempted to break out of the cage of these postwar peace agreements and resist the liberal hegemony, the United States once again roused itself to slam the cage door shut.

It was not unreasonable to ask what gave Americans the right to decide that it was unacceptable for Germany and Japan to enjoy the same kind of regional dominance that the United States enjoyed, or to acquire the kinds of empires that Britain and France had acquired over the previous three centuries. The Japanese made this argument repeat-

edly, claiming to seek only their own version of the Monroe Doctrine. Many Germans, too, and not just Hitler, believed that Germany required the kind of room to grow — the "living space" — that the United States enjoyed in abundance, thanks to its own past aggressions on the vast North American continent. Roosevelt could not even claim, as Wilson had in the lead-up to the First World War, that he was defending American neutral rights, since Hitler had been careful to avoid attacks on American shipping. So whether they had right on their side or not, Americans simply insisted, by dint of their power, that the liberal hegemony be preserved and strengthened and the international balance of power remain favorable to the liberal powers.

That, in the end, was what American intervention in World War II was about, and it was also what World War I had been about. If either war could be regarded as "necessary," it was not to defend the United States against an immediate threat, but to restore the kind of liberal order in which Americans preferred to live and which seemed to provide the greatest degree of protection against possible future threats.

Americans roused themselves to defend the liberal hegemony not because they were eager to make a "bid for world supremacy" or because they feared being supplanted as the world's "Number One power," as the historian Stephen Wertheim now argues, echoing the charges of the America First Committee and other anti-interventionists at the time. Americans had for most of the twentieth century consistently and deliberately avoided taking on such a role. They had not been jealous of British and French world leadership prior to World War One, and they would have preferred to see that leadership resumed after the war rather than take on the responsibilities of global "leadership" themselves. When they emerged

55

as the world's dominant power after World War I, they did not seek to exploit it but pulled back from exercising it.

American diplomacy in the 1920s had aimed at establishing a framework for international peace that would require little if anything of the United States: the Washington Treaties governing naval arms levels and outlining the terms of an Asian peace; the Dawes Plan which aimed at bringing economic stability to Europe; the Kellogg-Briand Pact which aimed to codify international strictures against aggression. In the late 1930s it was not with eagerness but with resignation that so many Americans who had once abjured any significant international role decided that, with the evident failure of these efforts, there was no choice but to place the United States at the center of world affairs. Suddenly, there was much talk of America's "world responsibilities," a concept most Americans had rejected throughout the two decades after Versailles.

Americans had simply changed their minds, both about the nature of the threats out there and about America's role in addressing them. Just a few years earlier, intellectuals such as Lippmann and Reinhold Niebuhr had abandoned their World War I idealism and interventionism for a postwar cynicism, or "realism," or, in Niebuhr's case, Marxism. Lippmann by the end of the 1920s had begun arguing that the United States "should withdraw from all commitments." Now, he and the others reversed course again. Like Senator Harry Truman, who had discarded his own anti-interventionist views after Munich and *Kristallnacht*, they believed Americans' failure to accept "our responsibility as a world power" had led to the catastrophic breakdown of the postwar world.

But the line between assuming "world responsibility" and exerting hegemony was a thin one. As Roosevelt put it,

"destiny" had made Americans heirs of European civilization, and "fate" now compelled the United States "to assume the task of helping to maintain in the Western world a citadel wherein that civilization may be kept alive." Niebuhr wrote of "the obligations which we owe to the community of nations ... as inheritor and custodian of the standards of justice of western civilization." It was America's fate, Lippmann argued, to give to "the world of the future that order under law which Rome gave to the ancient world and Britain to the world that is now passing away — that order under law in which alone can freedom prevail."

Vandenberg once warned that when it came to intervention in world affairs beyond America's shores, there could be "no middle ground." It was "either all the way in or all the way out." There was much truth in this. It was one thing when American foreign policy was limited to defense of the Western hemisphere, which by itself was an assertion of regional hegemony. But once the United States took on the goal of defeating the autocracies and re-establishing the ascendancy of the liberal world order, it was reasonable to ask where American commitments and obligations stopped. In 1943 Roosevelt set as America's goal "to organize relations among nations" so that the "forces of barbarism can never again break loose." This was not the United States as offshore balancer of last resort. It was the United States as proactive defender of an international liberal order. As Roosevelt saw it, the events of the interwar years had proved that "if we do not pull the fangs of the predatory animals of this world, they will multiply and grow in strength — and they will be at our throats again once more in a short generation." Such a view of the world and America's responsibility seemed likely to involve the United States in not a few foreign conflicts — none of which were

likely to be "wars of necessity" in the sense that American security was directly threatened.

American realism itself underwent a critical transformation as a result of World War II. Prior to the fall of France, self-described realists of the day had not believed American security would be threatened even after a German victory on the continent, and many realists continued to believe this right up until the attack on Pearl Harbor. It was only after the fall of France that some realists began to suggest that the United States had a vital interest in preventing the emergence of a hegemon in Euroasia. (Realists later promulgated the myth that the founders shared this view, but they too were guided primarily by belief and ideology: in the 1790s during the early years of the Napoleonic Wars, Hamilton feared Revolutionary France and favored an outright British victory, whereas Jefferson feared victory by the British monarchy and favored Revolutionary France.) Although rarely commented on, this was an extraordinary redefinition of American vital interests. To insist that no power should gain hegemonic control in Europe or Asia was tantamount to insisting on American global hegemony, since the essential prerequisite to American international primacy was precisely the absence of such a "peer competitor."

Nor should it be surprising that an American policy aimed at preventing the rise of a plausible challenger to the liberal order might lead to conflicts only tangentially related to that goal — such as preventing a communist takeover of southeast Asia or a hostile takeover of Middle Eastern oil fields. The degree to which American hegemony became baked into the common understanding of America's "interests" was most notable in Richard Haass' argument that the first Persian Gulf War was a "war of necessity." The notion that the United States

had a vital interest in the sovereign independence of Kuwait, a one-time Iraqi province, would have struck pre-World War II anti-interventionists as beyond absurd. Only an America that regarded its role as the defender and promoter of a liberal world order could possibly regard the liberation of Kuwait as a matter of "necessity."

All of which should raise questions about how useful the distinction between "wars of necessity" and "wars of choice" really is, especially for a nation that enjoys the degree of invulnerability that the United States has. It could be argued that no war is ever actually necessary, not even wars of self-defense. Realists such as George Kennan and Neville Chamberlain believed Czechoslovakia was better off not resisting German conquest, after all. The Japanese entertained hopes that the United States might not fight after Pearl Harbor, that the enormity of the task would be too daunting for a flaccid, selfish, unheroic people like the Americans. Given that the United States was not even threatened militarily when it began to take sides against Germany and Japan in the late 1930s, World War II could only be considered a "war of necessity" because the United States chose to take upon itself the defense of a liberal world order.

It is not unusual for people to claim to be acting out of necessity. For one thing, it relieves the otherwise unavoidable moral burden of wielding power. One is forgiven much when one has no choice. Americans prefer to regard themselves as simply reacting to the provocations of others, even when they are at least equal participants in the confrontation. They have been taught that to try to shape the world to make it more accommodating to their physical and ideological needs is "imperialism." Yet that is what all great powers do when they can, and the United States, perhaps alone among the great

powers of history, has done it with the voluntary collaboration of many other nations and peoples. Instead of insisting they had no choice, Americans, with all their flaws, can be relatively proud of the choices they have made.

JUSTIN E. H. SMITH

The World as a Game

What is a game? Ludwig Wittgenstein famously chose this nebulous concept to illustrate what he meant by "family resemblance," where the individual members of a class can be determined to fulfill no necessary and sufficient conditions for admission, and instead only share some traits with some others in the class, others with others. Yet we can at least identify two types of game, which seem not just distinct from one another but very nearly opposite. One class of games, which includes peek-a-boo, charades, and musical improvisation as representative instances, is characterized by free expressivity. It is the manifestation of what Friedrich Schiller called the *Spieltrieb*, the "play-drive,"

which is innate in all human beings insofar as they are free. The other class includes chess, fencing, and wargames as its representative instances. If there is still some dose of freedom operating in this sort of game, it is freedom under severe constraints. The purpose here is to win, and one does so by means of strategy aforethought. In such games, serendipity and spontaneity are disadvantages. While some such games may, like Schillerian free play, be "fun" (especially when you win and the other guy loses), at their outer edge they shade over into a domain of human endeavor that has little to do with leisure at all. At their most serious they can determine the fate of the world.

It is this latter sort of game alone that machines are capable of "understanding." Strategy games, in other words, are essentially algorithmic. A good portion of the history of computing has been dedicated in fact to training machines up algorithmically in such narrow domains as chess, then Go, and more recently a full array of natural-language processing tasks. This training has facilitated the gradual progress of the machines from domain-specific "weak artificial intelligence" — the ability to master all the possible moves within a given narrow field — to something at least approaching "general AI" — the ability to competently execute the whole range of tasks that we associate with human intelligence.

Yet curiously, as the machines draw closer to this peculiar ideal of humanness, the society they have been brought in to structure has grown correspondingly more inhuman. As the scope of algorithm-based applications in social reality has expanded over the past decades, we have by the same measure been conditioned to approach ever more fields of human life as if they were strategy games. The technology was honed in such narrow domains as chess and video poker. By the 2010s it had come to shape public debate as well, in

62

the transfer of the greater part of our deliberative efforts to social-media platforms that are, in effect, nothing more than debate-themed video games, where one racks up points in the form of likes and followers by "gaming the algos," just as one racks up points *in Super Mario Bros.* by smashing turtles. Soon enough algorithms bled out from behind the screen too, and began to transform the three-dimensional world of labor, first in "disruptive" app-based companies such as Uber, where gamified structures determine each "move" a driver makes, and then in domains such as warehouse work, where the laborer might never have used an app before signing up, and might not have understood the revolutionary significance of the top-down imposition of gamified structures for the measurement of his work productivity.

Finally, the development of social-credit systems for the algorithmic measurement of the civic standing of individuals living under authoritarian regimes extends the gamification process to the entirety of social reality. Life becomes, quite literally, a game, but emphatically not the kind of game that is expressive of our irreducible freedom. On the contrary, the spread of gamified structures to the entirety of life has brought about the near-total eclipse of the one sort of game by the other, the near-total loss of a distinctly human life of Schillerian free play, and the sharp ascendancy of a machine-centered conception of play: play as strategy, as constraint; the extremity of play where it shades over into never-ending high-stakes work and struggle.

It is against this background that we must understand the recent popularity in some circles of the "simulation argument,"

according to which all of reality is, or is likely to be, an algorithmically structured virtual system of essentially the same sort we know from our encounter with video games such as Pac-Man or Minecraft. This is by now an argument with a bit of history behind it. The philosopher Nick Bostrom has been promoting it for a few decades, and by means of it has gained the attention of such tech mandarins as Bill Gates and Elon Musk, who unsurprisingly are attracted to the idea that the world itself resembles the very products that they are in the business of selling.

The "simulation argument" has more recently been taken up by the philosopher David J. Chalmers in his book, *Reality+: Virtual Worlds and the Problems of Philosophy.* It is worthwhile to consider this work in some detail, because it is a rich document of our gamified world. The "technophilosophy" that it expounds is perhaps the clearest expression yet of a new sort of hybridism between industry and the academy, in which it is decidedly the first member of this unnatural pair that forms the head of the resulting beast. Philosophy, while in its most enduring expressions always stands apart from the era in which it emerges, also has a long history of subordinating itself to whatever appears in its day as the biggest game going, as the most dazzling center of concentrated power and influence. Once it was theology, then it was science, now it is Big Tech, whose ascendancy required the prior work of the scientists even as it now operates independently of any faithfulness to truth-seeking and has nothing other than capital accumulation as its logic and life-breath.

Before turning to Chalmers' central claims and arguments, some interesting characteristics of our moment are revealed in his style and method. It is instructive indeed to see what gets through the filter of the big trade publishers these days. One striking feature of the prose in this particular

piece of Norton-managed content is that even though the book includes a special online supplement that presumably may be opened in a browser window right next to a search engine such as Google, it presupposes no shared background knowledge whatsoever between author and reader, nor any ability or motivation on the part of the reader to undertake a quick search that would supplement any informational gaps. Thus Plato is "the ancient Greek philosopher Plato," and Queen is "the British rock group Queen," headed up by "lead singer Freddie Mercury" (identified a few lines later as "Mercury"). The opening of Chapter One seeks to draw the reader in by making the most profound questions of philosophy appear close to home, by reference to what must be for the author a treasured lyric from Queen's hit "Bohemian Rhapsody": "Is this the real life? / Is this just fantasy?" Now that the tone has been set, the philosopher seeks, as best he can, to flesh out the backstory. "These questions have a history," he writes. "Three of the great ancient traditions of philosophy —those of China, Greece, and India — all ask versions of Mercury's questions."

Such a framing is significant beyond what it reveals about one man's musical taste. Rather than understanding pop-cultural artifacts such as "Bohemian Rhapsody" as lying at the end of a tradition of romance ballads, faintly echoing that tradition's themes in words whose large and original meanings have been mostly forgotten, we are instead invited to see pop culture, or at least the pop culture of Chalmers' childhood, as the pinnacle of tradition, as bringing to its fullest expression what could only be more crudely attempted in centuries past. Here it is the past that asked "Mercury's questions," rather than "Mercury" channeling that past with only dim knowledge that this is what he is doing. And this order of things, which characterizes Chalmers' approach to philosophy in general, largely

65

obviates any need for him to dwell on what I, for my part, take to be the total debt that our present conceptual possibilities owe to the historical legacies that shaped them.

In the book Chalmers dispenses with style and metaphor in order to speak in plain language, indeed in the simplest sentences possible. But this is not a clarification, it is a conceit which does not really free him, in the way he might hope, from the perceived pitfalls of a more stylish language. For in truth his whole project rides on unacknowledged metaphor: a captivating image of reality taken for an account of reality. The simplicity of his style confers upon Chalmers' argument an unearned air of realism, and emboldens him to push for conclusions unmoored from the evidence of history and anthropology as if they were plain common sense. This is how the analytic tradition in modern philosophy has long operated: through the abjuration of "erudition" in favor of "straight talk," the rejection of the properly humanistic disciplines, embedded in centuries-old traditions, in favor of pandering and "relatable" pop-culture references from *Star Trek*, *Black Mirror*, and Queen.

Thus do analytic philosophers deliver their truths in the mode of naïveté, though they are not of course the first philosophers to do this. Descartes ("the French philosopher René Descartes") worked his way into this mode too, if only as an exercise of so-called "radical doubt" in the first of his *Meditations*, pretending that he never learned any truths from any book or authority, even though what follows in the next five *Meditations* is rich with the learning that he could only have received under the tutelage of the Jesuits, with whom he studied, among many other guiding lights, Saint Augustine ("the North African saint Augustine"). As far as I can tell, Chalmers, by contrast with Descartes, is a true naïf, "just some

guy," as Keanu Reeves' Neo memorably describes himself in *The Matrix* — one of Chalmers' touchstones, naturally.

We get an intimate sense of the scope of this philosopher's inner life on nearly every page. Here he is, for example, describing himself at leisure: "During the pandemic, I've... met up once a week with a merry band of fellow philosophers in VR. We've tried many different platforms and activities — flying with angel wings in *Altspace*, slicing cubes to a rhythm in *Beat Saber*, talking philosophy on the balcony in *Bigscreen*, playing paintball in *Rec Room*," and so on. There is a well established pattern in analytic philosophy, to which Chalmers has conformed in his career with something almost approaching grace, by which the refusal to put away childish things helps to establish the aura of a certain kind of philosophical brilliance. I have been told by someone who once shared a vacation home with the renowned analytic metaphysician David Lewis that the reading material he brought along for the summer consisted entirely in a giant stack of magazines for model-train hobbyists. When asked by my informant why these toys interested him, Lewis glared back as if the answer were self-explanatory.

The pop-culture encyclopedia on which so much recent analytic philosophy has drawn yields flat-footed examples at best, and at worst it betrays a cavalier indifference to the depth of the subjects it grazes. It is, in a word, slumming. Now I am generally the last person to condemn "appropriation." Who could possibly make sense of the unpredictable and scattershot and often demagogic way in which calls are made for switching out terms of art deemed to be "problematic," or to have been originally deployed in another cultural sphere from which it is allegedly not ours to borrow? A perfectly anodyne-seeming term can be targeted for elimination — recently I

observed a philosopher catching heat from another philosopher for hosting a podcast called "Unmute," which was seen as an ableist belittling of the hearing-impaired — while another term that appears, at least to me, far more open to criticism just keeps going, year after year, in innocent ignorance of its huge semantic charge. Consider, for example, the use in analytic philosophy of the figure of the "zombie." This is a use that precedes Chalmers, but that he did more than any other to make familiar in his book, *The Conscious Mind*, and that he continues to deploy in *Reality+*. Of course I see no particular problem with the figure of the zombie in American mass entertainment since the mid-twentieth century. I recognize that George Romero's *Night of the Living Dead* belongs at least to some sort of canon, and I have myself enjoyed Jim Jarmusch's recent spoof of the zombie genre, *The Dead Don't Die*. But the genre in question is what is sometimes called "exploitation," and it seems to me that if philosophy should not distance itself from this genre altogether, it should at least be cautious about deriving its thought-experiments from it.

What is the zombie genre exploiting, exactly? For one thing, it exploits its audience, enticing the viewer into a few hours of thoughtless titillation that could also have been spent in edifying contemplation; for another, it exploits a complex system of folk-beliefs and practices, in this case one that developed over the centuries among the African diaspora of Haiti, and does so without acknowledging any of the depths of experience or the internal cultural logic from which these beliefs and practices emerged. For Chalmers, a zombie is simply "a complete physical duplicate of a conscious human being [or animal], with the same brain structures but no subjective experience." He acknowledges that this is essentially the same thing as what Descartes called an "automaton" ("Descartes thought that

dogs were mere automata, or zombies"), but he cannot resist the lure of the new, or the temptation to break with history.

Some contemporary philosophers attempt to make this figure of thought more precise by calling it a "philosophical zombie," but what this misses is that the character from Haitian folk-belief is already itself philosophical: it is a representation by which a group of people make sense of and navigate the world. The folk-belief in zombies is not only, and not principally, concerned with the bodily zombie of interest to analytic philosophers. Their zombie is only half of the story; there is also the corresponding soul zombie, which an evil priest keeps in a bottle throughout the duration of a corpse's interment, and then deftly opens up under the corpse's nose in order to bring it halfway back to life — quickened enough to do the priest's will, and most importantly to work the fields in some living person's stead, but not enough to remember who it was before or to contemplate its unhappy plight. Belief in zombies is thus heavily dualistic. It is not that there remains for the zombie no locus of subjective identity, only that this stays under the priest's control while the body, also under his control, is elsewhere. The theory seems to have emerged, as it is not hard to imagine, in the encounter of Roman Catholicism, ancestral African beliefs about body and soul, and the grueling inhumanity of slave labor.

The idea of the separability of body and soul in fact has a long and complex history in both European and African folk-belief, and race is thematized with surprising frequency at many of this history's key moments. In 1690, for example, the French Jesuit Gabriel Daniel published a satire of Cartesian dualism under the title *Voyage du Monde de Descartes*, which tells the story of an African servant in Europe who falls asleep while sitting in a field under a tree. A white maiden has been

dishonored nearby, and a lynch-mob sets out to find the culprit. Little do they know when they find the servant that he is also an adept of the secret art of the Cartesian sect, by which an initiate can go out as his body sleeps for a little *ambulatio animae*, traveling around the earth and even into outer space as a disembodied soul. The mob kills what it takes to be the boy but is in fact only a "zombie." When the soul attempts to return, it finds it has no corporeal home to return to, and so it floats around as a specter, and ultimately befriends the disembodied soul of the long-deceased Descartes. It is at least possible that Daniel is drawing on some knowledge of the proximity of Cartesian dualism to what by the end of the seventeenth century may have appeared as a distinctly racial-ized cluster of folk-beliefs, of the sort that would later be associated with the figure of the zombie.

None of this is to say that there is anything misguided about the particular thought-experiment analytic philosophy enjoys contemplating, but only that the choice of the zombie as this experiment's vehicle reminds us of the limitations intrinsic to a philosophical tradition that considers, say, the oeuvre of George Romero part of its general culture, its universe of references and illustrations, but not, say, ethnographic reports from rural Haiti, or indeed the profoundly learned anthro-pology of the Jesuit intellectual tradition.

While it is simply naïve to start a reflection on zombies as if they were invented from scratch in twentieth-century Ameri-can popular culture, it is positively self-defeating to start a reflection on the prospect that reality is itself virtual as if the very notion had to await our current VR technologies in

order to be entertained. Perhaps under pressure from editors to give hasty shout-outs to non-Western ideas — the sort of shout-outs that are now *de rigueur* in Anglophone philosophy, which congratulates itself for being "inclusive" and then goes right back to doing what it would have been doing anyway — Chalmers duly catalogs in his book not only Nāgārjuna's Buddhist anti-realism about the external world, but also the famous dream of Zhuangzi (in which the Chinese philosopher believes himself to be a butterfly), as well as the even more famous account of dreaming provided by Descartes. In this mechanical nod to the history of philosophy (in the book's acknowledgments he provides a long list of the historians of philosophy who helped him to execute the nod) he seems close to recognizing that our brains themselves, for about eight hours a day, furnish us sufficient material for philosophical reflection in the remaining sixteen on the possibility that reality is in some way virtual. Chalmers even acknowledges early on that "[a] dream world is a sort of virtual world without a computer." But soon enough this concession to the timelessness of the problem in question gives way to a bold claim of the problem's novelty: "any virtual world," we are now told, "involves a computer simulation."

The possibility that we come pre-stocked with the sort of experiences generally thought to be novelties of the era of VR goggles looms as a threat to the entire project of what Chalmers calls "technophilosophy." He writes that "we haven't developed dream technology as thoroughly as we've developed VR technology, so Descartes' dream argument is less affected by technological change than his illusion argument. (The latter argument concluded that Descartes' own mind is in fact awake, but is being systematically deceived about the existence of an external world by an "evil genius.") But it is not

71

at all self-evident what ought to count as "dream technology," and an older and more capacious approach to the philosophy of technology, as distinct from Chalmers' technophilosophy, never lost sight of the fact that *tekhnê*, in its original sense, included not only gadgets and other objects of human invention, but also, crucially, practices. And in this sense it is important to note that "dream technology" has in fact been well developed in certain places and times: practices for the collective interpretation, social processing, and pragmatic management in waking life of dream experience.

In cultures where such dream technology is developed, it is typical to find very different philosophical commitments concerning the objects and beings encountered in dreams, and concerning the relation of these objects and beings to those encountered in waking life. The most common view of what dreams are, if we consider them from a cross-cultural and trans-historical perspective, is that they are either as real or more real than waking life. Significantly, the urgency of proving that this is not the case takes hold as a central task of modern philosophy, as in the work of Descartes, at precisely the moment when European missionaries, some of whom are in Descartes' own epistolary network, are encountering groups of people, in the Americas for example, whose practical rationality is largely governed by experiences had in sleep. Descartes is anxious to contain these experiences, to keep them cordoned off from the waking life whose basic constituents — the self, God, the external world — are alone worthy candidates for his project of epistemological foundationalism. This is indeed one way of going about things, but it is not the default way of humanity.

Repeatedly, in fact, what Chalmers takes to be the default way of humanity turns out to be only a local road taken by

modern philosophy in the centuries since the scientific revolution, often in an effort to remain faithful to the apparent implications of key scientific discoveries. But this faithfulness has frequently gone far beyond what is actually implied by science itself, and has forced modern philosophy into accepting as the default account of reality commitments that fall apart under scrutiny. Chalmers arrives on the scene at the moment when this falling apart is becoming impossible not to notice, and interprets it as evidence for philosophy's linear progress, rather than philosophy's return to other widely available and well-tested alternatives. This is particularly clear in his evocation of the current moment's "fall from Eden." Thus he reflects that "rocks in Eden were Solid, full of matter all the way through without any empty space. They had an absolute Weight, which did not vary from place to place." But now, subatomic physics has forced us to throw out this model. "People in Eden had Free Will," similarly. "They could act with complete autonomy and their actions were not predetermined." But now, physics and neuroscience together have significantly challenged this belief.

What is missing here is any acknowledgment that this Eden was never long-lived and never universal. The belief in irreducible external matter and the belief in free will come with distinct local histories, emerging originally as answers to specific contextual problems (as, in the case of free will, accounting for the causes of sin). And so when Chalmers suggests that a further instance of the fall is currently transpiring, from an idea of reality as inherently physical to one that acknowledges the virtual as well, one cannot help but wish for further genealogy and elucidation of the supposedly Edenic stage of the representation of reality which is supposedly now coming to a close.

The World as a Game

And now to the heart of the matter. What is the nature of the increasingly widespread contention that reality may be "virtual"? A great deal in our culture and our society hangs on the answer to this question. In Chalmers' book, the argument sets out from the observation that we, today, have become adept at running simulations of many things, from possible chess moves to possible pathways and chronologies of early human migration from Asia to the Americas. We simulate paleoclimates and the possible pathways of future climate change. We simulate hydrodynamic flow and the risks of nuclear escalation. We also simulate regions of the world, from, say, a digital model of Paris in 1789 to the Amazon rainforest. In time, it is reasonable to anticipate that we will have a fully immersive model of the entirety of the observable universe. In scientific research, in defense initiatives, and in leisurely gaming, we as a species have begun digitally to reproduce the world into which we have been cast, and even to generate new possible worlds that have the power to reveal to us the general form of the future.

74

Now, you might anticipate that as world-simulations become increasingly fine-grained, they will begin to include not just individual human beings but also the smallest details in the constitution of these human beings, notably the number and the arrangement of their individual neurons. But if these are simulated faithfully and exhaustively, supporters of the simulation argument contend, then they are likely to come to have the same conscious experiences as would be had by the neurons of a physical brain. Given our own tendency to run huge numbers of simulations for anything in the physical world that is of interest to us, it is reasonable,

the argument in turn holds, to suppose that any beings in "base reality" (that is, the physical reality in which simulations are generated) that develop the ability to run fine-grained simulations of human brains will bring into being vastly more simulated human beings than human beings who ever existed in base reality. That means, we are told, that if you find yourself thinking, and experiencing your life as a human being, and you acknowledge the possibility that our descendants may develop the ability to run exhaustively detailed simulations of their ancestors, it is highly probable that your own thinking is the thinking of a simulated human being and not of a human being in base reality.

This conclusion rests on a few fairly substantial presuppositions. One of them is what Bostrom, in an influential article in 2003 entitled "Are We Living in a Computer Simulation?," calls "substrate-independence." This is the view, widely but not universally shared among philosophers of mind, that the organic substrate in which human consciousness is realized is a contingent and not a necessary condition of this consciousness, which could just as well be realized in a silicon substrate, or in a substrate of toilet-paper rolls and string, or in anything, really, that faithfully reproduces the organization of the neurons in the brain. One implication of substrate-independence is that it would be in principle possible for each of us to "upload" our consciousness into a computer and thereby to achieve immortality.

If substrate-independence is not true, then the simulation argument is a non-starter. This is indeed a big if, and you might think that anyone who offers a version of the simulation argument would also feel compelled to make a convincing case for the truth of the claim on which it depends. But Bostrom simply presupposes it, a move that might be excused in an

article in the name of succinctness. Chalmers, for his part, dilates in his tome on every question of interest to him, often repeating the same basic claims several times — and yet the argument that he offers for the substrate-independence thesis is hasty and unconvincing, and sometimes seems to be one he would rather not have to make at all.

Early in the book the technophilosopher states the case for the consciousness of simulated beings (or "sims") hypothetically: "At least if we assume that a simulated brain would have the same conscious experience as the brain it's simulating..."; "Under reasonable assumptions, ... sims will have conscious experiences that are the same as those of the nonsims they simulate." His fifteenth chapter, called "Can there be consciousness in a digital world?," seeks finally to justify these "reasonable assumptions" — but it consists in a short introductory section telling of an episode of *Star Trek: The Next Generation* in which the philosophical problem of the android Data's contested consciousness is explored, which is followed by a section entitled "The problem of consciousness," in which Chalmers summarizes the philosophical contributions of his previous book on the philosophy of consciousness, in which he argued that "no explanation of consciousness in purely physical terms is possible." Chalmers does not reject this view in *Reality+*, though it does seem to be in some tension with the simulation argument: if base-reality consciousness is not to be explained by existing fundamental properties of the physical world, then it is not clear, at least to me, how we can be confident that a computer-based model of the structures we find in the physical brain will be conscious. If we don't know what the relationship between the physical brain and consciousness is, we would seem to be on even weaker ground in attempting to account for the relationship between a simulated brain and consciousness.

But Chalmers quickly sets the "hard problem" aside and moves on to another section, called "The problem of other minds," in which he runs through the familiar problem of skepticism about the consciousness of other biological beings such as humans and non-human animals. When it comes right down to it, for all we know it is not just machines that lack qualia — inner subjective states, something it is "like" to be them — but other humans and animals may lack them as well. We have no access to the inner experience of other beings, and so in a strict sense other naturally generated minds leave us with the same problems as artificially constructed "minds." But this problem is not directly relevant to solving the more narrow question of the possible consciousness of AI systems, and in this section again the philosopher of virtuality postpones the promised answer to the question that serves as this chapter's title. We finally get to the heart of the matter in the penultimate section, "Can machines be conscious?," and in a short coda entitled "Consequences." The stakes are high: without substrate-independence, you will remember, the entire simulation argument fails to get off the ground.

So, then, can machines be conscious? Chalmers focuses on one type of machine: "a perfect simulation of a brain, such as my own," that is, a brain simulation that is "a digital simulation running on a computer." The initial attempt to characterize such a simulation has a troubling air of circularity to it: "How would simulating a brain work?" Chalmers asks. And he answers: "We can suppose that every neuron is simulated perfectly." Alright, one wants to say, but how does it *work*? Chalmers acknowledges that it might *not* work: some believe, after all, that consciousness is not an algorithmic process at all. But even this obstacle, he supposes elsewhere in the book, might be got around eventually by simulating it, whatever

it is, on an analog quantum computer, when, and if, such a technology becomes available. But how again, now, using known technologies, would a simulated brain *work*? In what appears to me a startling bit of legerdemain, Chalmers moves from an apparently sincere concern to answer this question to what I take to be a reiteration of the presumption that a simulated brain *would* work (that is, would be conscious), and then proceeds to tell us what "one big advantage" of such a simulated brain would be (that "it raises the possibility that we might *become* the machine"), and, next, to tell us his preferred strategy for going about such a simulation ("the safest way to become a simulated brain is to become one in stages"). But this strategy for "gradual uploading" is not an argument for the view that uploading is possible. It is a proposal for how to go about testing, someday, whether it is possible or not. And this is all we get in the way of an answer to the question: "Can there be consciousness in a digital world?"

Beyond the simple non-delivery of the promised answer, there is a troubling conflation of two different kinds of models of the brain. Chalmers begins the penultimate section of Chapter 15 proposing to discuss a particular kind of machine, namely, again, "a digital simulation [of a brain] running on a computer." But then he goes on, with the example of gradual uploading, to describe something that looks a lot more like the successive removal of cells from the actual brain and their successive replacement by implants that "interact, via receptors and effectors, with neighboring biological cells." Now, it might well be possible to preserve the full functionality of a biological brain when it is partially, or even perhaps entirely, replaced by physical implants that do the same job as brain cells or neurons. But this does not seem to me to answer the question whether a separate

computer simulation of a brain — separate in the same way that a computer model of, say, the hydrodynamics of a river is separate from the river — could become conscious. In the case of brain implants, there is a clear respect in which the artificial implants are "like" the cells they replace, and in which both the artificial and the natural entities share in the same approximate nature, notwithstanding their distinct causal histories. In the case of the computer simulation, it is not at all clear to me that the simulated brain cell, even if it is a limit-case atom-for-atom simulation, shares the relevant properties with the biological brain cell, such that we may be able to anticipate that it is capable of facilitating consciousness — no more in fact than we might anticipate that a computer-based hydrodynamic model of a river, if it were to reach a sufficiently fine-grained degree of accuracy, would become wet.

That is just not something we can expect to happen inside a computer, no matter how much the computer is able to reveal to us about wetness, and I have seen no real argument that consciousness is relevantly different from wetness in this regard. Until I see such an argument, I must withhold a commitment to substrate-independence, and this means that I am also going to decline to take the simulation argument seriously, since it depends entirely on substrate-independence in order to work. Or at least, as with creation science and other similar deviations, I am going to take it seriously as a social phenomenon, and try to understand its causes, while refusing to take it seriously on the terms it would like to be taken.

Though we are both philosophers, Chalmers and I belong to different discursive communities, and most of my criticisms here (though not the criticism of his discussion of consciousness), I recognize, may be considered as "external" to his project as he conceives it. Ordinarily I believe projects should be criticized on their merits, according to the aims and the scope that those who undertake them have chosen. But in this case I am motivated by a concern about what gets to count as philosophy, and why. Although I am a philosopher, my preoccupation with such things as the ethnography of folk-beliefs about revenants has led to a general perception among my peers that I have strayed from the discipline, that I have let too much of the actual world seep into my thinking, that I have wandered off into mere "erudition," a term that is always used by analytic philosophers as a back-handed compliment to signal that the *erudit* in question is cultivating a lesser skill, one that compensates for the lack of any natural aptitude in what really counts: the art of rational argumentation and distinction-making. And so the result is that what gets to count as philosophy is often generated in a vacuum, ignorant of its sources, of the contingency and localism of what it takes to be its self-evident starting-points, and destined to be as ephemeral as the pop-culture that nearly exhausts its universe of references.

Chalmers may well be living in a simulation, but not the one that he imagines. He is simulating for himself a world that is not inhabited by scholars and critics adept at exposing the ideological forces that shape a given historical era's conception of reality; a world not inhabited by anthropologists and the people who inform them of models of the world inspired by objects of particular cultural value just as the video game inspires Chalmer's model; a world in which there are no other ways of representing reality than those of a highly specialized

caste in the learned institutions of Europe, India, and China, the latter two admitted as full members of the philosophical community only recently and begrudgingly, and at the expense of other traditions that could now more confidently be cordoned off as "non-philosophical." Ideology yields simulations too, and the highest goal of the philosopher, now as ever, ought to be a search for "signs" that might lead us out of this simulation. These signs will not be "glitchy" cats that walk by, revealing their virtual nature as a result of some defect in the program, but rather doubts that might arise, for example while reading a pro-VR book such as *Reality+*. A philosopher who has no interest in even acknowledging the way in which ideological structures shape our worldviews has no business presenting himself as an authority on the question whether the world is a simulation or not.

Somewhat surprisingly, Chalmers favorably invokes Jean Baudrillard's well-known postmodernist explorations in *Simulacra and Simulations,* which appeared in 1981. It is likely that this work entered Chalmers' universe of references primarily because it was, famously, featured as an Easter egg in an early scene of *The Matrix*. Lily Wachowski, one of the pair of the original movie's creators, claimed in 2020 that the film was born of "rage at capitalism," while the critic Andrea Long Chu would a year later make the case that the film is an allegory of transgender identity (an identity both Wachowski siblings would claim some years after the film appeared). But plainly these are high-theory retrofittings upon what was in its original form mostly a piece of standard-fare science-fiction fun, in which the Baudrillardian flourish adds or explains next to nothing. And in any case the extent of Chalmers' use of the French theorist involves little more than a technical distinction that Baudrillard makes between simulation and representation.

It is ironic that Baudrillard should find his way at all into a book arguing that physical reality itself may be a simulation, since Baudrillard's concern was with the way in which our picture of *social* reality is shaped and mediated in large part through media technologies. His famous (or notorious) declaration that "the Gulf War did not take place" was not, by his own lights, a denial that anyone actually died in Iraq or Kuwait in the early 1990s, but only that the idea that a typical American, and perhaps a typical European, formed in association with the phrase "the Gulf War" was excessively shaped by media forces, particularly the new uninterrupted onslaught of images on cable news networks such as CNN. And when you understand a war to be something that happens on your screen rather than in the world, this significantly constrains your capacity to arrive at a mature and sober analysis of war's moral and human costs. Baudrillard's analysis of simulation drew him toward the conclusion that our attachment to digitally mediated images of reality, an attachment that is pushed on us by the profit-seeking interests of the media companies, fundamentally weakens our ability to engage critically with reality itself. He was an *enemy* of simulation. He would have considered the "simulation hypothesis" — that what we think of as reality is in fact a virtual world of the sort with which we are most familiar from our screen- or goggle-mediated games — to have been a resounding victory for the forces of which his work is meant to be a condemnation. It is hard to think of any idea that would more gravely damage our sense of reality than the idea that it is virtual or simulated.

The gamification of social reality is a political matter, and not, in the first instance, a metaphysical one. To conceptualize reality as a whole on the model of the algorithmic gaming technologies that have so enraptured us in our own

age is to contribute to the validation of a particular form of social reality: namely, the model of reality in which gamified structures have jumped across the screen, from *Pac-Man* or Twitter or whatever it is you were playing, and now shape everything we do, from dating to car-sharing to working in an Amazon warehouse. The "simulation argument" is nothing but an apology for algorithmic capitalism.

The spirit of this new economic and political order has extended from Chalmers' philosophical writing into other para-academic projects, most notably the social-media network PhilPeople.org, which he co-directs with David Bourget, and which largely duplicates the structures of Facebook or LinkedIn for a global network of professional philosophers. As if to demonstrate the great distance that AI has yet to traverse before it achieves anything that might be called "intelligence" in a non-equivocal sense, I have more than once had to write to PhilPeople to request that false information in AI-generated stub profiles of me be taken down. Still today, there is a stub that appears to indicate that I am an "undergraduate" at Eastern University. There is no accounting for this, nor evidently, given that it is still there, any human being willing to be held accountable.

Such a landscape of artificial stupidity, in which there is a glut of undifferentiated information and misinformation issuing forth from machines that could not care less about the distinction between the two, is, much more than the possible dawning of machine consciousness, the real story of our most recent technological revolution. That we human beings are compelled to submit to the terms and the constraints laid out by thoughtless machines — for example, that we are expected to groom and update AI-generated stub profiles of ourselves that we never asked for in the first place,

lest misinformation about us spread and we "lose points" in the great game of our professional standing — is, quite obviously, an encroachment on our freedom, and therefore, again, an encroachment on the one sort of play by the other. Play is now left to the very youngest of us: those too young to understand what screens are, too young to discern the world that lies behind and beyond them. Adolescence begins, perhaps, when we learn to channel our innate playfulness into competition. The comprehensive gamification of adulthood, in this light, has the condition of permanent adolescence as its corollary.

PhilPeople is in the end a boutique affair, greatly overshadowed by such large-scale projects as ResearchGate, Google Scholar, or Academia.edu, which aggressively metricize scholarly output, and effectively transform the assessment of a scholar's work, even of a philosopher's work, into formulae so crude that even a machine, even a dull vice-dean with a background in business administration, can understand them. Universities now regularly take such metrics as the number of downloads an open-access article has received to be decisive for promotion and tenure, and there is no reason not to expect, in such a gamified landscape, that soon enough professors up for advancement will respond to this absurd predicament by paying an off-shore click-farm for bulk downloads of published work. In time we might expect to outsource the work of both scholarship and scholarship-evaluation to the machines, which would really just be the perfection of a system already emerging, in which the only real job left is the work of managing our online profiles, while the machines do everything else.

If you wish to set yourself up in this world as a poet, your plight is substantially the same as that of a scholar: you create

an account on Submittable, "the social impact platform," and you manage it. You also have to write some poems at some point, of course, but what can poetry hope to be in the age of "streamlined social-impact initiatives so you can reach your goals faster," as Submittable describes itself? In nearly every domain of public life in which I have any investment at all, I also have an online portal to it, and automated messages telling me that I need to update the information in my portal. In most of these domains, the activity in these portals is being tracked, and is taken as an ersatz measure of my commitment to the domains themselves. My experience is limited, admittedly, but I have trouble believing they are not representative of our contemporary situation, and that if I were a truck driver, or a restaurateur, or a cosmetician, I would be doing much the same thing as I am in my actual life: updating my passwords, checking my stats, pumping my metrics — feeding the machines.

That these are the real challenges of our current technological conjuncture, rather than, say, the search for glitchy cats that might show us the way out of the Matrix, is a sober fact that at least some professional philosophers are prepared to acknowledge. Daniel Dennett, a great influence and inspiration for Chalmers, has been increasingly outspoken in the view that we should not be wasting time speculating about the dawn of conscious machines when this time would be much better spent coming up with practical policy measures to ensure that machines be prevented from encroaching into distinctly and irreducibly human spheres of existence. Other philosophers are interested in the serious dangers of algorithmic bias, where machines that lack consciousness nonetheless discriminate against groups of people, with no awareness that this is what they are doing, and no accountability for doing so; and

the even more serious dangers of algorithmic defense systems, where machines that lack consciousness are imbued with the gravest responsibility of all, one that they could fail as a result of a simple technical malfunction, and once again with no real accountability. Sober philosophy, in sum, recognizes our human responsibility as the makers and stewards of the machines, rather than imagining that our entire reality is a virtual simulation produced by a machine.

At least some readers might expect a book co-written by Henry Kissinger and former Google CEO Eric Schmidt (along with Daniel Huttenlocher) to be more susceptible to ideological infection than a book about technology written by an academic philosopher. But these are strange times, and I must grudgingly report that in their recent work *The Age of AI and Our Human Future* these authors are surprisingly lucid about the actual challenges that we face at present. This lucidity extends both to practical risks and to philosophical questions about the nature of the new systems that create these risks. For them, AI's ability to process information about aspects of the environment that remain undetected by human beings fundamentally transforms the nature of several domains, notably warfare, as it adds a tremendous element of incalculability. But this information-processing capability is in the end only a further development of the same sort of computation that machines have been doing for many decades now, since they first began to be trained up on the rules of checkers and chess. No matter how far and wide their training extends, the ability of machines to process a wide range of moves more quickly and exhaustively than a human being ever could is by no means an indication that they are moving towards any sort of intelligence, let alone consciousness, of the sort that human beings experience. Indeed the fact that they are so much better

at processing certain bodies of information should itself be taken as an indication that they are not at all doing something comparable to what we are doing in our imperfect, limited way. Information-processing, no matter how vast, is not the same activity as judgement.

It is the presumption that human beings are, in their nature, algorithmic "problem-solvers," as Karl Popper was already saying in the 1950s, that leads to such poorly thought-out efforts at the integration of machines into human society as we are seeing in the present day. Already in the early 1960s, Norbert Wiener discerned the most serious challenges of the digital revolution, where simply training machines to execute evidently minor tasks already awakens threats that can be foreseen in their concrete form, and forestalled in good time, only with great difficulty. "To turn a machine off effectively," Wiener warned, "we must be in possession of information as to whether the danger point has come. The mere fact that we have made the machine does not guarantee that we shall have the proper information to do this. This is already implicit in... the checker-playing machine [that] can defeat the man who has programmed it." Our greatest challenge today is not that machines may gain consciousness, and still less that we are ourselves conscious machines, but that the machines may defeat us, and do not require consciousness in order to do so.

The real prospect of our total defeat arose in the middle of the twentieth century at the same moment that we began to take strategy games, even such trivial pastimes as checkers, to be paradigmatic models of the core endeavors of human life. The intellectual historians of the last century regard "game theory" as one of its great achievements, but it is past time that we regard it critically and recognize the poverty of its

understanding of human motivation and human action. We have conferred too much prestige upon games, just as we have mistaken algorithms for play. We should be highly wary today of anyone who continues to take games, even such trivial and seemingly harmless pastimes as the VR-mediated fun of Rec Room, as any sort of key for grasping the human difference and its place in our fragile and frightening world.

DARYNA GLADUN *and* LESYK PANASIUK

|||*to*|||*name*|||*every*|||*one*|||

1.
three hundred nameless
walk
holding names behind their backs
bone to bone
muscle to muscle
let us stretch their memory between our lines

2.
saved by death from life
name yourself
mouth-holes stare

3.
outside, it's not death that whitens with bones in the leaves
 of trees
you look closer
but indeed, it is death
outside, it's not death that blooms in the branches of trees
you look closer
but indeed, it is death
outside, it's not death that sings a birdsong in the white
branches in the white blossoms of trees
you look closer
but indeed, it is death

4.
death
that has saved so many from life
name everyone by name
the mouth-hole of death stares

5.
not the bones of earth
not the blood of heaven
not the voices of war
we
no one's

6.
and who is our memory about
everyone
and our words about no one
about everyone
our bones are muscles and blood about no one
about everyone
hair's falling out nails split cheeks sink into mouths
no one's

7.
bone to bone
blood to blood
death to death
poetry
for no one for everyone
grips the blood the bones the water in the tap the sand on the
temple the fingers the nose the jaw every skull grips the hem
like burrs asks to carry it to the better times carry it at least in
the mouth of one in the mouth of the three hundred nameless
I look closer
but indeed, it is a war
for no one
to everyone

Translated by Valzhyna Mort

DARYNA GLADUN

night forty-eight

1
I wear a second-hand country a second-hand city apartment
 bed pillow blanket
ability to walk across a park without checking under
 my feet without checking over my shoulder
but Poland is not safe
Lithuania is not safe
Germany is not safe

2
I wake up from loud conversations behind the wall fuss
 jostling banging of doors
I think
/// there we go, the war is here too ///
I roll over I try to fall asleep knowing
that Moldova is not safe
Romania is not safe
Estonia is not safe

3
every night now I see the same dream
in the dream I go to work in the morning
I return in the afternoon
I wash dishes I wash clothes I cook dinner I read books
 I go to bed

and even in this dream
Latvia is not safe
Georgia is not safe
Finland is not safe

4
to help myself fall asleep, I do simple exercises
1) I imagine two solid walls between myself and the window
2) I imagine myself behind a heavy metal door in front of
 which stands an oak armoire
3) I double-check my food supplies my drinking water and
 the contents of my emergency bag
because
Slovakia is not safe
France is not safe
Italy is not safe

5
having not found any safe areas on the map
I wait out the war

—

in the second-hand time

Translated by Valzhyna Mort

JAROSLAW ANDERS

An Open Letter to an Enemy of Liberalism in My Native Land

Dear Professor Legutko,

Early this year, when Russians were positioning their troops along Ukraine's borders and liberal democracies were debating what it all might mean, I started reading your books. I have heard that they are influential in Poland, and I am concerned about the weakening of liberal democratic commitments in our native land and more broadly in East Central Europe. Would their political identity, their liberal commitments, prove strong enough in what seemed like a new confrontation with Russians authoritarianism? It is a rather disturbing question to ask about Poland and Hungary,

and to a lesser degree about other former Soviet satellites, only thirty years after the fall of communism.

A lot has been written lately about the possible reasons for this weakening, and for the contemporary appearance in the West of "post-liberalism," but I decided to explore the issue by studying the work of Ryszard Legutko, your work, the work of a declared Polish anti-liberal, a philosopher, an educator, a former minister of education, a politician of the ruling illiberal Law and Justice party, and a member of my own generation. In our lives we have witnessed the same events — the student protests in 1968, the Prague Spring, the workers' protests of the 1970s, Solidarity and martial law. We have read the same books, we have heard the same people. I was exhilarated by Poland's, and the region's, attainment of democracy in 1989, a benevolent revolution that I considered a perfectly natural and logical development. You, on the other hand, believe that adopting democratic liberalism was our homeland's gravest mistake. You also claim, provocatively and rather counter-intuitively, that liberalism, or liberal democracy, which has always been rightly regarded as communism's eternal enemy, is in fact communism in disguise. Liberalism, in your view, is communism that is actually winning!

I was not sure what I expected to gain from reading your books. Keeping a vigilant eye on the enemy of everything I believe in? But attending to counter-narratives, even distasteful ones, can be instructive. An unapologetic liberal, I was prepared for a strange voyage. I was not wrong. When I was halfway through your book *The Cunning of Freedom,* Russia invaded Ukraine. Illiberal authoritarianism was on the march and liberal democracies were rapidly mobilizing. (I must note here that when you spoke before the European Parliament you condemned Moscow's invasion in the strongest terms.) Glued

to a TV, I became distracted and irascible. So many lives, all of them so similar to our own, were being destroyed, so much pain inflicted on real human beings, in the name of antiliberalism. Still, I kept reading.

In the foreword to your book *The Demon in Democracy*, John O'Sullivan, the British conservative commentator and erstwhile political advisor to Margaret Thatcher, tries to convince us that what you mean by liberal democracy is not liberal democracy at all. It should be called by an altogether different name, perhaps "liberal-democracy." It is certainly not liberal democracy "as it was understood by, say, Winston Churchill or FDR or John F. Kennedy or Ronald Reagan. That was essentially majoritarian democracy resting on constitutional liberal guarantees of free speech, free association, free media, and other liberties needed to ensure that debate was real and elections fair." Liberal-democracy, on the other hand, is ideological, "liberationist," and does not hesitate to restrict the freedom of persons and institutions "from parental rights to national sovereignty." It is, in other words, precisely what conservatives denounce as "leftist" or "progressive" liberalism. Whereas the "classical liberalism" of fundamental human rights, open debate, and governments of, by, and for the people, is, for O'Sullivan, just fine.

Your repeated complaints against feminism, the "enormous privileges" of homosexuals, the "persistent attempt to deconstruct family," multiculturalism, the general decline of public and private morals, the loss of self-restraint and shame and the sense of duty, all have a distinct odor of right-wing bigotry. But your ambition goes much further. All these modern abominations, you claim, are not excesses or aberrations of liberal life. They are, in your interpretation of them, direct and unavoidable consequences of the very essence of liberal philosophy. Yes, your enemy is the same liberalism that

O'Sullivan so gallantly defends — the liberalism of human rights, equality, and individual sovereignty. Liberalism, and with it liberal democracy, is poisoned at the root, in the fundamental and faulty premises of Bacon, Hobbes, Locke, Rousseau, and Mill. The whole intellectual and political structure created by the Enlightenment is, according to you, only now reaching its full potential, which is also its final undoing. You have your own version of the end of history.

You are not original or alone in your post-liberalism and your counter-Enlightenment. We have heard similarly hostile judgments about liberalism, and about modernity, and about the Enlightenment tradition, since the beginning of liberalism itself. Today they can be found in the works of academic anti-liberals such as Alasdair MacIntyre, Adrian Vermeule, and Patrick Deneen. Liberalism's cardinal sin, they claim, was Locke's concept of the "state of nature" — a hypothetical condition of perfect liberty, pre-political and pre-social, to which every human being aspires. But in the course of history various forms of governments, aided by religion, have imposed upon this naturally free human being piles of arbitrary restrictions and obligations that hamper and distort his natural capacities. To liberate the human individual and allow him to reach his full potential, every form of human association, every stricture and obligation, needs to be rationally examined, reduced to actual necessities, and legitimized by popular consent — the hypothetical "social contract." In your view and the view of other antiliberals, this was a revolutionary idea that struck at tyranny — but also destroyed everything that was good and useful in the pre-liberal and pre-modern world.

In order to fulfil its goals, liberalism, according to the account of the post-liberals, became the fierce enemy of the

intricate network of traditional interhuman relations, "social hierarchies, customs, traditions, and practices that had existed prior to the emergence of the new political system," of the very concept of human rootedness and continuity. Nothing old was allowed to stay in place. Everything had to be invented anew. Nothing was to be accepted on faith, except perhaps liberalism's own holy creed, which includes the concepts of innate human equality and inalienable human rights, which you and your comrades denounce as an absurdity without philosophical or theological justification.

According to this narrative, which you repeat almost verbatim, liberalism is in a state of constant and relentless war against the remaining bastions of tradition — local communities, the family, and religion — replacing them with its own artificial constructs. Freedoms needed to be regulated, lest they interfere with other freedoms. Liberalism benefitted from a reluctant and misguided need to be led to the light. Hence its ever-intensifying social engineering, its justifications of the coercive function of a supposedly minimal state — its continuous politicization of, and interference with, all aspects of human life, including the most private ones. Instead of the "natural" self-discipline and restraint that reigned in the pre-modern world, which was accepted, apparently without objection, by grateful members of all classes and estates, we got a multiplicity of laws and regulations imposed by distant, anonymous institutions. This process, started over two centuries ago, is yielding more and more dreary results — "absurd" feminist ideology, sexual candor and freedom, unlimited rights to abortion, genderism, euthanasia, and legislation against domestic violence and hate speech, which allow "further drastic intervention by government and the courts in family life, the media, public institutions,

and schools." Oh, and also the "transnational" homosexual movement that has grown so influential that one can no longer entertain a "harmless" "faggot joke." (You actually said that!)

Liberalism, in your intimidating and exaggerated view of it, is a hyper-ideology that coopts both the right and the left: welfare state advocates and free market fundamentalists, identitarians and globalists, radical environmentalists and greedy industrialists — they all bow to the same liberal idol. Gathered in its temple "the socialists and the conservatives are unanimous in their condemnations: they condemn racism, sexism, homophobia, discrimination, intolerance, and all the other sins listed in the liberal-democratic catechism." (Where are the bold, free spirits ready to defend racism, sexism, homophobia, and the rest? You know exactly where they are.)

Tolerance and pluralism are also liberal ruses. "One simply cannot put a Christian, a Muslim, a socialist, and a conservative into an individualistic/egalitarian framework and expect them to be Christian, Muslim, a socialist, or conservative in the standard sense of the word," you instruct. "Two loyalties — one particular to one's own community, and the other to an infinitely open system — cannot be reconciled." If two loyalties seem too many to you, dear professor, then you know precious little about the complexity and the richness of actual human identity. Moreover, the individualistic and egalitarian framework is probably the *only* framework in which you can safely put such different people together. Communities that exclude loyalty to other communities, or even limit contacts with those outside the community, do exist, but they are a rarity rather than a rule, and they are certainly not a model of social peace. The liberal framework, by contrast, tolerates and protects such exclusive communities, as long as they do not interfere with other communities or do something nasty to

their children. Consider the flourishing in liberal America of the Amish, who are much praised by Patrick Deneen.

In your view, freedom is a limited commodity that should be meted out judiciously. Some people clearly deserve more of it than others. Citing Aristotle, you remind us that some of us are born to be slaves and some of us to be masters. You contend that by extending freedom to some groups we must take it away from others. This does not add to the general pool of freedom. "Imposing the liberal system of freedom," you complain, "requires that the disadvantaged receive more free space while the privileged have a certain amount of it taken away from them." (I am reminded of Anatole France's ironic observation that "the law, in its majestic equality, forbids rich and poor alike to sleep under bridges, to beg in the streets, and to steal their bread." And also of your utterly unironic observation that "it would be true to say that both a beggar and a Rockefeller, if left alone, would have exactly the same freedom to sleep rough or spend their vacation in Hawaii....") All this, you say, leads to social engineering, "for instance upgrading women and blacks while restraining patriarchy," just as "encouraging homosexuals has meant limiting what has been called 'the monopoly' of heterosexuals in all areas of life." You have a strange way with empathy. I conclude that in your view it is better to leave the advantaged and the disadvantaged exactly as they are.

In your account, liberalism is an aggressive and expansionist force. It moves forward "relentlessly," "annihilates internal criticism," "hunts down old, incorrect rights," "ruthlessly imposes liberal-democratic patterns on everything and everyone." It conquers new territories "as if under a single well-structured and well-organized command following a superbly devised strategy." Very frightening! Liberalism

lures and corrupts by its false vision of an easy life — entitlements without obligations, no striving for moral merits, no need to justify claims, dignity possessed without moral achievement, by the very fact of being born. As a result, the denizens of liberal democracies have more and more rights but less and less freedom, which naturally breeds alienation and anomie. Despite its apparent vibrancy, therefore, life in a liberal democracy is lackluster and dull. Liberal art has been dehumanized; its literature is "speaking about nothing"; the rhetoric of diversity is "masking expanding uniformity." In the liberal world "there is neither conversation nor poetry." (Where have you lived?) Luckily, however, the whole liberal project is nearing its end. Liberalism's energies are almost spent, and it is entering a final crisis — which is entirely its own fault.

It is certainly true that in the name of liberalism we must allow, and even encourage, the criticism of liberalism — and so I hasten to say that it was indeed unfortunate that in 2019 your lecture at the Alexander Hamilton Forum at Middlebury College was canceled after student protests. That is emphatically not the liberal way. Freedom of speech is always a two-way street. The more of it there is, the better prepared we are to respond to our opponents. (I understand that eventually you were able to speak to a political science class at Middlebury.) You are also right to caution against accusing everybody who takes issue with liberal democracy of crypto-fascism. But your own work does not make it easy to enforce such a distinction. It is hard to ignore some of its disturbing, indeed odious themes — the rejection of individual human rights, the repudiation of tolerance, the dream of an organic and homogenous *Gemeinschaft* with little room for ethnic, religious, or sexual minorities.

An Open Letter to an Enemy of Liberalism in My Native Land

I detect something personal, something pre-intellectual, in your denunciations of liberal democracy — a visceral recoil from its uncontrollable scope and variety. It seems to make you profoundly anxious. You write that your doubts about liberal democracy started during your first trips to the West in 1970, when you discovered that liberals were reluctant to condemn communism in unambiguous terms. Was that the main thing that you noticed about the West? Your observation, by the way, was incorrect: many of the most ferocious Western adversaries of communism were liberals. But the hesitation that you detected in certain left-wing quarters made you speculate, and you came up with a theory: that there are deep affinities between the two systems. And this led you to the wild conclusion that liberalism sets itself the same goals that communism does. Both are future-oriented and both are "progressive," that is, both promise the constant betterment of the human condition — at a price, of course. Both are engaged in intense social engineering and social coercion to create nothing less than a new society and a new human being. Both are hostile to communities, families, and religions. (Though for you only one religion really matters.) Both are millennarian cults that strive for the ultimate victory, for the apotheosis of history.

Yet liberalism is worse than communism, in your view, because it is more clever: it achieves its goals without resorting to overt coercion, to anything as coarse as the Gulag and the KGB. It even allows you to publish your anti-liberal books! (Have you ever read Herbert Marcuse?) Liberalism is so insidious that, unlike communism, it has never openly claimed to struggle towards some ultimate future of harmony

and bliss, for the sake of which even genocidal atrocities are justified. Unlike communism, which is so *obvious*, liberalism never maintained that its vision of history has been scientifically, that is unquestionably, proven and beyond discussion. Yet you are not fooled. You have decoded the reality beneath the appearances. You know that we must await the hour when the mask will fall, and the totalitarian nature of liberal democracy will become visible to all.

If this is the truth that you have spent the best part of your career proving, I pity you. But again I must wonder what is eating at you. During you first visits to the West, you must have stumbled among the post-1968 leftists. This was practically inevitable. I remember my own first visit to the West — to London — in 1969, in the sophomore year of my English studies. In order to obtain a passport and a permit to travel, one had to produce a notarized invitation from someone abroad who would solemnly promise to pay for your upkeep. Who would take such a risk? Unless you had close and generous family in the West, you had to find a person, a friend of a friend, sometimes a total stranger, to sign the papers, with the silent understanding that it was a fiction and that you will not be a burden. In my experience, the people most likely to do so were the rebellious leftist types who, not unlike us, found a thrill in flaunting bureaucratic regulations. They were the curious ones who came backpacking to Eastern Europe to check it out for themselves. They visited our student clubs, came to our drinking parties, engaged in endless discussions, and invited us to backpack across their countries. Once we got there, they sometimes let us sleep on the floor in their dingy apartments with their Che and Mao posters. They were totally misguided in their politics, but they were awfully nice people. They were wrong, but they were free.

An Open Letter to an Enemy of Liberalism in My Native Land

I still remember my exhilaration when I set foot in London. Raised in a rather conservative and overprotective Polish family, I found myself for several eventful weeks completely on my own, immersed in a world that was strange but oddly recognizable — dense, vivid, constantly throwing me off balance yet never letting me fall. I walked through posh and shabby neighborhoods, sat with hippies in Hyde Park, watched multigenerational Indian families picnicking on the grass and little African boys practicing cricket on the pitch. I followed with amusement a march of somber-faced bearded members of the Young Communist League of London. I hitchhiked in a tiny car packed with jolly itinerants who must have been British travelers, and I stayed with hospitable Ukrainian emigres whose wartime past I preferred not to investigate.

It was hardly a vacation. I came with a hundred pounds in my pocket — a fortune, if you had to buy it on the black market. I slept in strange, unhealthy places. I washed dishes in pubs and painted houseboats on the Thames. I worked on a demolition site supervised by a Polish foreman, who showed the most extraordinary disregard for his workers' safety. All the time I entertained the absurd idea that absolutely nothing bad could happen to me because this was the world is as it should be. I was naive, of course, and I probably put myself in a lot of danger, but nothing bad happened and I returned to Poland with a clear idea of what the "normal world" is. I decided to recreate it internally, or in the close circle of my friends. We were not rebels, dissidents, conspirators. We were just ordinary people trying to live ordinary lives, that is, to express ourselves freely without nervously looking around, to possess "forbidden" knowledge as if it were the most natural thing. Once, on a bus in Warsaw, a stranger reproached me

104

for reading in plain sight a book of unmistakably *samizdat* provenance. I looked up at him in genuine astonishment. What could be wrong with reading a book?

Perhaps my approval of liberal democracy — for us it was simply democracy — was also pre-intellectual. I kindled instinctively to it. Political choices, as the Polish poet Zbigniew Herbert once remarked, are frequently a matter of taste.

What strikes me most in today's antiliberal narratives is their conviction that for over two centuries Western civilization flourished (and sometimes withered and flourished again) in a fog of misconceptions. To claim that everything humanity did in that vibrant, creative, often turbulent era was the result of a huge philosophical error, of certain wrong premises laid down in the eighteenth century by a handful of philosophers, is to deny the abundance of history and human agency. Were we so easily fooled, and for so long? And what would happen if we really tried to undo that fantastic fallacy and returned to the truth, returned to... what exactly?

You blame the philosophers of the eighteenth century for their revolutionary theories. I, too, have a reverence for ideas, but one does not have to be a Marxist to see that some non-ideological factors played a role in the great historical transformation. The history of ideas is not the whole of history. There is also the history of economics, society, technology, science, human geography. Momentous changes were happening in all those realms at that time. They caused political upheavals and religious wars. Sometimes the ideas came later. Locke wrote in the aftermath of Cromwell's Civil War, the regicide of Charles I, the Restoration, and the Glorious Revolution that ushered in

An Open Letter to an Enemy of Liberalism in My Native Land

constitutional monarchy in Britain. His philosophy expressed what was probably on the minds of many people. Liberal political principles started to take root, first in the Anglo-Saxon world and then in all corners of the Western world, not as a doctrine imposed from above, but as a response to the demands of the emerging new world. It was not the only response, but its success was hardly a matter of historical accident or of the machinations of "liberal elites."

The people whom we call the fathers of liberal thought were not always the most rigorous thinkers and they did not usually exert themselves too much to create elegant, abstract philosophical systems. (The conservative thought of the same period did not exactly cover itself in rigorous glory, either.) Liberal thought draws from many, sometimes contrasting, sources: anthropological optimism (man is rational and capable of freedom) and anthropological pessimism (man is endlessly corruptible), rationalism, empiricism, religion (mostly Protestant Christianity), natural law, a dash of utilitarianism. Liberal philosophers, especially those in the English tradition, often smoothed out the seams by referring to observable facts and to common sense. Bertrand Russell (definitely not one of your heroes) saw this piecemeal, empirical approach of the English liberal thinkers as their great advantage. Liberalism's loose structure leaves a lot of room to improvise, and it requires constant thinking, debate, compromise, and partial solutions. There is no political doctrine that provides less immediate and total gratification than liberalism. Moreover, I cannot name a single liberal politician who would quote Locke, or Mill, or Kant while proposing, or opposing, a policy or a law. Doctrinal purity is the least of their concerns. Their — our — liberalism is a framework of general ideas that supports a system of constantly evolving institutions,

106

procedures, and legal solutions — a matter of messy practice rather than immaculate dogma.

Many of the ills of contemporary liberal democracies that you list are real, and they are subject to constant liberal debate, in which common sense sometimes wins. Many of your allegations are familiar anti-liberal exaggerations, sometimes repeated in good faith also by liberals, and it is impossible not to notice that they almost inevitably come down to sex. You and your ilk peddle the strange view that liberals are at bottom hedonists, inveterate pleasure-seekers, *philosomatoi*, body-lovers, obsessed with sexual indulgence. At this point you put down Plato, Aristotle, and Mill and reach for dusty old issues of *Playboy*. The emancipation of the body from "the old moral teachings" and the triumph of sexuality has annihilated, in your view, "all hitherto existing moral hierarchies that made sexuality subservient to higher goals." Sex has been "transformed into a powerful instrument for creating collective ideologies that regulate life's most private aspect," with two great victories: "legal abortion and homosexual rights." Same-sex unions are "as good or as bad as the group marriage of several men and several women," and equally undermine our attachment to the monogamous unions of one man and one woman.

Who are these libertines? I wonder where you actually encountered this orgy of license and abandon, this wholesale rejection of the "traditional" family. In Krakow? I must have been hanging out with the wrong crowd. My own experience of liberal life has made me think that a medieval peasant must surely have had more fun, including carnal fun, than my constantly overworked, stressed, hurried, deadline-obsessed friends from the educated middle class. The 1960s, please remember, were a long time ago; we are no longer young and

that world (insofar as you portray it at all correctly) is gone. There is something, well, queer about the way sex keeps coming back as the perfect metonymy of everything that has gone wrong in liberal democracy. Isn't a sex-obsessed analysis of society an intellectual kind of sex addiction?

Can a society survive without virtue, excellence of character, self-control, and a sense of duty? Obviously not, and the liberal world is no exception. Not long ago, in these pages, Samuel Moyn wrote about the central role of duties in liberal theory and practice. That was not only because duties are necessary to safeguard our rights, but also because rights are necessary if we want to dispense our duties properly. Moyn observes that in recent decades the subject of duties seems to have fallen out of liberal discourse. In my own experience, the situation "on the ground" may not be so dire. The spirit of civic self-organization, activism, and voluntarism — all requiring a strong sense of duty — is as alive as ever. A free and self-reliant individual seeking his own version of *eudaimonia*, or flourishing, does not need to be a selfish hedonist. (Call me provincial, but I do not know a single person who would fit that description.) It is past time for you, and other sentimental communitarian post-liberals, to notice that individuals form associations for common purposes. They belong to groups and they support causes. They are generally not Dionysian monads. You would be surprised at how often the pursuit of happiness means the pursuit of the happiness of the other.

The spirit of uncoerced duty, of excellence of character, of a willingness to sacrifice — virtue in the most classical sense — is on plain view in Ukraine, which is fighting for its liberal life. So is barbarity and the viciousness of liberalism's enemies. We are witnessing the perennial *danse macabre* of the best in humankind with the worst. I now see, on live

108

television, pictures from my parents' war stories: women and children lumbering through fields of broken stone and glass, families huddling in shelters, civilians of all ages training for combat against professional soldiers, housewives storing Molotov cocktails. It is Warsaw in 1939, and the Warsaw Ghetto Uprising in 1943, and the Warsaw Uprising in 1944, with some striking anachronisms. The neighborhoods in Ukrainian cities that have been leveled by Russian bombs look exactly like the neighborhoods in which I grew up. The same dreary socialist classicism, the same anonymous concrete apartment buildings, now in ruins. The exodus also looks familiar, just like my future mother must have looked walking out of Warsaw after the fall of the Uprising — women and children, vulnerable and scared — they are still walking, this time with roller suitcases and cheerful school backpacks. They stream into all the neighboring countries, but mainly into Poland. Poland has accepted over two million refugees. To put it in proportion, it is as if twenty-four million people descended on the United States within a few weeks. But this is not a relationship between a victim and a protector, between a supplicant and a charitable helper. After all, Ukrainians also do something for Poles and the rest of Europe. *They are our protectors.* Taking care of their women and children is the least we can do. That, too, seems to be obvious to Poles — Poles and Ukrainians, together.

There is a lot of close, entangled, and mostly unhappy history between the two nations. An intimate bond often led to bloodshed, most recently during the horrid Volhynian Massacres in 1942, when the Ukrainian Insurgent Army was brutally cleansing ethnic Poles from Ukrainian lands in the hope of establishing a Ukrainian state under Hitler's protection. (Hitler had different plans.) Between 50,000 and 100,000 thousand Poles, mostly civilians, including women

An Open Letter to an Enemy of Liberalism in My Native Land

and children, were slaughtered, as well as many Jews, and also Ukrainians who tried to protect their neighbors. Poles retaliated in kind, killing 10,000 to 30,000 Ukrainians. The Germans, who occupied the territories at that time, stood by and watched. "Hatred grew into the hearts and poisoned the blood of brothers," wrote the nineteenth-century novelist Henryk Sienkiewicz about an earlier epic bloodletting, the Khmelnitsky uprising in 1648. There seems to be no trace of that poison now.

Am I like the hapless, pedantic Settembrini in *The Magic Mountain,* haggling, on the eve of the Great War, with the Hegelian-Marxist anti-liberal Naphta, a Polish Jew schooled by the Jesuits in Spain? Settembrini stands for reason and enlightenment. He is a decent and likable man, but Thomas Mann, his creator, equipped both of the interlocutors in the grand debate with telling human defects. Naphta is beguiled by death and is clearly uncertain about his identity, including the Jewish identity that he tries to conceal. Settembrini, a man of great passion, fears the power of human emotions and tries to push them out of his world. He wants to ignore everything that is irrational, dark, dangerous, or sublime in the human soul. He finds music politically suspect because it lifts the spirit too high, beyond the reaches of reason. Obviously he does not want to hear about metaphysics.

In this regard he exemplifies a liberal characteristic that is often criticized: its preference for "the mean" at the expense of greatness, its indifference — or hostility — to metaphysical strivings. Man's spirituality is not one of liberalism's concerns. And so it can appear small and pedestrian and boring. In

his review of *Mein Kampf*, George Orwell noted that while capitalism and socialism (Orwell's creed was democratic socialism) promises mainly a gradual improvement of material conditions, Hitler, Stalin, and Mussolini offered their followers the rapture of pain and the ecstasy of struggle. Hence their immediate, and disastrous, appeal. One can object that Churchill, too, promised "blood, sweat, and tears," but they were not his ultimate goals — they were a way to win the comforts and the banalities of peace.

There are those who claim that Vladimir Putin also harbors such an authoritarian grandeur — that, influenced by the ideas of a twentieth-century Russian fascist mystic named Ivan Illyin, he truly believes in a celestial and divine soul of Russia, and in its holy mission to convert and sanctify the rest of the world. Myself, I think this flatters him with too much spiritual depth, but it is indisputable that metaphysical language is present in Putin's propaganda. If only Ukrainians, seduced by liberal materialism, would renounce their Western error and return to the holy Russian womb! This may require a dose of purifying violence, a common sacrifice to restore a common spirit.

The mystical streak runs deep in Russian political tradition. In 1831, when the Russian troops were bombarding Warsaw and finishing off the Polish-Lithuanian anti-Russian uprising that inspired (among other things) Chopin's "Revolutionary Etude," the great Russian poet Fyedor Tyutchev waxed metaphysical in comparing Poland to Iphigenia as she was sacrificed by Agamemnon "for the breath of fair winds":

Pierced by your brother's arrow,
fulfilling destiny's pronouncement,
you fell, single-tribed eagle,

onto the purifying fire!
Believe the word of the Russian people:
your ashes will be preserved by us in sanctity,
and our general freedom,
like the phoenix, will be reborn in them!

(translated by Frank Jude)

The Poles were not impressed by such grandiose sanctification, and neither, it seems, are the Ukrainians. Governments should stay out of transcendental preoccupations. Imperfect human laws have more quotidian tasks. One thing is certain about liberalism: it does not lead to religious wars. But having said this, I wish Settembrini would allow himself to enjoy music. It would, ironically enough, make him a better liberal.

In the days of our youth in Poland, some of us dared to challenge our "socialist civics" teachers by asking an impudent question. How come "bourgeois democracy," the infamous system of exploitation and suppression of the working class, has not yet succumbed to the inner contradictions described by Marx? Whence its durability? Why do its citizens seem to be thriving materially and culturally — with better cars, better food, better movies, and generally with a more colorful, rich, varied, and exciting existence than in our gray and ascetic world? With communist parties legal, active, and sometimes even participating in governments, citizens could easily send the bourgeois parties packing.

As a rule, the answer that we were given was curt and threatening. It was that we had succumbed to Western propaganda. We watched too many Western movies and

112

listened to too much Western music. In fact, they told us, the West is nothing like that. There is unemployment, and racism, and widespread crime. What we mistake for the good life is a materialistic façade meant to deceive and enslave people, to turn their attention away from their loneliness, their alienation, their inner poverty. For Western freedoms are meaningless. The system owes its continuity to its control of everything, including human minds. This is what Marx called "false consciousness" — a deceptive system of ideas, beliefs, and habits that creates a veil of obfuscation which prevents people from recognizing their true condition.

Today's anti-liberal criticism on the right accepts this Marxist narrative almost without modification. The resilience of liberal democracy troubles the "post-liberals," and so they predict its imminent downfall. But still they need to explain its apparent resilience, its continued attractiveness. Why does liberal democracy enjoy the support of the very people whom it has purportedly enslaved? Why are its fundamental and systemic flaws not more obvious to those who live with them daily? Why are millions still trekking from illiberal countries into liberal countries, and not the other way round? You, Professor Legutko, admit that "alternative political models have not been drawn or even seriously considered, and the effectiveness of the regime is still impressively high." But why?

Your answer sounds oddly familiar to people such as ourselves, who were educated in communist schools. You admit that liberal democracy is "perfectly tailored to the aspirations of the people inhabiting it," and that the human model that it promotes "is perfectly tailored to the opportunities offered by the political system and to the aspirations enhanced by it." It would seem, then, that free people have created a system that suits them best. But this cannot be,

since it is a wrong system — and so this can only mean that the people living in this system are not really free, or do not know how to use their freedom. How can they be free? They have departed too much from the ideals taught by the ancient philosophers and religions. They are too far gone in the liberal lie. And so they are in urgent need of being saved from themselves. Yes, false consciousness! Nothing here is real. Everything is an illusion. Everything is its opposite. As you write, "pluralism means monopoly; diversity — conformity; tolerance — censorship; openness — ideological rigidity." Our teachers, and Orwell too, would have been proud.

You wonder why, after the fall of communism, Poland and the rest of East Central Europe, "as if charmed by powerful but invisible political magicians," settled for liberal democracy. After all, the huge moral mobilization represented by the overthrow of communism should have culminated in something more profound and spiritual, something that would contain "classical metaphysics, morality, and Christian religion," something that would have reflected Poland's unique historical experience. You see post-communist Poland as a slavish imitation of the West induced by an intellectual inertia, by a "contagious" concept of historical inevitability, or, worse, as the result of brainwashing by Poland's "liberal elites" and conniving by former communists eager to establish a system that would allow them to retain some of their privileges. (Where else would they feel at home if not under a regime similar to communism?) But you do not despair. In your view, the opportunity for redemption may not be entirely lost. People are waking up and voting against the liber-

als in Hungary and Poland, and soon perhaps in the rest of the region. The trend may even have pan-European consequences. Anti-liberal, or post-liberal, or illiberal parties in your part of the world — the only such parties that actually hold power — may give a much-needed boost to their comrades in West. Some of your fellow anti-liberal politicians even speak openly about Poland's mission of re-Christianizing Europe.

Not sharing your misgivings about liberal democracy, I see the post-communist transformation of Poland as both natural and welcome. It is true that the struggle against communism in Poland, and probably in other East-Central European countries, appeared to many people as more of a moral battle than a political one. Yet if high-minded and general language was preferred by the anti-communist dissidents, it was partly, but not entirely, for strategic reasons. After Solidarity's initial and quite unexpected successes — the strikes spreading like wildfire and forcing the government into an unprecedented dialogue — there was confusion about what exactly the workers should demand. At first their postulates were mainly economic and labor-related, but under the influence of opposition intellectuals they gradually expanded into the social and cultural sphere. It was quite obvious that the proposed changes would gravely curtail the communist monopoly of power. It was hard to predict, however, how far the changes would go and what the new hybrid arrangements would look like. It is safe to assume that most Poles, if asked directly, would have said that they wanted to live in a "democracy of the Western type," but in those days such an outcome seemed a rather remote possibility. Something unfamiliar was happening, something that should not have been possible, and it was better not to be too specific in one's plans, or even in one's dreams.

An Open Letter to an Enemy of Liberalism in My Native Land

As a result, a language of lofty imponderables dominated the public discourse: truth, dignity, honesty, respect, solidarity, fraternity, national identity, and of course "Christian values," were affirmed loudly by nearly everybody, including anti-clericalists. The Church was a much-needed ally in the struggle, providing spiritual and material assistance, and liberals responded with good will. (There was even a rash of baptisms and church weddings among people who had lived happily without them.) On the liberal left's side, the textbook of this *rapprochement* was Adam Michnik's book *The Church and the Left*, which appeared in 1977 (and years later in English). But this may have given the wrong impression about the intellectual and political realities. For some Western conservative commentators, such as George Weigel in *The Final Revolution*, published in 1992, the Church's struggle with communism was a millenarian battle with the "tyranny of politics." It was what Weigel saw as "the human turn to the good, to the truly human — and, ultimately, to God." You would have thought that Solidarity's program was wholly cribbed from the Sermon on the Mount, that it was less about the form of government than about the shape of the human soul.

116
After the crackdown on the anti-communist opposition and the declaration of martial law in 1981, it was no longer possible to believe that the system would be vanquished or transformed by righteousness alone. Something new, as yet unknown but quite specific, would have to appear in its place. In the midst of the repressions, there was a pervasive sense that by resorting to military force the system has written its own death sentence. It had no more arguments left. It was a junta, and juntas do not last forever. "You can win a fight with a bayonet but you cannot sit on it," was the slogan of the day.

The breakthrough in 1989, and the quick collapse of

the remnants of communist power, confronted Solidarity and other anticommunist movements in the region with the urgent task of translating their victory into political institutions. Ideological differences, kept in check under communism and martial law, came to the surface. There was, indeed, an abundance of ideas. Should Solidarity constitute itself as a political party? One of many, or perhaps, at least at first, the only one, if strictly pledged to internal democracy? Or should the new dispensation be based on local citizens' councils or worker's committees, like those that ran strikes and negotiated deals with the authorities before martial law? Should the government-controlled economy be privatized, or marketized and kept in the hands of state, or ceded over to workers' collectives? There were also the programs of radical nationalists, and Catholic integralists, and monarchists. There was even the Party of Beer Lovers, with its own utopia of replacing vodka with good beer as the staple of Polish social gatherings. In many circles, mainly on the left, there was a longing for something called "anti-politics," which the Hungarian writer Georgy Konrad defined as the domination of civil society over the political elites, or, in his own words, "the emergence of independent forums that can be appealed to against political power; a counterpower that cannot take power and does not wish to. Power it has already, here and now, by reasons of its moral and cultural weight." But finally, to the disappointment of some and the relief of many, it came down to parliamentary democracy and constitutionally guaranteed fundamental rights. Liberal democracy triumphed not by the suppression of the alternatives or the clandestine plots of the elites, but the way it always triumphs — by being the most acceptable, or the least objectionable, to the largest number, including its own opponents.

An Open Letter to an Enemy of Liberalism in My Native Land

What happened later was more problematic, owing not to liberalism's intrinsic shortcomings but to specific circumstances in East Central Europe. These were countries with very weak liberal traditions. They had only a scarce familiarity with the problems that liberalism elsewhere had to work through, sometimes repeatedly, during its history. Liberal democracy came to Poland and other post-communist countries fully cooked and ready to serve in a late twentieth century version, to the absolute delight of many and the uneasiness of equally numerous others. The former group had long cultivated their "Western" identity in defiance of communist political and cultural pressures. The latter group had responded to the same pressures by falling back on traditions, extended families, national history, and the Catholic Church. They also considered themselves Europeans, but their concept of Europe was sometimes vague and antiquated. Under communism both groups coexisted, treating each other's peculiarities with a good dose of forbearance. Under democracy, they often found themselves on the opposite sides of political divisions, treating each other with growing impatience and hostility. They were free to fight bitterly over the high political and cultural stakes.

Culturally conservative Poles were disturbed by some of the manifestations of instant political liberalism — gay pride parades and women's pro-abortion protests (often under deliberately provocative and offensive slogans), sexual education in schools, including instruction about gender identity and non-standard sexual orientations, and harsh media attacks on the Church for its sexual scandals and political overreach. The response of the liberals was often contemptuous and dismissive: this is how things are done in the civilized world, end of discussion, and whoever does not agree is a bigot, a chauvinist, a religious fanatic, or a moron.

(Students of contemporary American liberalism will recognize this phenomenon.) "The nation is so stupid!" I have heard that on many occasions from my liberal friends. It always reminds me of Brecht's famous poem "The Solution": wouldn't it be easier if you dissolved the people and elected a new one, more to your liking?

One should not underestimate the role of economic dislocations after the collapse of the communist planned economy, which often overlapped with a sense of cultural marginalization. The main factor of liberal instability in Poland today seems to be cultural rather than economic. Quite a lot of Poles live happily, comfortably, and a bit overconfidently in the modern, and sometimes post-modern, culture. But quite a lot of Poles are ill at ease in it. Those two cultural constituencies grow more and more distant; they do not talk to each other and they have no common language. As a result, the fabric of the relatively young Polish liberal democracy is fraying. This development, of course, is not unknown in the West. The "basket of deplorables" language is carefully avoided in public speech, but the contemptuous sentiment persists. In this sense, Eastern Europe may indeed hold a lesson for the West as an example of a problem that needs to be acknowledged before it grows too big to solve.

Illiberal parties in East-Central Europe benefit from this dilemma by stirring and channeling social fears and resentments. How illiberal are they? Both the Fidesz Party in Hungary and the Law and Justice Party in Poland have solidly liberal antecedents. Fidesz, under the leadership of the young democratic activist Victor Orban, was the hope of Hungarian liberalism in the 1990s. The Law and Justice party harkens from the more conservative wing of the Solidarity movement. Their drift to the far right was largely opportunistic — the

filling of a political vacuum left by a series of missteps by the left and left-centrist governments that preceded them. They position themselves as defenders of "European Christian traditions" against the purported threat of "Islamization" and "neopaganism." They present themselves as protectors of the family from the double threats of feminism and LGBTQ "ideology." They are morbidly oversensitive about national sovereignty and have strong anti-EU elements. At home they try to curtail opposition media — in Hungary much more successfully than Poland — by financial means and by manipulating media ownership laws. Most importantly, they tamper with judicial independence by packing constitutional tribunals and supreme courts with political sympathizers, and defying the European (though not American) tradition of a depoliticized judicial nomination process.

Yet the opposition in both countries are far from impotent. Independent opposition-leaning media remain vocal, especially in Poland, and vigorous political debate is continuing. Non-governmental organizations of various stripes remain active, and fundamental human rights are generally protected. Even "reformed" constitutional tribunals and courts sometimes decide against the governments' policies. National and local elections are conducted regularly, and international observers deem them generally free and fair, although marred by the politicization of the media and the governments' deployment of administrative resources on behalf of their preferred candidates. There are no political prisoners.

The continuing electoral success of those parties, despite their impressive list of failures and the glaring lack of charisma in their leaders, is helped in no small degree by the divisions in the opposition, which in Poland still fails to realize that dismissing forty percent of the electorate — the Law and

Justice voters — as uncivilized and dispensable is not a winning strategy. It is laughable to credit these tacky right-wing parties with some bold vision of a new post-liberal order, but it is equally wrong to present them as fully authoritarian, dictatorial, or even fascistic. These are seriously imperfect democracies, but it is offensive and impertinent to compare them to Putin's Russia or Lukashenka's Belarus.

And yet I do not wish to make light of the concerns that the rise of illiberalism provokes in these countries and in the wider world. There is a historical basis for alarm: the liberal traditions in these countries are weak, and there is a lack of respectful and patient debate about liberalism's problems and paradoxes. (Some, of course, are too far gone in anti-liberal hatred and ignorance for any civilized debate.) I am quite confident that no one in today's Poland would deliberately relinquish the liberal freedoms that they have come to take for granted. But many Poles may fail to distinguish between liberalism's core elements and its accidental, transitory, and debatable manifestations. They may watch with satisfaction their governments' creeping and calculated antiliberal interventions without realizing that sooner or later their own freedoms may be at stake. Cultural dissonances can push them beyond the point of no return. This is also in evidence today, for slightly different reasons, in some "mature" liberal democracies. Putin has been exploiting our unaddressed cultural dissonances for quite some time.

My dear professor, we are already quite far from an academic philosophical discussion. But you are far from being a disinterested seeker of truth. You are a politician representing your

party in the European Parliament, a party that is slowly and methodically dismantling the liberal checks on power. You are, to quote Marx again, a philosopher who wants to change the world instead of just interpreting it, to lead us boldly "beyond the liberal-democratic horizon." But where, exactly, do you wish to lead us?

Revolutionary anti-liberals of old were quite specific in their remedies. Liberalism is finished, it's communism or fascism now: this was the anti-liberal refrain of the 1930s. Today's anti-liberals are more cautious. When their books approach their conclusions, they grow vague and elusive. No, they concede, they cannot propose an alternative. Not yet. But an alternative will emerge and it will be a good one. It will preserve all the good sides of liberalism and erase all the bad ones. It will be something entirely new, because liberalism cannot be improved, it can only be replaced. And the new dispensation may turn out to be an old one, a restoration of some kind. It will teach us true freedom by re-establishing its proper meaning, by reviving traditional virtues, by reintroducing the metaphysical dimension to our social life, by returning us to the long-forgotten ambition of achieving spiritual greatness by political means. Your American colleague Deneen lamely admits that the ideal post-liberal system may one day be called... liberal. In the meantime, let us, the right thinkers, stick together, study the classics, give testimony to the truth, despise the secular modernist liberals, and sooner or later one of us will come up with a heroic idea.

Not to dismiss the appeal of utopian thinking, but once in a while we need to return to the serious world of political reality. In the old days, when our backpacking leftist friends from the West maintained that Soviet communism is not a "true thing," we pointed out that it is the only real thing. Today, the only

real alternative to liberal democracy is illiberal authoritarianism. It seems, in fact, to be on the rise. For years, Putin's Russia has been playing the same role toward the illiberal parties in Europe that the Soviet Union used to play for the communist parties in Europe. It has been gathering them under its wings, supporting them with money and disinformation campaigns, nudging them into positions most favorable to Putin's geostrategic plans. (The Polish Law and Justice party seems to be an exception to the rule, despite sometimes echoing some of Putin's anti-liberal and anti-Western rhetoric. Poles have coddled Orban, and the Polish Prime Minister has met with Le Pen and Salvini, but it is only fair to note that Law and Justice has not joined them in their pro-Russian position.) Like the Soviet Union of old, Putin's Russia is always on the lookout for the disappointed and the dissatisfied, for clueless fellow-travelers, for useful idiots. And like the Soviet Union of old, it finds them.

Your views, Professor Legutko, and the views of other antiliberals, cannot be discussed in a vacuum. They have concrete consequences. They are used by autocrats who wish to weaken liberal democracy not in order to replace it with something better, but to seize, solidify, and maintain their own power. Their visceral fear of liberal democracy is not philosophical, it is existential. We see this today with the utmost clarity in Ukraine. In a sense, Putin is right. Ukraine *does* pose a mortal threat to his regime, not because it plans to march on Moscow but because it chooses to pursue its own liberal future. The victory of Ukraine could spell the end of Putinism. And Ukraine's defeat would trigger truly frightening consequences in Europe and elsewhere. That is why Ukrainians have been fighting *our* war, a war for the version of history that you would like to cast away. History

has not ended, which means that everything is still possible, but at this moment in history it is liberal democracy that has provided us with the largest scope of freedom and the lowest level of coercion in human history. It may also be the only protection we have against the authoritarianism and the autocracy that has reappeared on the historical stage. Old demons are back. It is not the "demon in democracy" that we have reason to fear.

The demon in democracy: you end your book of that peculiar title with a sigh of resignation. Perhaps, you admit, the story of liberal democracy does express the "basic truth about modern man who, after many adventures, downfalls and ascents, exultations and tribulations, after following many chimeras and surrendering to many temptations, finally arrived at the accurate recognition of who he is." You say it with regret and with disappointment. No further change in our condition will be possible, except for the worse. We have revealed our true nature and its name is mediocrity.

I refuse to succumb to your gloom. During my life as a denizen of liberal democracy I have seen my share of mediocrity, but also enough creativity, goodness, and even heroism to believe that our story is far from over. And are there no mediocre people on the post-liberal right? Are you all visionaries and supermen? Anyway, mediocre people, however you condescendingly define them, also have rights and are also worthy of respect. As I write this, the Russian offensive in Ukraine has stalled. Ukraine has been defending itself longer than Poland did in 1939 and will outdo France in 1940. We are in for a long, dark, tense period, with Poland once again on the front line of defense. You and your comrades have nothing to contribute to this defense. It will be won or lost by the moral mettle of Western liberalism. It is the strength of our

124

convictions, the ones that you have haughtily repudiated, which will decide the outcome.

Liberal democracy has won similar confrontations before. I really do not see anything else — certainly not your ugly and illusory post-liberal order — that can take its place.

125

ELLIOT ACKERMAN

A Dangerous Desire to Do Right

War begets war: it is an old truism, and internecine wars — of the type twice fought on American soil — typically have their antecedents in prior wars. Consider our Revolutionary War, whose *cri de coeur* was "no taxation without representation." But how often we overlook that Britain imposed these heightened taxes on the colonists to service debts from the French and Indian War. Consider our Civil War, which was fought to preserve the Union and abolish slavery. But how often we overlook that what upset the balance between free and slave states were territorial acquisitions made during the Mexican-American War. This pattern extends also to the key

personalities of these conflicts, who first appeared on the historical stage in the prior war — George Washington, who at the end of the French and Indian Wars was a minor officer of mixed reputation who had once surrendered to the French, and Ulysses S. Grant, who mustered out of the army not long after the end of the Mexican-American War. When Robert E. Lee surrendered to him seventeen years later at Appomattox, Grant reminded Lee that they had met once before, in Mexico. General Lee, who had been a colonel in that first war, apologized; he could not recall having ever met Grant.

A recent raft of commentary — from articles to books to endless cable news segments — has asked whether the United States is headed toward another civil war. Anxiety about the subject grips us. Could our divisions metastasize into war? We watch the trend lines: increasing income inequality; racial resentments; hyper-partisanship; outbursts of violence. Which of these could prove combustible enough to incite a war? In recent years an alarming number of Americans have been moved to protest, to riot, and even to engage in insurrection. And like our Civil War and our Revolutionary War, the propellant that turns civil discord into civil war may not exist in our current discontents, but rather in our last war, which was fought far from our shores.

"The baby boomers turn is over," said Marine Lieutenant Colonel Stuart Scheller as he stared into the camera. "I demand accountability, at all levels. If we don't get it, I'm bringing it." His video, posted to Facebook, immediately went viral. He recorded it at his desk in Camp Lejeune the day after a suicide bomber at Kabul International Airport's Abbey Gate killed

thirteen American service members and over 170 Afghans. In his nearly five-minute-long post, Scheller lamented the Biden administration's handling of our withdrawal from Afghanistan and called out senior military leaders, including Chairman of the Joint Chiefs of Staff General Mark Milley, Commandant of the Marine Corps General David Berger, and Secretary of Defense Lloyd Austin. "People are upset because their senior leaders let them down, and none of them are raising their hands and accepting accountability or saying, 'We messed this up.'" But Scheller's remarks went one step further than a simple demand for accountability. He went on to quote Thomas Jefferson, who said that "every generation needs a revolution."

When I finished watching the video last August, I wasn't certain what to make of it. My first instinct was to categorize it as a rant. If it wasn't clear already, after the bombing at Abbey Gate it became evident that the Biden administration had handled the evacuation of Afghanistan with an exceptional degree of incompetence. Emotions remained raw, so a rant — even if inappropriate and perhaps even illegal when delivered by an active-duty officer — seemed understandable. Upon further reflection, however, I slowly came to realize that what I had watched was something else: an act of self-immolation.

Before his swift relief by senior officers that same day, Scheller held battalion command. The Marine Corps is very selective about which officers it grooms to become battalion commanders; the fact that Scheller held that job means that he was — until recording his video — well-regarded, a Marine with a future in the Corps. Furthermore, Scheller was seventeen years into a twenty-year career. At twenty years he would have been eligible for retirement at half his base pay with other benefits, such as healthcare for life. It took him

128

exactly four minutes and forty-five seconds to throw all that away. Scheller is a husband and a father. Why did he do this?

Before last year's cataclysmic withdrawal, Afghanistan was not a place, or an issue, most Americans cared about. In 2018, according to Rasmussen, 42 percent of the country couldn't even say whether we were still at war there. Over the past two decades, the war in Afghanistan was waged by an all-volunteer military and funded through deficit spending. Unlike other wars, there has been no draft and no war tax. It is often said that while America's military has spent the past twenty years at war, America itself has been at the mall. This has led to a massive civil-military divide.

The botched Afghanistan withdrawal, in which many active duty as well as retired military members received hundreds of phone calls and texts daily from their Afghan allies who were being left to fend for themselves against the Taliban (and who have already suffered at the hands of the Taliban in the months since our retreat) only deepened this sense of alienation among many who had served. One need only look back through history — from Caesar's Rome to Napoleon's France — to see clearly that when a republic couples a large standing military with dysfunctional domestic politics, democracy doesn't last long.

These are the exact conditions that exist in the United States today, in which we are witnessing a politicization of the American military with few precedents, from General Mark Milley marching across Lafayette Park in his fatigues with former President Donald Trump, to the congressional testimony of senior officers — on everything from January 6 to right-wing extremism to critical race theory — becoming fodder for late-night cable news anchors who seek to position those in uniform on one side or another of the

Democratic-Republican divide. Our military is, historically and ostensibly, an apolitical organization, but this has never meant that military members do not have political views. Of course they do. Yet the military stays out of politics because its highest authority is a civilian one and to voice political opinions publicly is to question that authority. And so as it pertains to politics, our military practices a code of *omertà*. Scheller's video broke that code.

The Marine Corps is a small community. As a lieutenant, Scheller served in 1st Battalion, 8th Marine Regiment (or 1/8, as we call it) a year after I did. I received his video from a friend, a lieutenant colonel who also served in 1/8. And one of the two infantry battalions guarding Kabul International Airport during the Afghanistan withdrawal was 1/8, too; that commander was a classmate of mine at Quantico. The all-volunteer military, the men and women who have fought two decades of war, has become increasingly insulated from the broader American culture. We all know each other, but fewer and fewer Americans know us.

The model of the citizen soldier which characterized the American military for generations has become replaced by a professional soldiering class, one that is increasingly closed, insular, and living in its own atomized reality — just like the rest of America. A military identity that segregates itself from American life (identitarianism being *de rigueur* these days) should concern us. As divisions cleave citizens apart, it is not unreasonable — indeed, it is prudent — to believe that those same divisions could cleave some in our military apart from the civilians they serve. This will be dangerous.

Our military remains apolitical because its involvement in politics would threaten to subvert the supremely democratic principle of civilian control. Civilian control over the military

was written into the Constitution by its framers as one of the many measures that divided powers. Article II, Section 2 states, "The President shall be the Commander in Chief of the Army and Navy of the United States, and of the Militia of the several States when called into the actual Service of the United States." By vesting ultimate authority into a single civilian in the chain-of-command, the Constitution safeguarded against a military that could find itself at odds with the society it served.

Still, the words in the Constitution are only sufficient if they exist within a culture that values civilian authority. Although that civilian authority has never broken down entirely, there have been moments when the military has tested its civilian leadership — from Lincoln with General McClelland to Truman with General MacArthur to Obama with General McChrystal — and always civilian authority has trumped military authority, exactly as the framers of the Constitution intended. But the more dysfunctional our politics become, the more cravenly our partisans behave, and the further military culture deviates from civilian culture as we rely on a professional soldiering class to fight our wars, the more stress we place on the barrier between military power and civilian power. It is a barrier that has allowed the United States to exist successfully in a condition that should otherwise be a contradiction: we remain both the world's leading democratic power and the world's leading military power.

The first presidential election I witnessed as a member of the military was George W. Bush versus Al Gore in 2000. I was in college, a naval ROTC midshipman, and on Election Day I remember asking a Marine colonel who was a visiting fellow

at my university whether he'd made it to the polls. In much the same way one might say "I don't smoke" when offered a cigarette, he said, "Oh, I don't vote." His answer confused me at the time. He was a third-generation military officer, someone imbued with a strong sense of duty. He then explained that as a military officer he felt it was his obligation to remain apolitical. In his estimation, this included not casting a vote on who his commander-in-chief might be.

Although I do not agree that one's commitment to remain apolitical while in uniform extends to not voting, I would over the years come across others who abstained from voting on similar grounds. That interaction served as an early lesson on the lengths to which some in the military would go to steer clear of politics. It also illustrated that those in uniform have, by definition, a different relationship to the president than civilians do. As that colonel saw it in 2000, he wouldn't be voting for his president but for his commander-in-chief, and he didn't feel it was appropriate to vote for anyone in his chain of command. As it turned out, the result of that election was contested. Gore challenged the result after Florida was called for Bush, and the dispute went all the way to the Supreme Court between the election and the inauguration, by which point Gore had conceded.

There are many ways to contest an election, some of which are more reckless and more unseemly than others, but our last two presidential elections certainly qualify. In 2016, Democrats contested Donald Trump's legitimacy based on claims of collusion between his campaign and Russia. In 2020, Republicans significantly escalated the level of contestation around the election with widespread claims of voter fraud, which ultimately erupted in rioting on January 6.

Today, as is well known, dysfunction runs deep in

American politics. While the images from January 6 remain indelible, the images of entire cities in red and blue states boarded up in the days before the 2020 presidential election should also alarm us. If contested elections become the norm, then mass protests around elections will also become the norm, and if mass protests become the norm, then police and military responses to those protests will surely follow. All sorts of fundamental firewalls in our politics and government will fall. We will find ourselves in a Constitutionally twisted and socially inflamed new normal, in which the boundaries that form the structure of a democratic republic will collapse. Little progress has been made to circumvent this cycle of contested elections in which we are trapped, with the most recent attempt — the January 6 commission's investigation — receiving only tepid support in Congress.

Destructive complexes are not new in American life. In his farewell address to the nation, President Dwight Eisenhower issued a famous warning: "In the councils of government, we must guard against the acquisition of unwarranted influence, whether sought or unsought, by the military-industrial complex. The potential for the disastrous rise of misplaced power exists and will persist." Eisenhower, who in his military career had commanded Allied forces in Europe against the Nazis, delivered those remarks in January 1961, at the height of the Cold War, which had led to a drastic militarization of American society. In the more than sixty years since Eisenhower's address, the term "x-industrial complex" has been used to describe the self-justifying and self-perpetuating nature of various industries — medicine, entertainment, and education, to name a few. But it is the political incarnation of that juxtaposition that we are most dangerously mired in now. Just as the military-industrial complex threatened to undermine

democracy in Eisenhower's time, the political-industrial complex threatens to undermine democracy in ours.

An analysis published in 2020 in the *Harvard Business Review* by Katherine Gehl and Michael Porter describes this systemic threat succinctly: "Far from being 'broken,' our political system is doing precisely what it's designed to do. It wasn't built to deliver results in the public interest or to foster policy innovation, nor does it demand accountability for failure to do so. Instead, most of the rules that shape day-to-day behavior and outcomes have been perversely optimized — or even expressly created — by and for the benefit of the entrenched duopoly at the center of our political system: the Democrats and the Republicans (and the actors surrounding them), what collectively we call the political-industrial complex."

This political-industrial complex includes not only legions of campaign staffers, pollsters, consultants, and other party functionaries, but also media (both traditional and nontraditional) that inspire division because division keeps people engaged, keeps eyeballs on screens, and so drives profit. While average prime-time viewership across the top three cable news channels had fallen by roughly a third from 2008 to 2014, the advent of Donald Trump's candidacy and election caused viewership to soar, with CNN posting nearly $1 billion in profits in 2016. In the lead up to the 2020 presidential election, Fox News became the highest-rated television channel during the prime-time hours of 8 to 11 p.m. This wasn't just on cable news. It became the highest rated channel in all of television. There was a time when higher numbers of citizens watching the news would have been regarded as a positive sign of greater civic engagement. But this is not such a time. There is something degraded and ferocious about the new partisan engagement that makes these numbers not edifying but troubling.

The effects of this political-industrial complex extend far outside politics. Politics now devours everything. Today, nearly every facet of life falls somewhere along the left-right political spectrum. Every question we ask ourselves is shot through the lens of politics. During the pandemic, for instance, I desperately wanted my elementary school-aged children to be in the classroom, with their friends. But even such an expression of paternal care about what I believed was best for my kids could have been mistaken for a declaration of ideology. When speaking to other parents, did this fervent desire to see my children in the classroom, even as we grappled with the coronavirus, make me look like a Trump supporter? A Republican? The most dispiriting aspect of the pandemic, aside from the suffering and the dying, was surely the way even the virus was immediately politicized.

I am also a veteran. When I tell my military buddies that prisoners of war should never be slandered and that convicted war criminals shouldn't be trotted out as national heroes, do they assume that I'm also a fan of the Green New Deal? A Democrat? Again, the tyranny of politics. It is the universal filter. Indeed, the politicization of American life is swiftly becoming total, with virtually no thought or action existing outside the realm of partisan sorting.

In 1939, when America was emerging from the throes of the Great Depression, our military ranked nineteenth largest in the world, standing behind Portugal. World War II, and the Cold War that followed, epitomized what theorists call "total war," in which every facet of a society is mobilized. This was a departure from centuries past, where nations typically waged "limited

war," relying on professional armies instead of the widespread enlistment of its citizenry and means of national production. One consequence of total war is that even non-military parts of society become military targets: manufacturing, agriculture, energy, even civilian populations. By the time Eisenhower delivered his address, total war had reached its zenith, as the development of civilization-ending nuclear weapons had made the human race's continued existence contingent on a precarious doctrine of "mutually assured destruction" between the United States and the Soviet Union.

We now live with total politics; and one way to measure our current state of "total politics" is to look at the ballooning economics of presidential campaigns. In the presidential election of 1980, spending by Republican and Democrats combined totaled $60 million ($190 million when adjusted for inflation). In 2020, filings show that the election cost $14.4 billion, which represents a 75-fold increase in spending. Just as the military-industrial complex fed off the U.S.-Soviet conflict in the Cold War, the political-industrial complex feeds off the left-right conflict. If the military-industrial complex led us into a paradigm of seemingly perpetual warfare with shifting and at times incoherent objectives (Korea, Vietnam, Iraq, Afghanistan), then the political-industrial complex has led us into a paradigm of seemingly perpetual campaigns in which our political class needs divisive issues to fight over more than it needs solutions to the issues themselves — crucial issues such as gun control, immigration, and health care.

Our passions are being inflamed and manipulated for profit by a political-industrial complex that feeds off our basest fears of one another. Our experiment in democracy has worked when it appeals to the best in us, as opposed to the

worst. Eisenhower recognized this, and it was that instinct in each of us he appealed to as he closed his farewell address: "Down the long lane of the history yet to be written America knows that this world of ours, ever growing smaller, must avoid becoming a community of dreadful fear and hate, and be, instead, a proud confederation of mutual trust and respect."

And if we do become a community of dreadful fear and hate? In the Cold War, failure meant mutually assured destruction through nuclear war. It was an outcome that, fortunately, never arrived, though it is instructive that Eisenhower's farewell address came a little less than two years before the Cuban Missile Crisis, the closest humanity has come to a thermonuclear exchange. Today, we sit on a different sort of precipice. Are we entering an era where we hold elections in a nation so hopelessly divided that neither side is willing to accept defeat? In a democracy, that is the truest form of mutually assured destruction.

This takes us back to the question of politics and the military, and to that colonel I knew in college and his conviction to stay out of politics. Increasingly, in military circles, this view seems to have fallen out of favor, particularly among senior retired officers. In 2016, for the first time in recent memory, we saw large speaking roles doled out to prominent retired military leaders at both parties' national conventions. This trend has accelerated in recent years, and in the 2020 election we saw some retired flag officers (including the former heads of several high commands) writing and speaking out against Donald Trump in prominent media outlets, and others organizing against Joe Biden's agenda in groups such as Flag Officers 4 America.

The United States military remains one of the most trusted institutions in our society, and so support from its leaders has become an increasingly valuable political commodity. If this trend of increased military polarization seeps into the active-duty ranks, it could lead to dangerous outcomes, particularly around elections, and specifically a presidential one.

Holding contested elections is like driving drunk. The drunk driver goes to the bar, has one too many, and often makes it home safely. They convince themselves in the morning that the night before wasn't that bad, that they can hold their liquor. Typically, a safe return will only reinforce the drunk driver's belief that they can get away with a little irresponsible behavior at the bar; that is, until they wrap their car around a telephone pole. Many commentators have already pointed out that it is likely that in 2024 (or even 2022) the losing party will cry foul, and it is also likely that their supporters will fill the streets, with law enforcement, or even the military, called in to manage those protests. In short, it is likely that we will soon be driving drunk again.

There are, of course, many ways we could wrap our proverbial car around a telephone pole. When gaming out the pitfalls of future contested elections, it's worth imagining one alternate outcome to the 2020 election: a narrow Trump win. This scenario seemed most likely to involve the military in dangerous ways. And it is a pattern that could repeat in subsequent contested elections with different players so long as the current political climate endures.

Imagine if Trump had won in 2020 by a narrow margin — say, the same margin by which Biden won. Prominent voices on the left had already questioned the wisdom of conceding the election, so it is quite likely that had Trump won in anything less than a landslide, national-level Democrats would

138

have questioned the legitimacy of the vote. The interregnum between Election Day and the Inauguration would have seen recounts and legal challenges, and the election outcome would not have been settled in a single night. Under these conditions, it is also likely that major protests would have occurred in American cities, including Washington, D.C. Canyons of boarded-up windows in the capital already attested to business-owners' fears of a Trump reelection and the inevitable protests that would have followed. In their scope and their passion, these protests would have equaled if not exceed those of the summer before. Biden supporters might not have stormed the Capitol, but they would have assembled, and Antifa or their equivalents would have been among them. Lafayette Park certainly would have filled, likely in much the same way it filled in the summer of 2020, in chaotic and at times violent ways.

Voices on the right would call for these protests to be broken up. Senator Tom Cotton would likely reprise his calls from the summer before, in which he had encouraged Trump to evoke the Insurrection Act and deploy federal troops on American soil to restore order. The limits of Trump's patience would be breached as thousands of protestors shut down Lafayette Park, to say nothing of protestors in New York shutting down Fifth Avenue in front of Trump Tower.

One can imagine General Milley and his colleagues at the Pentagon counseling patience. And one can imagine Trump's response: *What are these generals good for? All they do is lose wars. They certainly don't know how to win an election.* Under such conditions, it is not difficult to imagine Trump calling up Marines from Camp Lejeune and paratroopers from Fort Bragg. After all, this isn't without precedent. During the riots in Los Angeles in 1992, with which these protests would draw comparison, Marines from Camp Pendleton were mobilized

A Dangerous Desire to Do Right

to stop the violence. More recently, after Hurricane Katrina, President Bush deployed a battalion of Marines to New Orleans, a unit that had just returned from Iraq. (I happened to be part of that deployment, and that battalion was the aforementioned 1/8 in which Stewart Scheller served.)

Had Trump won narrowly in 2020, none of the above would have been improbable; indeed, it would have been likely. So then what happens? Let us imagine those several battalions have now arrived in Washington, and that one of them is under the command of a charismatic Marine lieutenant colonel. He is a decorated and esteemed veteran of the wars in Iraq and Afghanistan. He is popular among his troops, who trust him. Like most any battalion commander, including Stewart Scheller, the fact that he holds command attests to his solid record and reputation within the Corps. The climate in Washington is explosive. Our lieutenant colonel orders his Marines to stay off social media, but politics are now total and so impossible to escape. Protestors carry signs that read *Not My President*, but what does this mean for our lieutenant colonel and his Marines? They are following orders that are predicated on the legitimacy of that president, yet they have major political leaders — to include, I would imagine, the Speaker of the House and the Majority Leader of the Senate — questioning his legitimacy and thus the very legitimacy of their orders.

Specific orders soon come for our lieutenant colonel. When the protestors break yet another curfew, he and his Marines are ordered to clear out Lafayette Park, a repeat of the much-derided actions of the summer before. But those protests had been different. In the aftermath of the murder of George Floyd, their cause was social justice, a far more amorphous set of aims. Now, however, you are either with us

or against us, the president is either legitimate or illegitimate. Americans, including our lieutenant colonel, are being asked to make a very binary choice.

Clearing out Lafayette Park means batons, tear gas, and, most despicable of all, rubber bullets. Like Lieutenant Colonel Scheller, our lieutenant colonel harbors resentment toward those in power. He isn't a partisan, but he knows it doesn't feel right to aim a rifle at his fellow citizens. He has been to war, sent there by the politicians and the politicized flag officers whose decisions have misspent the blood spilled by him and his comrades. These politicians and flag officers have since retired and made exorbitant sums sitting on the boards of defense companies, or setting up lucrative Netflix deals, or signing contracts as cable news contributors in which they lecture others on democracy while making more in a month than he has in his entire retirement account. Like Lieutenant Colonel Scheller, our lieutenant colonel has reached his limit. But unlike Scheller, he isn't sitting behind his desk at Camp Lejeune when it happens. He is standing in front of one thousand frightened, confused and heavily armed Marines who trust him a lot more than those elites issuing their orders. When the order comes to clear out Lafayette Park, our lieutenant colonel refuses. And when he refuses, his Marines also refuse. In today's America, a soldier's loyalty to his general—or his colonel—might be a little understood as a political force, but it is a political force that as far back as the Roman legions has dissolved democracies.

Our lieutenant colonel doesn't simply refuse his orders. He goes a step further. He approaches the leaders of the protests in Lafayette Park. He believes that the protestors have a right to peacefully assemble, and he plans to secure that right. And so he asks the leaders of the protest, "Where would you like my Humvees?"

A Dangerous Desire to Do Right

The Democrats hail him as a hero (in the mold of Lieutenant Colonel Alexander Vindman) and call for other officers to refuse their orders. The right condemns him as a traitor (even though they were quick to laud Lieutenant Colonel Scheller) and call for his court martial. Our lieutenant colonel becomes a lightning rod, and his actions set off a chain reaction within the U.S. military. If Democrats and Republicans cannot agree on the legitimacy of the president, and if they are calling in the military to arbitrate this dispute, for those in uniform the very action of following an order now confers legitimacy on one side or another. Everyone who wears a uniform is being forced to choose. And they do, disastrously so, because when military members become partisans, they take their equipment with them.

That question, *Where would you like my Humvees?*, is one that every citizen should fear. If America ever did descend into another civil war, the weapons that would decide it are not sitting in the gun lockers of Oath Keepers or Antifa deadenders; they are sitting in the armories, the motor pools, and on the flight lines of hundreds of American military bases.

142

If the result of the above scenario sounds implausible, ask yourself whether any of the incremental steps do. We have seen violence in Lafayette Park reach levels of intensity that required the president's evacuation by the Secret Service to a secure bunker in the White House. We have seen our leaders contest the last two elections. Already both parties are laying the groundwork to contest the 2024 election with controversies surrounding voting rights. If another contested election leads to violence in America's streets, it is quite possible a presi-

dent of either party could evoke the Insurrection Act. Those troops would then have to face off with protestors. What would be the result?

After I served in Afghanistan and Iraq, I covered the war in Syria as a journalist. It is often forgotten that the refusal of Sunnis in the military to follow the orders of Bashar al-Assad was determinative in pushing that political crisis into a civil war. When the military there splintered, the defecting elements took their tanks, their guns, and their jets with them. Obviously we remain several steps removed from that sort of instability. But cautious speculation has its uses: it can be critical in heading off conflict, particularly as the forces our politicians are playing with couldn't be more combustible, and they are playing with these forces in the presence of two conditions that could cause events to spin out of their control.

The first of those conditions is the already discussed civil-military divide, particularly in the context of a lost war. Disillusionment and the veteran experience often attend one another. The end of a war — particularly a failed war — heightens these feelings of disillusionment. From George Washington (a major) to Mustafa Kemal Atatürk (a lieutenant colonel) to Napoleon Bonaparte (a second lieutenant) and Adolf Hitler (a corporal), these revolutionary figures all got their start in the army of the old regime and, at one point or another, could be categorized as disgruntled veterans. If revolutionary embers are blowing, a large contingent of disgruntled veterans represents a massive pile of kindling.

The second of those conditions are divergent realities — our grave nation-wide cognitive crisis. Today, according to Reuters, approximately a quarter of all Americans believe that Trump is the "true president." This is not only an ideological certainty; they are certain also about their facts. If you extrapo-

143

late that number to our military, it means roughly 345,000 men and women in uniform do not believe in the legitimacy of the current commander-in-chief. Whether those people are right or wrong doesn't matter. What matters, from the standpoint of social stability and social peace, is that they believe it.

A similar divergence existed in our last civil war, in which one half of the country believed the Constitution allowed for their secession from the Union while the other half of the country believed in preserving the Union at all costs. Indeed, the issue of secession and its legality was a widely debated issue in the decades leading up to the Civil War, a contested issue analogous to abortion or affirmative action today. David A. Strauss, a scholar of constitutional law, has observed that

> before the Civil War, there was a lively and inconclusive debate over whether the Constitution permitted states to secede. There is no longer any such debate; the issue was settled by the Civil War. No one today would seriously advance the position that the Constitution permits secession, at least the kind that the Confederacy attempted. Where is the text that settled his question? The answer, of course, is that this question, like other important constitutional questions, is decided by something other than text.

One reality triumphed over another, not because it was proven illegitimate in the minds of those who believed it, but because it was defeated on a battlefield. After the war, the mythmaking of the Lost Cause focused on certain aspects of the Southern cause (states' rights) over others (slavery), so much so that the term "states' rights" evolved into a racist provocation in subsequent fights against desegregation. Yet this doesn't change the

fact that many Southerners truly believed in the defeated view of reality. They believed that their first allegiance was to their state as opposed to the federal government, and that their state legislators had the right to secede; and if those duly elected legislators did secede, their obligation as southerners was to fight in defense of their state. The fact that neither side ever agreed (and in some cases continue to disagree) on what the war was fought about simply demonstrates why the war was fought in the first place.

Most famous among those who believed that his allegiance belonged to his state was Robert E. Lee. By the standards of that time, Lee enjoyed an impeccable reputation. In 1861, he was President Lincoln's first choice to command the Army of the Potomac, an appointment that Lee refused because, as explained in a letter written to his sister, he could not "raise my hand against my relatives, my children, my home." By the end of the war, in defeat, Lee's thinking had changed somewhat. In a letter written to President Andrew Johnson, requesting a pardon, Lee remarked: "True patriotism sometimes requires of men to act exactly contrary at one period, to that which it does at another, and the motive which impels them — the desire to do right — is precisely the same." Lee then evoked his great hero, George Washington. "At one time he fought against the French under Braddock, in the service of the King of Great Britain; at another, he fought with the French at Yorktown, under the orders of the Continental Congress of America, against him."

Those who would discount Lee's motives as malicious treason, or discount those who doubt the legitimacy of the last election as malicious perpetrators of "A Big Lie," create caricatures of their ideological counterpoints at the expense of understanding their worldview. It would be reckless to

145

discount that worldview, particularly if one wishes to triumph over it. It is a worldview sincerely held by one-quarter of our fellow citizens, many of whom serve in our military and have their own political values and passions, like all other citizens.

The threat the military represents to our democracy is not — as is too commonly asserted — a monolithic one, in which the military will act as an ideologically homogenous entity in accordance with the orders of its senior officers. The true threat from the military will occur as a consequence of a collapse of our politics, in which the legitimacy of the chain-of-command, from the president down, falls into question. We glimpsed this possibility in January 2021, when General Milley went outside his chain-of-command to assure China through backchannels that the election results would be honored despite President Trump's statements to the contrary, and that the military remained under steady control. Did such back-channeling make Milley a hero or a traitor? It depends on who you're asking.

If one-quarter of our military believes that the current president is illegitimate, it is entirely plausible that under certain conditions they, like Lee, might believe that "true patriotism" requires them to act against a president whose legitimacy is being questioned. The threat to the republic is not a military split between those who are on the right side of history and those who are on the wrong side. The true threat is a military whose ranks split between divergent realities, divergent facts, divergent public philosophies, in which those on either side — like Lee, or Grant, or Washington — are possessed by a dangerous "desire to do right."

JAMES WOLCOTT

And the Bleat Goes On

Wait long enough and every enjoyment is eventually placed on the altar, gussied up, and sanctified. Rock 'n' roll lyrics were once a readymade source of ridicule, regarded as gibberish written by and for bubblegum brains and blasting out of transistor radios to drive mom and dad mad. The late-night television host Steve Allen, equipped with Clark Kent glasses and a quipster's fast draw, did a routine where he read aloud the lyrics of a popular pop song as if performing a poem at the 92Y in full authorial pomp. Most of the kinescopes from his show have been lost in the ghostly landfill of time, but Allen's goof on Gene Vincent's "Be Bop a Lula" circa 1956 somehow survives

on YouTube, as Allen invites the studio audience and viewers at home to drink in the song's simple beauty: "Be bop a lula, be my baby/bop a lula...I don't mean maybe." It was all in the timing, and Allen knew just when to pause for pregnant effect.

Allen, a classic postwar liberal who jousted with William F. Buckley, Jr. on *Firing Line,* didn't harbor hostility toward rock and roll, even though he was much more of a piano-tickling jazz guy; he was simply making sport of its conventions, much as he mimicked the hothead apoplexy of newspaper letters to the editor, and most of us wisenheimers who grew up with *Mad* magazine went along with the gag. But there were others watching in the cavernous dark of rec rooms across the land who took rock and roll more seriously, more protectively, and resented its being picked on. Allen's mock-mimicry lodged in their craws as Exhibit 1 of the adult condescension toward the passionate, unfettered joy of rock and roll. These old gassers just didn't get it! Rock and roll, it was righteously felt, would have the final say and the last laugh. Demographics were on its side. On *our* side, if you were a teenage baby boomer ready to stampede into tomorrow.

It took awhile, but a counterblow was struck. It seemed a soft counterblow at the time, not a ringing manifesto, but it resonated nevertheless. In 1969, the pioneer pop journalist Richard Goldstein edited an anthology titled *The Poetry of Rock*, a choice floral arrangement of rock and folk-rock lyrics that was published as a slim Bantam Books paperback that fit neatly into a jeans pocket or a small purse, like Kahlil Gibran's *The Prophet,* only groovier; it was the perfect everyday companion for English majors, pop fans, and studious aspiring songwriters of a sensitive nature, a sizable cohort back then. Goldstein had been miffed by Allen's professorial buffoonery — "I recall being pretty pissed off with Steverino

then for his dishonest presentation of rock," he states in the introduction — and here was the rebuttal. "I do not claim that these selections constitute a body of 'undiscovered' poetry. This is no pop-Ossian. But I do assert that there is an immense awareness of language, and a profound sense of rhythm."

The timing of *The Poetry of Rock* couldn't have been more propitious. By 1969, rock had largely lost its "and roll" and strengthened into a four-letter word of cultural prowess, a raised fist demanding to be reckoned with. Essays such as Richard Poirier's controversial "Learning from the Beatles" in *Partisan Review* in 1967 and Albert Goldman's reveille call "The Emergence of Rock" in *New American Review* in 1968 had elevated the status of rock, and the first ponderous stirrings of Dylanology rumbled through the forests, thickening in time into an academic industry. Woodstock Nation had become a kingdom of the imagination, a muddy, momentary Camelot. Although undertaken in an underdog spirit, *The Poetry of Rock* spoke to the cresting countercultural moment and went into multiple printings, earning a spot in the pop-studies curric- ulum and pride of place on countless dorm room bookshelves next to *Stranger in a Strange Land* and *The Harrad Experiment*.

Thumbing through *The Poetry of Rock* today makes for a wistful ride in the wayback machine, the book's graphics and fonts a garden of hippie nostalgia, its contents a reminder of how prophetic Goldstein's anthology choices were. From Chuck Berry, "America's first rock poet," the father of us all who "sang about an America of pure motion and energy" ("In a Chuck Berry song, you couldn't tell the girls from the cars, and some of the best marriages ended up in traffic court"), to the flossier troubadours, social prophets, flower-power bards, and asphalt-jungle serenaders represented here, a pantheon takes shape. Each inductee benefits from Goldstein's

149

elegant inscriptions — deft, evocative, and seldom guilty of over-salesmanship. "The Supremes sing like satin," he writes in the citation for Holland, Dozier, Holland's "Baby Love": "The lines move in even strokes, like a pendulum. You can sense the ebb and flow of feminine hips behind that gently rocking refrain." He catches the inherent contradiction of the Rolling Stones' "Lady Jane," "a chivalric ode against a tinkling dulcimer" that is sung (tongued?) by Mick Jagger with his usual lewd larceny. He's also quite sharp on how Lennon-Mc-Cartney contrive an enigmatic vignette out of the snug nest of "Norwegian Wood."

Fittingly, *The Poetry of Rock* finishes its survey of the hidden subtleties of the hit parade with a peer into the abyss titled "The End," the nightscape tour guided by Jim Morrison, lead singer of The Doors, Lizard King, and leather-sheathed shaman whose musky voice seemed to resonate from his majestic crotch with a swell of reverb echo. Not everyone was captivated by his charismatic ooga-booga. "Jim Morrison sounds like an asshole," decreed Robert Christgau, the Dean of American Rock Critics, who recently celebrated his eightieth birthday. Christgau also deemed Jimbo a bad poet, and it's hard to disagree when he cites pearls such as "We need great golden copulations" and "Death and my cock are the world." Yet the Morrison mystique endures a half century after his death, and not only because of the erotic, vampiric aura of his persona that would inspire the classic *Rolling Stone* cover line "He's hot, he's sexy, and he's dead."

It also endures due to what one might dub the Rimbaud Factor, the proto-myth of the poet as a young, incandescent, self-destructive, genius-propelled comet of orphic utterance — a Romantic hand-me-down from the revolutionary age of Shelley-Keats-Byron. Born in 1854, Arthur Rimbaud was the

precocious rebel who joined the Paris Commune at the age of sixteen, flipped the table on French Letters with *Illuminations* and *A Season in Hell*, was shot by his fellow poet and lover Paul Verlaine (a bromance gone bad), and, trading in a life of words for the pursuit of money, action, and exotic locales, shipped off to Africa to seek his fortune as a mercenary and a gun-runner. Considering the embroilments that followed, he should have stuck to *vers libre*. But had he done so, he wouldn't have become the live-fast, die-young aspirational/inspirational legend and action figure, a category in America that had been reserved for the likes of Billy the Kid and James Dean until rock matured enough to erect shrines for its early departed.

Bob Dylan admitted in his memoirs that reading Rimbaud as a teenager rang his bells, but apart from a close call with a motorcycle accident that temporarily took him out of circulation, it was clear that Dylan was a long-hauler for whom death and Dionysus held no siren allure. Morrison, however, consciously modeled himself on the human cannonball side of Rimbaud, busting through the doors of perception to pursue "the derangement of all the senses" through the heavy bombardment of music, movies, drugs, sex, poetry, and incantation. It's a lot to take on, even without the police looking for any excuse to arrest you for public indecency and the music press beginning to snarl, and Morrison beat a strategic retreat that turned out to be fatal. Like Rimbaud radically uprooting himself from the literary soil, Morrison removed himself from the fame and clamor of the rock scene and shifted to Paris in 1971, dying under murky circumstances in a bathtub of a probable heroin overdose at the age of 27. Morrison's grave at Pere Lachaise cemetery became a pilgrimage site for hordes of Americans paying homage, including Patti Smith, another Rimbaudian on a mission.

The publication history of Morrison's poetry, prose poetry, and spoken word seances set the template for the posthumous engorgement that has become more the norm for lyrics collections. The first books, *The Lords — Notes on Vision* and *The New Creatures*, were self-published, small press titles later incorporated into one volume by Simon and Schuster that tallied a tidy 144 pages. A third, *An American Prayer*, was also published in his lifetime. The death-cult industry and discipleship demanded more and, augmenting the memoirs, reconsiderations, documentaries, and movie biopics (*The Doors*, directed by Oliver Stone at his most Oliver Stone-ish), were additional troves of poems, aphorisms, transcripts, and unfinished projects that stuffed the turkeys of the two-volume *Lost Writings of Jim Morrison: Wilderness* in 1988 and *The American Night* in 1990. But too much is never enough, not when the faithful and famished cry out for more, and in 2021 up from the catacombs rose *The Collected Works of Jim Morrison: Poetry, Journals, Transcripts, and Lyrics*, a multimedia compendium that included family photographs, a full-sized reproduction of his Paris notebook, the shooting script for a never-released film, and a recording of his final poetry reading, along with audio renditions of Morrison's work by Patti Smith, Tom Robbins, and Liz Phair. The only thing missing was a shroud bearing His image which glowed in the dark.

The *Collected Works* were touted by the publisher as "immersive," but immersion is a dicey proposition. It can do a disservice to the artist undergoing preservation, blurring and burying the original bold strokes — the signature moves — under a grainy mass of bone fragments, nail parings, napkin scribbles, false starts, fizzled experiments, and memorializing blab. (As Wilfrid Sheed wrote of James Agee, this scavenging represents the quest to find the hidden clinching evidence of

Greatness: the missing sonnet.) Distance enables us to see and hear and mentally frame more clearly than an archival tour of the mothership. I grew up with The Doors. Their first two albums were long drives into the night with laconic touches, and nearly everything that came after was blubber and drift. The bluesier Morrison tried to be, the blowsier he looked and sounded, and his poetic scratchings were a hit and miss proposition where the misses prevailed. The *Lost Writings* bear this out.

This is the curse of completism: the a-critical desire to leave no scrap behind, so as to enable the construction of a sacred grotto or shiny monolith that can sink under the density of its own motley debris. It's especially perilous for the reputation of an *enfant terrible* who outlives the outrage stage and spends decades professionally releasing product to keep the name and brand solvent: too much incriminating evidence is left behind. Lou Reed, a student and protegé of the brilliant, bedeviled poet, critic, and fiction writer Delmore Schwartz, first made his scowling mark as the lead singer and songwriter of the Velvet Underground (the house band of Andy Warhol's Exploding Plastic Inevitable), introducing a street argot, caustic sneer, and gender-bending insouciance into rock lyrics that established the unbeatable standard of New York snottiness, a source of municipal pride. The snottiness became less of a signature trait with the passing years, especially after Reed romantically partnered with choppy-haired multimedia spellbinder Laurie Anderson; he practiced tai chi and dined at macrobiotic restaurants without ever being credibly accused of turning mellow. When Reed died in 2013 he had become a crusty institution, the Harry Dean Stanton of gravelly gravitas, and many New Yorkers were taken aback by how deeply they mourned.

Reed himself was too cantankerous to be canonized, but his oeuvre could be propped up for posterity. Posthumously updated from an out-of-print edition, *I'll Be Your Mirror: The Collected Lyrics of Lou Reed* has an authoritative heft and imprimatur. Six-hundred-and-seventy-nine pages thick, it houses an ample apparatus: a preface from the oracle himself; introductions by Martin Scorsese (who divulges that Lou auditioned for the role of Pontius Pilate in *The Last Temptation of Christ* — now *that* would have been a trip) and the critic and biographer of Delmore Schwartz, James Atlas; remembrances from guitarist Nils Lofgren and Laurie Anderson; and a comprehensive discography. The lyrics of the gritty ditties and croonier tunes from the early albums are here — *"Walk on the Wild Side," "Sister Ray," "White Light/ White Heat," "Pale Blue Eyes," "Sweet Jane," "Rock 'n' Roll"* (with its inspired rhyming of "computations" and "amputations") — and somehow manage to maintain their identity and integrity despite the accumulative tonnage of dreck, filler, dopey sentiments ("I found a reason to keep living, and the reason dear is you"), dippy rhymes ("You scream, I steam, we all want Egg Cream"), body-horror frissons ("Pus runs through matted hair"), dubious provocations (such as "I Wanna Be Black," whose white-bread narrator wants to have natural rhythm and shoot twenty feet of jism), florid theatricals (dozens of pages expended on Reed's Edgar Allan Poe tribute "The Raven," with its promise of "No Nosferatu, Vincent Price or naked women here..."), and an appendix of Miscellaneous Songs that includes an ode to "Gravity," which, get this, is "pullin' us down."

All this fodder and more, and for *what*, for *what*? It doesn't do Reed any good, piling everything in. Lyrics reclining flat on the page can't compete with the Lou-ster trotting them through their paces to the squall of guitars and the drone

of former bandmate John Cale's viola, and Reed's vocals themselves dwell in a lesser dimension than the monochromatic hypnotics of the Velvets' chanteuse and unholy ghost, Nico. Reed may have written the words to "I'll Be Your Mirror," but Nico's interstellar transmission made the song forever hers. And who other than Nico could have made "All Tomorrow's Parties" sound ominously near to a battle march?

Even with musical stars who began as poets, such as Patti Smith and Leonard Cohen, the initial words on the page usually become superseded by the husky voice in the microphone and put into harness, becoming part of the soundtracks in our heads. I first came across Patti (forgive the familiarity but we intersected too often at CBGB's for formal pretense) through her poetry chapbooks that could be found at St. Mark's Bookstore or prominently placed next to the cash register at Gotham Book Mart, alongside Henry Miller's *The Death of Mishima* and numerous Edward Goreys. *Seventh Heaven*, that one I still have. Also *WITT*, whose cover photo featured Patti at her most Falconetti-ish. I have both the American and French editions of *The Night*, her poetic duet with Television's Tom Verlaine (her former boyfriend, who took his last name from Rimbaud's volatile sidekick), which might bring me a sweet return on eBay if I were ever in a financial pinch or simply mercenary. These handy little bibles carry flashback associations for me (St. Marks Church poetry readings, Anne Waldman standing on one leg like a stork as she chants her poems, Allen Ginsberg plodding the East Village), lines that still reignite, intimations of future glory — unlike when I behold the handsome paperback of *Patti Smith: Collected Lyrics 1970-2015*, which enscrolls the lyrics to *Horses*, *Radio Ethiopia*, and subsequent Patti Smith Group albums. It's a more austere collection than Lou Reed's catch-all,

yet likewise directed at the already devoted — the Church of Patti, for whom *Just Kids* is scripture. It's difficult to imagine anyone picking up this book on impulse — the literary world has been impoverished by the lack of impulse buys — and getting zapped by a rogue stanza, ready to run off and seek fresh possibilities. The song lyrics to *Horses* etc., like so many rock lyrics, seem "poetic" without actually being poetry, too proclamatory to insinuate themselves like a private communication. When she sings "Pissin' in the river / watchin' it rise," we wonder and worry how full Patti's bladder might be.

Not every rock lyric collection functions as a hymnal. Some serve as songbook memoir (see the Foo Fighters' chief pilot Dave Grohl's recent *The Storyteller: Tales of Life and Music*) and/or showbiz seminar, a tradition that goes back to the songwriting team of Betty Comden and Adolph Green recounting the backstories and performing their most beloved Broadway show tunes. The late super-syllabic musical theater marvel Stephen Sondheim elevated this approach into a masterclass, presenting a guided tour of his wizard's workshop with *Finishing the Hat and Look, I Made a Hat*. The Sondheim duo, collected in a slipcase edition titled Hat Box, may have supplied the inspiration for the blockbuster, best-selling double whammy of *Paul McCartney: The Lyrics*, edited with an introduction by the poet Paul Muldoon, its volumes split alphabetically from A-K and L-Z, and weighing in at 8.6 pounds, a few ounces heavier than Hat Box. Together, they'd make a swell pair of yoga blocks.

It is a measure of the bountiful good will that McCartney has accrued for over half a century that the size, extravagance, and aggrandizement of *The Lyrics* are not seen as an expression of ego but a gesture of generosity: fan-service on a galactic level. It's a charm offensive from a performer whose charm

bears a Cary Grant stamp of eternal youth. Open up either volume at any page and the factory showroom new-book smell welcomes you like an old friend. McCartney's gregarious reminiscences of how the songs were stitched together or spontaneously took wing are full of mundanities and memorabilia — references to Nivea cold cream and crystal radio sets in the gloss on "Eleanor Rigby" — that remind us how even in the mod brashness of the Swinging Sixties, Beatles music was ingrained with filmy nostalgia, gray weather, and an almost Dickensenian domesticity. Alternating with the pull into the past of "Penny Lane" and "Strawberry Fields Forever" was an antic absurdism inspired by Lewis Carroll, Edward Lear, the Goon Show (Spike Milligan, Peter Sellers, et al.), and Peter Cook that found its way even into a hoarse-shouting, high velocity guitar-grinder like "Helter Skelter," whose lyrics were based on the Mock Turtle's song from *Alice in Wonderland* and subjected to woeful misinterpretation by Charles Manson. Most of McCartney's post-Beatle output has the peppy tunefulness of cheerful busywork, but it seems churlish to expect more from pop's roving ambassador of good vibes.

As poetry, most of McCartney's lyrics wouldn't survive serious examination — as when he compares "distractions" to butterflies buzzing round his head (ahem, butterflies don't buzz), or rhymes "neurosurgeon" with "nothing urgent" (egad) in "Temporary Secretary" — but as a boomer artifact the double volume brings us full circle to Goldstein's *The Poetry of Rock*. Here, too, Chuck Berry is hailed as a poet for whom the automobile was the all-American freedom chariot, love wagon, and status machine. "I know there's a theory that rock and roll couldn't have existed without the guitars of Leo Fender, but it probably couldn't have existed without Henry Ford either. I'm thinking of the relationship between the motorcar and

what happens in the back seat. We know that people shagged before the motorcar, but the motorcar gave the erotic a whole new lease on life. Think of Chuck Berry 'riding along in my automobile.' Chuck is one of America's great poets." The success of McCartney's *The Lyrics* has prepared the runway for the upcoming publication of *Lyrics* by Bryan Ferry, the lead singer and finger-snapper of Roxy Music and *Wading in Waist-High Water: The Lyrics of Fleet Foxes*, the latter an indie folk band with a complicated history that needn't detain us. Where it will all end, knows only God.

Of course, the greatest vindication of Goldstein's crusade to crown rock lyrics with laurel was the awarding of the Nobel Prize in Literature in 2016 to Bob Dylan, who reacted with his usual hazy aplomb, bless him. To many high-minded kibbitzers, this honor was the final rude slap to the face of Philip Roth's Nobel hopes, but an equally strong case could be made that Leonard Cohen was the more deserving candidate if the druids of Stockholm were determined to anoint a cross-pollinating itinerant entertainer: a genuine poet, meticulous songwriter, elegiac novelist, thinking person's sex symbol, and every inch the craggy Jewish sage and dharma bum Dylan is. The compact Everyman edition of Cohen's poems can be read as a thing unto itself, whereas a dutiful slog through the 688 pages of Dylan's *The Lyrics: 1962-2012* (which leaves another decade of new material yet to be gathered from the hayloft) at best re-acquaints you with the live-wire magpie modernist phrases and *Waste Land* imagery of his first electric *Bringing It All Back Home/Highway 61 Revisited/Blonde on Blonde* glory run, where the amphetamine rush of the words were lashed to "that thin, wild mercury sound" achieved in the studio.

As poetry, Dylan's songs don't repay scrutiny; their effects are mostly wrought from the musical and nasal delivery, his

coyote cunning. When Dylan salutes the outlaw John Wesley Harding for traveling "with a gun in every hand," you wonder: what is he, an octopus? How many hands does he have? And you could butter your biscuits with the cornball platitudes of *Nashville Skyline*. It's unlikely Dylan will be read in the future as a poet, but he will be studied as an epic phenomenon, a traveling medicine man embodying and enriching the American mythos on the last legs of its Whitmanesque voyage. It's a testament to his tireless, restless nature and vocation that in November he will bestow upon us a treatise titled *The Philosophy of Modern Song*, or as I prefer to think of it, *Bob Dylan's Guide on How to Write Songs Real Good*. In it he intends to lift up the hood of songwriting and show us the nuts and bolts of songwriting, the tinkering required to get things right. Beaming from the cover of Dylan's book in all of his pomaded radiance is the now deceased, eternally irrepressible Little Richard, the lyrics of whose "Long Tall Sally" can found on page 21 of *The Poetry of Rock*. If all of this smacks of ancestor worship, well, why not? Respect your elders, kids, and someday you too may be immortal.

WILLIAM DERESIEWICZ

Soul-Making Studies

I'll admit to being biased here. Teaching a great books course at Columbia — I was a graduate student, my charges were freshmen — was the pedagogical experience of my life. I was never the same again, and I know that many of my students also weren't, because they told me so, and because, decades later, some of them still tell me so. It confirmed me as a convert to the mission: to great books courses in particular, and to the humanities in general, as unique and indispensable parts of the undergraduate experience.

So when that mission is attacked — or defended particularly well — I tend to pay attention. Lately, it's been both.

Last fall, Roosevelt Montás, a senior lecturer at Columbia and former director of its Center for the Core Curriculum, published *Rescuing Socrates*, a beautiful, powerful, personal argument on behalf of great books programs. Together with another book, *The Lives of Literature* by Arnold Weinstein, a senior professor at Brown, *Rescuing Socrates* elicited a rebuttal — in the scornful, condescending tone he takes on such occasions — from none other than Louis Menand. Menand is a professor at Harvard. It has long been fashionable, among a certain kind of wised-up academic, to dismiss the humanistic enterprise as hopelessly naïve and retrograde. Such is also the case with another recent book, *Permanent Crisis: The Humanities in a Disenchanted Age*, by Paul Reitter and Chad Wellmon, professors of Germanic studies at Ohio State and the University of Virginia respectively. The authors describe the development of what we now call the humanities (as an idea, an ideal, and an institutional structure) across the German nineteenth century, with inroads into the American twentieth. But their attitude toward that ideal — the belief that the humanities can play a unique role in the moral development of young adults — is much like Menand's: sneering, patronizing, and contemptuous.

Before we get into the meat of this, a few disclaimers. I figure myself in both critiques. Menand lists my book *Excellent Sheep*, from 2014, in a roster of similar (and, in his view, similarly misconceived) polemics. Menand, I should say, is a writer I have long admired, so much so that I have asked him more than once to blurb my books. He has demurred, which in retrospect is just as well. For as long as I've admired him, I've also been infuriated by him. He is as clever a critic as they come, with an elegant wit and a bloodhound's nose for humbug. But he also exemplifies Wilde's definition of a cynic.

If I were asked to edit a selection of his work, I would call it *The Price of Everything*. As for Reitter and Wellmon, I appear in their volume, along with Nietzsche, Dilthey, Edward Said, Andrew Delbanco, and others, as a "melancholy mandarin" (although I am neither), one of the nostalgic fools who actually believes in the humanities' transformative potential. If the authors understand the other targets of their inquiry as badly as they do my work, their book is worthless. But to give them the benefit of the doubt — they seem more careful when it comes to their principal areas of concern — they do appear to be a useful pair of guides to the historical dimensions of the issue.

What is that history? It is one of discontent, on the part of certain scholars (by no means all of them in the humanities), with the direction of their institutions: their perception that the modern university, especially with respect to its teaching of undergraduates, is excessively utilitarian in its approach — overly specialized, narrowly practical, subservient to market values — and that it is therefore failing to discharge a crucial spiritual obligation. "Professors have been making the same complaints," writes Menand, "ever since the American research university came into being, in the late nineteenth century." In fact, as Reitter and Wellmon show, the words "American" and "late" can be deleted from that formulation. The criticism dates to the beginning of the modern university, circa 1810, in Prussia.

For Reitter and Wellmon, as for Menand, that very persistence negates it ("it's a song that never ends," Menand writes), as if the duration of a problem were a brief against its existence. But the criticism persists because the problem is structural. "The conflict these professors are experiencing between their educational ideals and the priorities of their institutions," Menand writes of Montás and Weinstein,

"is baked into the system." Indeed it is, but that is not, as he intends, a strike against them. It is precisely the point. The modern university came into being under the banner of *Wissenschaft*, to use the German term: systematic empirical research and scholarship, conducted by specialists trained in one or another of an emerging set of academic disciplines — philology, history, chemistry, physics. The word for that in English, before its meaning became restricted to a specific branch of *Wissenschaft*, was "science." The modern university, as it is often said, is a "knowledge factory," supplying that essential raw material for modern industry and modern states, enhancing the profits of the one and the power of the other, and it is on that basis that it has secured its lofty levels of prestige and funding.

Wissenschaft in all its dimensions — the investigation of reality — is a noble and magnificent endeavor, and its results represent the greatest intellectual achievement (one of the greatest achievements, full stop) in human history. But something, some have always felt, went missing in the enterprise. For universities are not just centers of research. They also teach and, in particular, teach undergraduates. In this they inherit the role of the institutions from which they emerged: in Europe, the pre-modern universities, with their feet in the Middle Ages; in America, the early colleges, which were largely church-affiliated institutions. Both understood their mission, at its core, in moral terms: to inculcate virtue, to shape character, to produce men, or gentlemen, of cultivation.

So what would become of that mission? From the beginning, it was recognized that disciplinary study alone would not be adequate to discharge it — indeed, that the two were, if not incompatible, then utterly distinct. Some of the more research-forward institutions sought to exclude

undergraduates altogether. Such was the initial vision for Johns Hopkins, which was founded in 1876 as the first American university on the German model. In 1889, Frederick A. P. Barnard, the president of Columbia, a school that was then in the process of rapid divisional expansion, proposed abolishing its college. But there and elsewhere, the two halves of this schizophrenic arrangement — call it the college mission and the university mission — remained uneasily conjoined. Institutions, in addition to conducting research, would train undergraduates in the new scientific learning, preparing them for careers as professionals, as experts and technocrats, as doctors, lawyers, scientists, and engineers, as academics themselves, and then — then there was this other thing.

What was that other thing, that something some have felt went missing in the research model? It has traveled under many names. The Germans called it *Bildung*, a term with a notorious plurality of definitions: formation, self-cultivation, education as opposed to training. John Erskine, the Columbia professor who, in 1920, taught the first (elective) great books course, spoke of "intelligence," conceiving it as something one developed — a broader awareness that saved one from becoming, in Saul Bellow's later phrase, a "high-I.Q. moron." Many have understood this desideratum in holistic terms, as the imperative to educate the "whole person" for the "whole of life." The Yale Report of 1828, a signal document in the history of American higher education, speaks of bringing all a student's powers into play: imagination, taste, creativity, judgment, as well as reason and memory. "A man is [not] to be usurped by his profession," wrote John Henry Newman in *The Idea of a*

University in 1852. He has roles to play "as a friend, as a companion, as a citizen at large; in the connections of domestic life." The end of undergraduate study, Newman said, "is fitness for the world."

The methods to achieve that end have also traveled under different names: liberal education, general education, core curricula, great books courses, the humanities. In earlier generations, as Reitter and Wellmon explain, such endeavors were conceived in normative terms. Students were to be instilled with a specific set of virtues, deriving from Christianity and the classical world. They were to be inducted into an appreciation of the "timeless truths" embodied by the Western tradition. They were to be instructed in the nature of the good life.

But no one has thought that way for a very long time. In a pluralistic world, where values clash with values, the goal is understood to be the development of a student's ability to question and examine values, especially such values as they bring with them to campus, to reach their own determination as to what is good, true, beautiful, just. And to reach it not just once, but in an ongoing way, across the whole of life, as experience reshapes their understanding of the world and of themselves. That is what Socrates meant by the examined life, which was, for him, the only one worth living. "A liberal education," Montás writes, "lives in the questions, not in the answers." And, especially for college students, about to set out on their road, those questions, as he says, boil down to one: "What is worth striving for?" What should I do with my one precious life, so that I do not waste it? A college education should be practical — it should provide you with the means to achieve your ends — but it also must be liberal. It must equip you with the ability to discover what those ends are in the first place. "Liberal" education means the kind of education that is

appropriate for free people. It is a preparation in making the best use of one's liberty.

But Menand will have none of this:

> If, as these authors insist, education is about self-knowledge and the nature of the good, what are those things supposed to look like? How do we know them when we get there? What does it mean to be human? What exactly is the good life?

> Oh, they can't say. The whole business is ineffable. We should know better than to expect answers.

I don't know whom to feel more sorry for, Menand or his students. Is he really so shallow? Are they really so sure of what they want out of life? Well, he teaches at Harvard, so maybe they are. When, at an event there many years ago, I suggested that college students need to keep examining their decisions, that now was the time to take a breath and think about what they really wanted out of life, one student said, "We already made our decisions back in middle school, when we decided to be the kind of high achievers who get into Harvard."

Okay. But not everyone is so serene in their acceptance of the dictates of their twelve-year-old self, and of the social and parental pressures that produced them. The only reason I have thrown myself into these matters is that I saw so many of my students floundering at Yale — not because they couldn't do the work, but because they could no longer remember why they were doing it. Like Wile E. Coyote pedaling furiously in thin air, they had finally looked down. And looking down, they had plummeted: into confusion, into depression, into despair. And not just them, but the hundreds of students and

recent graduates, from across the country and around the world, who have written to tell me the same. That they had been sold a bill of goods. That success had not turned out to fill their souls.

In *Quarterlife: The Search for Self in Early Adulthood*, the psychotherapist Satya Byock explains that a healthy adulthood rests on the twin pillars of stability and meaning. These map precisely onto the practical and liberal aspects of a college education. Meaning, as I understand it, denotes the feeling of being connected to something larger than yourself: a community, an ideal, a tradition, a cause — a purpose. It means feeling connected to yourself: feeling, as Byock says, that your outer life is a manifestation of your inner life — that you are living a life, as I would say, that feels like it belongs to you, a life in which you recognize yourself. When that feeling goes missing, you might end up in Byock's consulting room, or my inbox. And by then, things have usually gotten pretty bad. It is all well to pooh-pooh self-knowledge and the question of the good, to scoff at words like "spiritual" (by which I mean the dimension of life that is concerned with meaning) and "soul" (by which I mean the part of ourselves, or the sense of ourselves, that feels the need for meaning), but it turns out that we cannot do without them.

So why are the humanities, and in particular the great books, so important for all of this? The first thing to say is that they are not necessarily so important. Plenty of people find their way to meaning without ever studying the humanities or reading the great books — in many cases, because they never went to college. But we are talking about people who *are* going to

167

college. They got there in the first place by jumping through an endless series of hoops, and they are still jumping. They are majoring (often double-majoring) in economics or business or computer science or biology; they are bulking up their resumes by running frantically among their internships and extracurricular activities; they are self-medicating with their screens, or their meds, or their drunken hook-ups, or all of the above. But they are also on the cusp of young adulthood, the stage at which it's most important to ponder questions of value and purpose. And they aren't getting a lot of opportunity, to put it mildly, to do so.

That is where the humanities come in. The humanities deal with questions of value, as the sciences (by which I also mean the social sciences) do not. Philosophy takes up such questions directly. Literature does so indirectly, by instantiating them in stories, which are records of the choices of imaginary people — a set, as it were, of moral hypotheses. What is justice, Plato asks? What does liberty consist in, Mill wants to know, and why is it important? Achilles chooses between a life that is glorious but brief and one that is long but obscure — though, in the end, the question collapses in the face of the death of his friend, of the love he has for him and the duty of revenge he thinks he owes him.

To put the matter differently, the distinction between the sciences and humanities, for college students, is exactly one of means versus ends. Science equips you with means, with tools to operate in the world. When the humanities attempt to justify themselves with reference to means, as they tend to do today (we teach you to think analytically, we teach you to communicate), they end up looking foolish, because there's little in that line that cannot be acquired in the other disciplines, but more to the point, because the argument buries

168

the lead. The unique and essential value of the humanities, as a subject of college instruction, is that they furnish an arena in which to reflect upon ends, for that is what they do themselves. You can use an equation to build a spaceship, but what can you do with a poem? Only change your life.

I say all this with no prejudice against science, nor in entire ignorance of it. Yes, I was an English professor, but in college I majored in biology-psychology. I took two courses in math, two in physics, four in chemistry, four in biology, and six in psychology, mostly of the "hard" or physiological kind. I also grew up in a scientific family. My father was a professor of engineering; my older brother, a research physician. So I have a fairly good idea of what science is about, and a very good idea of what goes on in an undergraduate science classroom. What goes on is exactly what should: an education in the findings and procedures of empirical research — in facts and the establishment of facts. Facts: not values. Questions of value have no place in the conduct of science as such. Indeed, the scientific disciplines established themselves on the basis of that exact exclusion, that exact distinction. Even a discussion of the values that science embodies and, still more, of the uses to which it should be put, has no place, strictly speaking, in the conduct of science. Physics tells you how to build an atom bomb, but it cannot tell you if you should. Economics teaches you how money works, but it cannot teach you what you ought to do with it. Such questions can't be answered scientifically, precisely because they deal with values — with choices — not facts.

There is another distinction that is crucial to the special role of the humanities in the undergraduate experience. The humanities are personal. I don't mean that students can't have personal feelings about the material they study in ecology or

169

sociology. But the material doesn't have personal feelings about them. It isn't pointed at them. But Socrates, Emerson, Rousseau, or again, Euripides, Tolstoy, Dante: they grab you by the lapels. They ask you, is it well with you? Or, as Lionel Trilling put it, are you content with yourself? Are you saved or damned? Reitter and Wellmon imagine that the proponents of the humanities believe the latter "offer moral succor." That is pretty much the opposite of what they offer. "I bring not peace but the sword," said Jesus. "I am not a man," said Nietzsche, "I am dynamite."

The humanities are personal, and the response to them is personal as well. Mark Edmundson, who has written more incisively about this process than just about anyone, speaks of "the incessant labor of combining your own experience, taken in and metabolized by intense feeling and thought, with what you have acquired in books." The movement is dialectical: you think, or think-feel, from your life to the books and the books to your life, each illuminating the other. To study the humanities, in other words — to study them properly — is itself to undergo an experience. Again, this is not a claim that one would make about calculus or anthropology, where the goal of study is confined to comprehension, the absorption of knowledge and method. In *The Last Days of Roger Federer*, Geoff Dyer has a paragraph that draws the distinction nicely:

> In 1910, at the age of twenty-one, de Chirico wrote to a friend, "I am the only man to have truly understood Nietzsche — all of my work demonstrates this." The claim to exclusive comprehension is something all readers of Nietzsche will recognize....If you don't feel this way you haven't experienced Nietzsche at all; you've only studied him.

But this idea, too, Menand cannot abide (or comprehend):

> "The value of the thing," Montás explains, about liberal education, "cannot be extracted and delivered apart from the experience of the thing."…It all sounds a lot like "Trust us. We can't explain it, but we know what we're doing."

My father had the same objection, though he at least had the excuse that he was a professor of engineering, not English. He was skeptical about the value of fiction — which, after all, contains no information. "You'll have to sit me down with pencil and paper someday," he said to me once, "and explain to me what this is all about." I couldn't, I told him. You have to see for yourself, and once you had, you wouldn't need me to explain it.

From the beginning, great books courses have been subject to the charge of dilettantism — on the part of students, but, even more, on the part of instructors. Such courses typically cover an enormous range of works, from the Greeks to the present or near-present: Homer to Joyce or Woolf or Toni Morrison, Plato to Freud or Fanon or Foucault. But no one is an expert in more than a few of those works. Or, as Menand puts it, "Why should an English professor who got his degree with a dissertation on the American Transcendentalists (as Montás did), and who doesn't read Italian or know anything about medieval Christianity, teach Dante?" Because you don't teach these works as a specialist, in a great books course; you teach them as a fellow seeker. Montás teaches Gandhi, who asks, in his *Autobi-*

ography, "How heavy is the toll of sins and wrongs that wealth, power and prestige exact from man?" "I cannot read Gandhi," Montás comments, "without asking that question not of humanity in general but of the particular human that I am." And if you aren't a fellow seeker, if such questions aren't alive to you, you have no business teaching such a course.

Indeed, the specialist's approach is exactly the wrong one to take. I taught Columbia's core literature course, familiarly known as Lit Hum, for two years, then a departmental version of the same kind of course for seven semesters at Yale. My academic work was in Jane Austen, and *Pride and Prejudice* was always my weakest book, precisely because I could no longer see it as an ordinary reader, could not resist the urge to interpose my learning between my students and the text. One of the goals in a great books course is to make your students into lifelong readers, to empower them to approach the classics, in the future, on their own. The idea that you can't gain access to the *Inferno* without a doctorate in medieval literature is exactly the wrong kind of message to send.

This is not to say that teachers should be ignorant. Every time I taught these courses, I read around in secondary texts, to continue to refresh my understanding. I discussed the books with fellow instructors, often in the context of regular staff meetings. In the Lit Hum program, section leaders meet for weekly talks by specialists. But, ultimately, my value as a teacher rested on my experience as a reader.

My experience, but also my expertise. For I do believe such courses must be rigorous. "The instructor's job," Menand contemptuously writes, "is not to give the students a more informed understanding of the texts, or to train them in methods of interpretation," but "to help the students relate the texts to their own lives." This is precisely the wrong approach,

though it is, alas, a common one. It is the kind of approach that often gives these courses a bad name — that turns them into, as one of my Lit Hum students put it, in reference to the sections that her friends were taking, "group therapy." By the end of the first semester, she told me, her roommate had taken all of two pages of notes, to my student's thirty-six. Because training my students in methods of interpretation is exactly what I sought to do. Literature, like all art, creates meaning through form. You can't relate a text to your own life unless you have a sense of what it means, and you cannot have a sense of what it means unless you can interpret form.

So when I taught the *Odyssey*, I didn't ask my students whether they could "relate" to Odysseus (or Telemachus, or Penelope), or whether they had gone on any "odysseys" themselves. I wasn't happy if I simply "got them talking" ("shar[ing] their responses with their peers," as Menand puts it). I asked them questions such as: Why, in the poem that bears his name, does Odysseus not appear until Book Five? Why do we so often find him sitting on thresholds? What is the function of the story of the scar? How does the poem respond to the *Iliad* (which they had just read)? And so forth. The "relating" part I knew that they would do themselves — though it isn't so much relating as a kind of fertilization, where the works compost down in your consciousness, to nourish revelations. The great books are great because their power is inescapable. The teacher's job is to unlock it.

The other common charge against great books courses, as everybody knows (it is often the only thing they know), is that they are ethnocentric. The texts, historically, have all been products of Western culture, and all, or almost all, have been written by white men. Montás, like most contemporary proponents of core curricula, is receptive to the idea of

173

opening syllabi to works from other cultures, as he did himself by introducing Gandhi at Columbia. But he still believes, as I do, that the Western tradition should stay at the center. For one thing, it *is* a tradition: the *Odyssey* responds to the *Iliad*, Virgil rewrites Homer, Dante rests on Virgil, etc. In philosophy, it's Aristotle talking back to Plato, Aquinas building on Aristotle, and so forth. This is itself empowering to students. They begin to acquire a vocabulary — the motifs of Western epic, the concepts of Western philosophy — that enables them to understand, and join, the conversation.

As it happens, Menand co-founded a great books course at Harvard under an antithetical set of principles, those of cultural diversity and the authority of specialists. It is taught by a team of six professors, who lecture in turn on the readings. Discussion is confined to one hour and fifteen minutes a week. (In Lit Hum, at Columbia, it is three hours and forty minutes.) The most recent syllabus for the fall semester included works by "Homer, Plato, Sappho, Augustine, Ferdowski, Murasaki, Dante, Boccaccio, Hafez, Basho, Dickinson, Nietzsche and Luiselli." That is, three writers from ancient Greece, one from ancient Rome, two from medieval Persia, two from medieval Japan, two from fourteenth-century Italy, one from nineteenth-century Germany, one from the nineteenth-century United States, and one from twenty-first century Mexico. Also, two philosophers, four lyric poets, and seven writers of narrative (epic, novel, story, autobiography). It will not surprise you to learn that the selection corresponds to the instructors' respective specialties. I would call this a Chinese menu, but it's more like a dog's dinner.

Yet the most important argument for a Western core is not coherence. It is that we live in the West. The Western philosophical and literary traditions are the foundations of

our politics and our imaginations, and the great books are the central spines of those traditions. I would no more substitute Confucius for Plato at an American university than I would substitute Plato for Confucius at a university in China. Nor is it only Enlightenment concepts, which still undergird our political system, that descend from Western sources. It is also post-Enlightenment concepts. It is the critique of the Enlightenment, as practiced ubiquitously in the contemporary academy. It is the whole empire of postmodernism. Foucault, Derrida, Judith Butler, they are as much a part of the Western tradition — which has always been one of acerbic dissent — as Locke, Voltaire, and Kant. They are the most recent chapter in the Western tradition (they descend from Heidegger, Nietzsche, and Marx, among others). Where, again, did contemporary feminism come from? It didn't come from China. It didn't come from Persia. It didn't come from India. It came from the West — from the Enlightenment, first of all — even as it often pits itself against the West. The very idea that Western texts should be decentered in Western core curricula could only have originated in the West. Not to understand the Western tradition is, as a Westerner, not to understand yourself.

175

I have sometimes conflated, in this essay, the humanities in general with great books courses in particular. So it is worth asking: how, outside of core curricula, should the humanities be taught to undergraduates? As specialized disciplines, or as what Montás refers to as liberal learning? The question came up for me at Yale when I was asked to participate in my department's teaching practicum for second-year graduate students, a

seminar designed to prepare them for the start of their instructional duties the following year. In a session about the use of secondary sources in the undergraduate classroom, I said that I don't use secondary sources in the undergraduate classroom, because I don't believe that our role as teachers of undergraduates is to produce future graduate students. The comment fell with an audible clunk — there were three other professors in the room — so I pressed the point. If our role *were* to produce future graduate students, I continued, we'd be doing a terrible job, because we graduate about ninety majors a year, and only about five of them end up going on to doctoral programs in the field. Nor would we want any more to do so; those five will have trouble enough finding faculty positions, assuming that they even finish their degrees. So what are we doing for everyone else?

No one had an answer. The question had apparently never occurred to them. Mine was essentially the one that I have outlined here. Or as I put it then, taking a phrase from Keats, our role is to point students down the vale of soul-making. I recognize that this is not an answer that's designed to please a provost or a parent, but the fact is that humanities departments have been finding more and more trouble coming up with a compelling rationale for their existence, certainly with respect to undergraduates. As of now, the leading candidates are the instrumental one (we teach you analytical and rhetorical skills) and what might be called the political one: books, at least the ones by "dead white men," are evil, or complicit with evil, and the reason to study them is to unmask them.

Well, as even English professors have been forced to acknowledge of late, almost no one's buying what they're selling anymore. As a share of all bachelor's degrees, the humanities have been declining for more than thirty years,

176

but over the last decade, the numbers, even in absolute terms, have been falling off a cliff. From 2012 to 2020, the number of bachelor's degrees awarded in English declined by 29%, with declines of roughly 25% in both foreign languages and philosophy and religious studies. Menand cites these numbers, too, but only to circle the wagons. "This is the moment they have chosen," he writes of Montás and Weinstein, "to inform readers that academic humanists are not doing their job." That's right: when things are going badly, the last question you want to ask is why. Better to shoot the messenger.

Now, I don't think this decline has mainly to do with anything that is happening in the classroom. 2012 is the year when the first individuals who started college after the onset of the financial crisis began to graduate. With steeply rising debt burdens and a rapidly contracting middle class, students have decided, correctly or not, that the humanities are not a good bet. But I don't believe that that's the whole of it. If you tell people that old books are evil, that the Western literary and philosophical traditions are nothing but a giant cesspool of cisheteronormative white patriarchy, they will eventually wonder why they should bother with them at all. And if you tell them that the point of college is to learn to overthrow the cisheteronormative white patriarchy, they will migrate to fields like the social sciences (as I've been told that a lot of prospective humanities majors are doing) that are more obviously relevant to the cause.

Menand's solution to this predicament is a little different than Montás's and mine. Humanists, he writes, "should be defending their role in the knowledge business." In other words, in *Wissenschaft*, the production of knowledge on the scientific model. "Philology," he notes, "prevailed in literature departments" — he means in the nineteenth century —

177

"because philology was scientific. It represented a research agenda that could produce replicable results." But it's been a long time since the literary enterprise in academia was primarily philological. Primarily, it is interpretive. Critical theory, which has dominated literary studies since the 1970s, Menand goes on, "aim[s] to add rigor to literary analysis" — but rigor and science are not the same. You can have the first without the second. Critical theory might like to conceive of itself as a science of reading, but there is no such thing. The real value of critical theory, for literary academics, is that it keeps on changing — that it is, precisely, *not* replicable. Critical theory is just an interpretive lens, or rather, it is a succession of lenses — structuralism, deconstruction, feminism, New Historicism, and so on — and every time the paradigm shifts, the interpretations need to be redone all over again, providing the excuse for another trainload of monographs and journal articles. The latest lens, in fact, is "digital humanities" — big data applied to the archive of texts, a contemporary iteration of the scientistic illusion.

My guess is that Menand believes that most of what his colleagues do is worthless (though he is surely too savvy to say so). Not just because he undoubtedly thinks that literary interpretation is unscientific, but because he also doesn't think too much of literature itself. "'Read a good book,'" he wrote some years ago, "is a phrase that has the ring of virtue. It implies that what is, after all, just another form of distraction is more than that." When I read that, I thought, he should at least have the decency to change his title from Professor of English to Professor of What Is, After All, Just Another Form of Distraction. When I say that Menand is a person who knows the price of everything but the value of nothing, this is the kind of thing I mean.

But if art has no value, then the study of art has no value, except perhaps as a chronicle of the way that other people waste their time. Certainly, the teaching of art has no value. But if you do teach art, including the art of literature, you ought to be able to give an account as to why. And that is what the humanities must do: to say, without embarrassment, that art has value, that its value is primarily internal to the individual, and that the methods to educe that value are interpretive, not scientific. If the humanities insist on being judged by scientific standards, they will lose, and they should.

What they must not do, though, is go to war with science, as Montás and Weinstein do, and as Menand is right to criticize them for doing. Science is not the problem. The problem, again, is the structure of the university — or, at least, the structure as it has evolved. More than any other institution in society, the university is constituted by a set of tensions: research vs. teaching, *Wissenschaft* vs. *Bildung*, science vs. the humanities, practical utility vs. the pursuit of knowledge and learning for their own sakes. The tensions in themselves aren't bad; both sides, in each case, are valuable. What is bad is that over the decades, the first sides have pretty much won (mainly because they are lucrative, while the second sides aren't lucrative at all). Which means that liberal education has lost.

It's funny: liberal education, contra Reitter and Wellmon, does not mean preaching a particular morality — "deliver[ing] ready-made worldviews," "inculcat[ing] comprehensive and ultimate moral commitments," "stipulat[ing] how students are to lead their lives." In fact, as I have suggested, it means the opposite. Yet preaching a particular morality — delivering, inculcat-

179

ing, and stipulating — is exactly what colleges and universities now do. I mean, of course, the morality of the progressive elite, known variously as political correctness, wokeness, or, in Wesley Yang's term, the successor ideology. This is the morality that produces concepts like cisheteronormative white patriarchy, and dispatches students into battle with it. Though institutions, to be fair, are largely preaching to the choir. The successor ideology is now what many students bring with them to campus, and what needs to be put into question.

Even Montás misses this: that the gravest threat to *Bildung* now is not crass materialism, but a totalizing moral system that students are expected to receive without examination. Though the two, I should say, are perfectly compatible. Or as Menand writes (as only he can): "Students at places like Brown and Columbia want to make the world a better place. ... If some of those students make a lot of money, who cares?" Those last twelve words deserve to be inscribed above the gates to Harvard Yard, as a kind of mission statement. But it's the first part that I'd like to call attention to. Students at elite institutions "want to make the world a better place." The one thing I thought I could count on Menand for is skepticism, especially with respect to claims of virtue, but here, in the face of his students' pretensions, it deserts him. Do they really want to make the world a better place, or is that just a phrase that they kid themselves with, on their way to making a lot of money — to law, finance, consulting, and tech, which together continue to constitute the lion's share of postgraduate destinations at elite schools?

And if they do want to make the world a better place, what do they mean by that? Have they ever really thought about it, or is it just a cliché they repeat? "Better" means "more good," which means in turn that the first thing that you need to do,

180

if you want to make the world a better place, is inquire into the nature of the good. For the answer, it turns out, is not self-evident, despite what current dogma seems to think, and if college doesn't teach you that, the world eventually will. Rigidity is fragility, and the fragility with which the system saddles students now is intellectual as well as psychic. This is the urgent task of liberal education in our present illiberal moment: to liberate students from their own unexamined certainties, to endow them with the incomparable power of thinking things through for themselves.

PASCAL BRUCKNER

The Oblomovization of the Western World

Ilya Ilyich Oblomov is a mid-nineteenth century landowner outside of Saint Petersburg. An honest and decent man, he suffers from a natural tendency towards inertia. He lives less in his home than on his sofa, and less on his sofa than in his capacious dressing gown of Persian fabric, and less in his dressing gown than in his "long, soft, and wide" slippers. His body is flabby, his hands are plump, his movements are all suffused with a graceful languidness. Oblomov lives mostly lying down. Walking and standing are, for him, brief flights between a landing on his bed or his sofa. He is the very definition of the weak-willed, overworked man tortured by the mere

idea of what he has to do. "As soon as he rose from bed in the morning... he would lie right back down on his sofa, prop his head on his hand and ponder, until, at last, his head was weary from hard work and his conscience told him enough had been done today for the common weal." Something as simple as writing a letter takes him weeks, months even, and entails a complex ritual. Each decision comes at enormous psychological cost. His falsely obedient valet Zakhar shirks his duties and lets the house sink into an unspeakable state of disorder. There are days when Oblomov forgets to get up, only opening an eye around four in the afternoon, and tells himself that anyone else in his position would have already gotten through piles of work. Feeling overburdened by that mere prospect, he goes back to sleep. When his friend Stolz introduces him to a young woman, Oblomov panics. He is terrified at the very idea of sharing his life with a wife, going out into the world, reading the papers, living in society. While he falls in love with the charming Olga, who is put in charge of ensuring he that doesn't fall asleep during the day, and takes long walks with her, he cannot resolve himself to see the relationship through. Olga teases him, wants to break him of his napping habit, rebukes him for not being more daring, for his clumsiness. Weighed down by this pressure, he breaks things off with her. Olga turns her back on him, despairing at him, calling him a "shabby, worn caftan" and a coward. Continually overwhelmed by small tasks he never has the time to finish, Oblomov is, at thirty years old, always just about "to enter life's field."

Behind its appearance as a farcical comedy, Ivan Goncharov's novel *Oblomov*, which appeared in 1859, is a poignant description of a failure to launch. The more our protagonist sleeps, the more he needs rest. Having never known great joys, he has also avoided great sorrows. Locked up inside him is a

light searching for an escape, but which only "burned its own prison" and then went out. With only the will and not the way, he has never been able to move forward, for "moving forward meant suddenly throwing his roomy dressing gown from his soul and mind as well as his shoulders." His life ends with him "finally interned in the plain, otiose tomb of his retirement which he had fashioned with his own hands."

Why remember Oblomov in 2022? Because he is the leading man of lockdowns, only without Netflix and the internet. The man lying down was us, was you, in that low-flying existence into which we were recently banished. For over two years, many people have transformed the relative powerlessness of science and medicine to curb the pandemic into rage against our elected officials. The pandemic will wane, but in the meantime quarantine has become a real option for frightened souls. Goncharov's novel is perhaps less a depiction of the Russian soul, as Lenin lamented, than a premonition for us all: literature not as entertainment but as forewarning. The virus has, of course, been a tragedy for many millions of people, but it has also kept the world behind closed doors for years. It has breathed impressive new life into the struggle between homebodies and wanderers. The isolation of whole populations would not have gone off so well, almost overnight, had something not mentally prepared us for it. Lockdown life's victory had lain dormant, at least since the 9/11 attacks that considerably disrupted air traffic. That was when, alongside climate disruption and the fear of terrorism and war, what one could call the Great Seclusion began. We were already locked down mentally, without knowing it.

The late twentieth century was a period of openness both in terms of mobility and our way of life. That period is over; the lockdown of minds and places is well underway. Orbital

tourism for millionaires has begun, but crossing a border or leaving one's house is still "problematic." Covid came like a sign from heaven to a West that no longer believes in the future and sees in the coming decades the confirmation of its collapse. It affixed the terrible seal of death to all those fears. As opposed to the flu of 1969, forgotten by all, this pandemic has already comprehensively changed how we live. How many experienced the return to normal as a shock? Pandemic measures restricted them, the return to freedom depresses them. Won't they miss the fenced-in nightmare that they wholeheartedly cursed when it was first implemented, like prisoners who, upon release, sigh for the bars of their cell and for whom freedom has the bitter taste of anxiety? Any excuse is seized as an opportunity to cloister themselves again. Bedrooms, like houses, are self-sufficient microcosms, so long as they have Wi-Fi.

More than enforced lockdown, we should fear voluntary self-lockdown in response to our dangerous world. This slow-motion period of life has enabled an extraordinary easing in social pressures: reduced contact with others, limited outings, curtailed nights out, remote working, absent bosses, a couch-potato (or pajama-wearing) lifestyle, authorized slouching, splendid regression. The Other as a disrupter, tempter, interrupter has disappeared, or been kept at bay. A few at least derived a paradoxical pleasure from the hermit lifestyle: complying with curfews, the constraint of masking, shielding measures — the six-foot radius surrounding us was annoying but it also gave us structure. The pandemic worried us, but it also freed us from a greater concern: the problem of freedom. It is possible that, in the years to come, and not only as a result of the pandemic, freedom will acquire the bitter taste of memory, or of a pipe dream.

The Oblomovization of the Western World

Who could have foreseen that this experience would, on the whole, be regarded indulgently by a substantial number of our contemporaries, and regarded almost as a long vacation? (In the spring of 2020 a French magazine published an article about "the young professionals who already miss lockdown.") Many were for what could be called an intermittent lockdown or, at least, a conditional reopening. We must not be misled by the cliché, certainly widespread in France, of a return to the Roaring Twenties or post-liberation Paris, or of a new Movida Madrileña. Countless Europeans no longer want to return to the office, dreaming instead of a simple life in the countryside, far from the noise of cities and the turmoil of history. Admittedly, many people want to resume their lives and re-emerge, bars and restaurants are teeming with patrons, impatient crowds are chomping at the bit, travel is resuming, all of which are good signs. Life is excess. Life is unbridled profligacy or it is not life, just mere existence. But the forces of isolationism remain very powerful. An end of carefree living comes with the triumph of negative passions. We now define ourselves in terms of lessness: we want to consume less, spend less, travel less. Or we define ourselves in terms of what we are against: we are anti-vax, anti-meat, anti-mask, anti-nuclear, anti-vaccine passport, anti-car. (In medicine, of course, "negative" — not being infected with HIV or the coronavirus — has acquired a happy meaning, whereas "positive" has become a synonym for mortal danger.). The Before Times were already dead when Covid broke out and we did not know it.

~~~

Pascal said that all of man's problems stem from his inability to sit quietly in his room. He continued: "Hence it comes that

men so much love noise and stir; hence it comes that prison is so horrible a punishment; hence it comes that the pleasure of solitude is a thing incomprehensible." We could tell Pascal that for human beings over the past two years, the problems stem from their inability to leave their rooms. In this case, what threatened them was less the virus than inaction, less the risk of falling ill than of dying of boredom. No offense to Pascal, but amusement is essential, frivolity is vital and without these interludes to break up daily life, existence would quickly feel like punishment. Between the meditation on the misery of man without God and distraction, there is a third term that Pascal, a man of the Ancien Régime, could not conceive of: action and work.

Despite this, not everyone lived through the hardship of Covid in the same way; the poorest and young people experienced it harshly, the well-to-do less so. But we were prepared for the state of emergency to become the norm. And the protests by the last holdouts, the sporadic riots, were only a last stand before grudging consent. Society went from stunned to angry, and from angry to exhausted. Rage was only the temporary cloak thrown over a deeper weariness. In the name of freedom we clamored for the right to do as we please when we please, while demanding that society take care of us when we are sick or struggling. Leave me alone when all is well, take care of me when all is not. The modern patient is also *im*patient, irritated by the limits of medicine — "incurable" is the worst obscenity in our vocabulary — which he suspects either of unwillingness or hidden financial interests. The negative connotation with which we saddle the Before Times, as if they had been a time of depravity, leads one to think that the pandemic was seen by some as an ordeal of moral purification. Some people's puritanism found confirmation in that ordeal.

We should think about the current situation in terms of a tension between the level-headed and the restless, the cautious and the bold. There will always be people in the streets, crowded trains, people driven by the instinct to live, by wanderlust, by rational compromise. But another inclination could prevail, if fear wins the day: the rise of the closed-off, of the at-home. The pandemic will become normalized, added to the list of everyday scourges. It will remain virulent enough to obsess the worried and not lethal enough to trouble the happy-go-lucky.

What is a historic event? An incident with consequences that feeds on and reinforces an earlier mentality. The default mood of our time is apocalyptic: terrorist threats, unchecked immigration, wars in Europe and the Middle East, natural catastrophes, environmental doom. Everything calls for a pause in travel, for withdrawal into small communities as we wait for the curtain to fall. Only one solution is proposed to address these very real problems whose existence it would be absurd to deny: that of dread and seclusion. Whatever the reason, be it global warming, terrorism, or armed conflict, since the century began we have been soaking in a permanent fear in constant search of reasons to grow bigger still. "I want you to panic," the doom-monger Greta Thunberg declared at Davos a few years ago. It is an epitaph for our time.

The dogmatists of decline and apocalypse would suspend us in our anxieties as if in amber to keep us at home and persuade younger generations to do the same. It matters little whether the diagnosis is accurate, it is the symptom of a state of mind that both preceded and confirmed the event. The After Times? They will consist, in fact they already do consist, in an indoor world, the probable legacy of a wily virus, ebbing and flowing with the regularity of an infectious tide.

188

Inside; the negative romance of our times; the prestige of the uterine home; the house as cradle; the womblike hearth. The virus didn't just mean Covid but the pre-existing allergy to the outside. For two years we have been living in a repeating horror, at once both impressive and weak. What did we learn in that time? That we should wash our hands. A vast improvement, to be sure, but it won't set anyone's heart racing.

Our situation since 2020 boils down to one word: *obstacle*. What was simple is now hard, what was hard is now well nigh impossible. Not long ago, drinking a coffee at the counter required proof of vaccination, buying a baguette meant wearing a mask, grocery shopping meant long lines like in the cold war-era Soviet Union. Not to mention the innumerable forms, supporting documents, and QR codes. For two years, France has demonstrated a kind of genius in creating a bureaucratic labyrinth of bans, restrictions, limited permissions, and recommendations of such lexical richness and jargony inventiveness as to delight the language professions. Sadly, France was not alone in that frenzy and few nations escaped the red-tape nightmare. In such a situation, there is only one outcome: people stay home. There will always be a thousand reasons to encourage people to burrow down into a hole under the state's benevolent guardianship. The Ten Plagues of Egypt rain down upon the too fearful humanity of the North and the too impoverished humanity of the South, opening the door will become a highly dangerous act.

A lock is ambiguous: we turn a key in it to come home after a busy day or we lock or we bolt it to keep the outside out. The expansion of our domestic space will elicit the equal and

opposite reaction of a shrinking public space. So we should limit our possessions, our ambitions, our movement. Future man will be a diminished man to go hand in hand with digitally augmented reality. The first lockdown had the novelty of the unprecedented, almost picturesque in its brutality. It promised to be brief. Subsequent lockdowns began to look like a self-fulfilling prophecy. What if lockdowns became a symbol of our future? What if they shape the world of tomorrow, along with masks, distance, mistrust, and increased regulation? For two years we have been "Platos in dressing gowns" (Emmanuel Lévinas on Oblomov) holding forth on vaccine effectiveness, Big Pharma "conspiracies," our elected officials' lies, and the dangers of community life. There is a comfort to seclusion, and one could even delight in an abridged life reminiscent of the long-established Western monastic tradition: the monk's cell, minus God but plus social media. The intense pleasure of being enshelled, endowed with all the properties of resistance to climate change, crime, and violence. It is now imperative that we stay rooted in place to prevent exposure or a heavy carbon footprint. The earth is becoming immense again. Lockdown was space constricted and time dilated. Post-lockdown is the opposite: distances increase exponentially. Getting a train and especially a flight is still a feat, an obstacle course. The nearby has become faraway and the faraway has become inaccessible.

Take the Swedish word "*flygskam*," or flight-shaming, popularized by some green activists. No longer should we travel by air, so as not to contribute to historic greenhouse gas emissions. Yet, according to the International Civil Aviation Organization, flights only account for three per cent of worldwide carbon emissions. Who cares? For some, the urgent matter at hand is not global warming but punishing humankind. We must be kept on the ground to teach us a

lesson. Changing one's life now means reducing it by as much as possible. If each decade is the field on which a battle between opposing trends is fought, the prevailing option today is to close off the horizon. Covid will perhaps have converted us all to the cave-dwelling lifestyle. No effort is spared to discourage travel, not to mention the near-criminalization of car use in Europe. Many leaders warn of the aberration it would be to return to traditional tourism, strangled by its own success. An environmentally minded mayor in Poitiers, Léonore Moncond'huy, saw fit for the planet's sake to cut subsidies to an association called Rêves de Gosse, which enables disabled children to take their first flight. On her view, "flight should no longer be a childhood dream." Please keep your feet on the ground. Increasingly we reassess the need for cars, planes, trucks, ocean liners, and tanker ships.

The new nationalist or collapsologist narrative always ends with an indoor serenade. All that's left is to timidly conduct the somber inventory of what we are now forbidden from doing in the name of climate or protecting our borders, which are erected now as ramparts, spike strips, walls. Freedom has become a burden from which only enclosure can deliver us. Hibernating citizens are told to stay in bed, or at least snug and cozy. At the slightest transgression, the smallest excess, our carbon footprint goes up, the planet is harmed, and the cure is delayed. Hence the widespread idea of setting individual consumption quotas to curb pollution. A new aristocracy of the carbon-conscious will form an elite with whose behaviors the majority will have to align their own. Consider, for example, a new game released in France to instill environmental awareness in children called The Zero-Waste Family (*La famille zéro déchet*) — doubtless a wonderful initiative. But will a saga based on vegetable peelings and sorting the garbage

replace Clue or Trivial Pursuit in children's imaginations? If, as Tennessee Williams wrote, desire is something made to occupy a larger space than that afforded by the individual being, what remains of desire when it's put on a diet? Whole peoples, families, and individuals are overwhelmed by a reverse Napoleonic complex: since we have consumed so much, we must reduce the space we occupy to the extreme, everyone in their little nook. For a generation raised under the dark stars of catastrophe and decline, any trip outside the nest would cost considerable energy.

It is symptomatic of our new century that we no longer speak of change but of salvation: we must save the planet, save France, save America, save the left, save the right. An absolute alternative makes intermediate solutions sound laughable. It's redress or death. Yet to preserve something — a landscape, a language, a country — sometimes you have to innovate, to upset things. Freedom is something you learn, and so it can also be unlearned, and we could lose our taste for it in a single generation. Freedom is the possibility of creating something new on this earth; it is the ability of each of us to lead our lives as we see fit, to feel unique. Covid didn't just kill, punish, and weaken millions, and disrupt the whole planet's social, political, and romantic lives, it has also freed us from freedom as an ideal. And since our only tomorrows leave everything to be desired, let us slow down our today, quell our ambitions, shackle the Dionysian lusts. Let us become the still waters that nothing can stir.

This is pure *oblomovschina*. Our contemporaries can all be found on the sofa, facing a screen, the last bastion shielding us from the world's horrors, which arrive filtered through images, and only further whets our appetite for our homes. Such is the scenery in which, from Los Angeles to Beijing, all of humanity

192

shuffles through its days. Each of us behind our fences, in our homes, apartments, yards. During lockdown we have been reduced to the square-footage of our living rooms, forced to venture out via radio waves and sight alone, without permission to physically leave an assigned perimeter. For Jean-Claude Kaufmann, in his book *C'est fatigant, la liberté*, or *Freedom is Exhausting*, pajamas have become a "political object," just as the paving stone is political in the rioter's hand or the ballot in the citizen's. In slippers and bathrobes, we have resisted the cruel world's assault. Our slippers are internet-ready, iPad- and smartphone-compatible, connected to the worldwide, cosmic, interstellar web. But can this really be enough?

Here we are, with our best intentions, under existential house arrest. What some have called pandemic tyranny has been replaced by what we might call static tyranny. Stop moving, don't budge. (It is not surprising that protests of public health policies on both sides of the Atlantic have grown out of the mobile professions, drivers and truckers, as was already the case in France in 2018 with the Gilets Jaunes, so named for the hi-visibility vests French drivers are required to carry in case of emergency.) A new anthropological type is emerging: a huddled, hyper-connected being who no longer needs others or the outside world at all. All contemporary technology favors incarceration masquerading as openness. How could we not sympathize with the preference for staying home and teleworking on the part of people who have for years suffered the soul-crushing effects of the commute, office life, and micromanaging bosses?

*La vrai vie est absente*: Rimbaud's famous verse could be interpreted as "real life is absence of life." For all those still advocating the spirit of exploration, the fondness for other people, and the joy of discovery, the misfortune is two-fold:

**The Oblomovization of the Western World**

add to the five to ten million dead from the virus a scrubby penitence as atonement for our sins. Our belief in reason was once supposed to afford us mastery over the world and nature. In the 1960s the historian Alexandre Koyré wrote *From the Closed World to the Infinite Universe* to mark the passage from the closed cosmos of the Middle Ages to the expansive one of the Renaissance. Five centuries later, we are living through the opposite: our knowledge and technologies seem limitless but the boundaries start at one's front door. Each of us, alone or with our families, in our bedrooms or living rooms, doomscrolling through alarming news, considers the Outside a place of peril. Therefore it is important to note that the Inside is not peril-free, either: it delivers us into the hands of banality, relentless boredom, the weariness of being, our souls swallowed up in fog. Almost everything has become possible from home: restaurant meal delivery, entertainment, film, concerts, theater delivered over platforms, workouts with digital coaches, technology-assisted working from home, video games, occasional partners found on Tinder or Grindr, and so on. Even safe sex using sensors and suction cups is a conceivable option with faraway partners. The key lies in that "almost." Does "almost" suggest inevitability?

In "The Man of the Crowd," in 1845, Edgar Allan Poe followed a sixty-five-year-old man through London. The man's clothing is torn and he loses himself in the maze of streets and the flow of pedestrians. He has a fondness for the principal thorough-fares, and as the darkness comes on he seeks out the busy bazaars, audiences emerging from theaters, crowded cabarets. When the evening establishments, packed with drunks and

girls, close their doors, he is filled with distress. At dawn he heads into the heart of town, plunging into the bustle and activity of the first employees leaving for work, and there he starts over his unflagging wandering until evening, without stopping to rest.

It is tricky these days to be a devotee of crowds or to fraternize with thousands of strangers in a warm closeness. Please don your armor and put a wall up around yourself. Don't touch me, don't brush against me, don't stare at me. Anyone who coughs nearby is a leper to be avoided. The pleasure of strolling amid the multitudes, attending a concert or sporting event, going out to eat, elbow to elbow with other people, drinking and laughing, the exquisite delight of people-watching, the hunger for new faces: that was yesterday. Today we dial back such behavior, because the other is a potential enemy for me as I am for him. We have lost the innocence of company in favor of a six-foot bubble between guests. And this will continue long after the pandemic; now that the idea has caught on, mistrust will prevail over casual abandon.

Thirty years ago, AIDS forced us to comply with a vital obligation: use protection to avoid infection, while kissing was cleared of all suspicion. It was a blissful combination, symbolizing the coming together of bodies. Condoms enabled union without contagion, a basic precaution that saved generations. Covid makes room for no such protection: the virus floats in the air and lands on you at random. Your spouse might inhale it in the wake of a panting jogger, or get it from someone in the supermarket who exhaled the fatal particles at the check-out line. And the cycle is set in motion, the curse ever repeating: the whole world rapt in anticipation of the swab's verdict. To the ancient Greeks, *pneuma* was the divine breath that gives life, the primordial breath which became the Holy

Spirit for Christians. Now, this breath is potentially lethal: the damp warmth of breathing can kill. Breathing in another person used to be a heady experience; now it might be a death sentence. Is there anything more conducive to squelching desire? Will we develop a distance-compliant erotica, a *Corona Sutra* with sexual positions recommended by the medical establishment? Will there be a scarcity of skin and screen-mediated orgasms, as in *Barbarella*, Vadim's old B-movie in which the heroine, played by Jane Fonda, made love to her partner using only her fingertips? There is now a counterintuitive arousal in seeing the objects of our desire take off their masks, as if nudity began there. Life in public risks no longer being a place of exchange and human commerce, but one of suspicion and hostility. There is little margin between indispensable precautions (vaccines, various passes, increased hygiene) and redundant disconnection. Covid has revived the two great modern phobias: paranoia, the fear of others, and hypochondria, the fear of oneself, the certainty that our bodies hide within them the germ or disease that will kill us.

Some cultures are accustomed to physical reserve. In Asia people bow with their hands joined. They have acquired a group instinct that is not, like here in the West, considered a herd mentality but the art of living together in a population of fifty million people. In North America, people wave at each other so as to better avoid each other. People do not smile at you to start a conversation, but to ask politely that you stay where you are. I've clocked you, take my presence into account, walk on by. As for hugs, they are not warm embraces but an interlacing of arms that must be performed stomach-in, avoiding all contact with the body. In my native France the *bise* is disappearing, to the great relief of those who could no longer bear those damp effusions against their cheeks, those

lips that smacked two, three, or four times. It will survive in families or among close friends, like a forgotten treasure to be added to the UNESCO cultural heritage register. The winners are the misanthropes.

Covid, of course, is not the only cause of the new disparagement of touch, of physical contact. But what is a life without touch worth, a life in which we do not hold each other? We live in an urban civilization and the art of the city is ultimately the art of theater, the art of putting oneself on display and appreciating the displays of others. In France, looking at each other, taking the measure of other people, is an essential part of public life. Watching the passersby from a sidewalk café is a delicious pastime, on that vast stage where all ethnicities, genders, and ages act as in a play, always similar yet always different, whose energy and variety fascinates and exhausts us. The crowd astonishes itself through the individuals forming it. What will become of this urban wonderland if we have to wear masks, face shields, and surgical gloves, muzzling ourselves with fabric? We have been summoned to a re-education: for example, over the bad habit the French have of crowding the person ahead of them in line, out of irritation.

A cold geometry has prevailed over the dance of atoms. In the mid-twentieth century, the body revealed itself. Today it is covering itself back up: thirty years ago it was condoms, today it is masks, gloves, face shields, scrubs, lab coats, hairnets, perhaps soon a deep-sea diving outfit, not to mention veils and burkinis in Muslim countries. Times are tough for sensual pleasures. This ordeal has revealed to us how happy we were without knowing it, the extent to which ordinary life in the Before Times was in fact extraordinary. Is it a surprise that birth rates have flagged slightly since 2020 and that peoples' sex drives are on the wane, as mere contact with others

197

portends inordinate threat and we might no longer find others appealing? (Again, the reasons are as much cultural as epidemiological.)

In the years to come we may witness the disappearance of office life with the broad roll-out of telework. *La droite de la paresse*, or "the right to laziness," which was conceived in the late nineteenth century by Paul Lafargue, Karl Marx's son-in-law, will have become the majority's fate, with the twofold consequence that a broad swath of the population, as unfortunate as they are unoccupied, must be entertained night and day, hypnotized in front of their screens and immersing themselves in mandatory free time. Work will become the privilege of the rich and idleness the burden of the poorest. In a reversal of the ancient curse attached to labor, the very rich will flaunt their mind-boggling working hours and humblebrag about their burnout, while the rest head to the unemployment office to live off assistance and a minimal income. Work may soon become a rare good reserved for the most fortunate, while the plebe will "amuse himself to death," in the words of Neil Postman.

What, then, will be left? Safety at the cost of boredom or freedom at the cost of risk. When home becomes a burrow, as in Kafka's story, a "hole for taking refuge in," life consists in consolidating one's den, burying ourselves deeper. In the burrow, the whole of life consists in ensuring the occupant enjoys total serenity and comfort: even a grain of sand sends the burrower into a commotion. Sealing a passage shut, filling in a gap, is his daily activity. A persistent noise, at first a hiss, sends him into a panic: is it the start of a cave-in or some small

animal digging tunnels? The fortress is under siege, and it is under siege precisely because it is a fortress and therefore, by definition, hostile to others. The person as burrowing mammal: "When autumn sets in, to possess a burrow like mine, and a roof over your head, is a great good fortune for anyone getting on in years." The world's hostility to the burrower is unremitting; the struggle against the outside world never ends. These days the burrow seems like a hypothetical mass solution, be it an isolated house, a forest cabin, or a survivalist's bunker.

The Renaissance and the Enlightenment had heralded fertile times, carried forward by the promise of better. Since the late twentieth century, we have entered a sterile period and too many sides dream of subjecting humanity to a regressive imperative. The joyful endorsement of existence, curiosity about foreign places, and gratuitous meandering have become suspicious. Day after day we dispense lessons in applied despair to the young. The common thread between the doctrines dominating the current ideological field, on the one side decline and isolationism, on the other catastrophism, is the recommendation to survive. We have an embarrassment of horrors, all of which are presented as absolute priorities: the pandemic, unstemmed immigration, neighborhood violence, Islamist terrorism, climate disruption, and above all, war in Europe, which absorbs them all. It is also an embarrassment of ways in which the world ends, which pile up rather than cancel each other out. We can choose between dying of disease or from extreme heat or enemy bombs, which various popular fictional stories and TV series all announce in their ways. Based on fear, these interpretations of our prospects have the same effect: the temptation for people who seek above all to protect themselves from major historical disasters is to withdraw from the world.

**The Oblomovization of the Western World**

We can hardly be astonished that younger generations are haunted by nightmares, no longer believe in the future, and run, headfirst, into the burrow to await the world's end. Or that the need for absolute security and perfect safety has quenched even the pleasure that we take from each other's company. *The end of the world is first the end of the outside world.* The 1960s thirst for life is over: now we must throw water on the sublime, scale back our ambitions, and invite everyone to orgies of scrimping. We fervently denounce clutter; we crusade to simplify, with the goal of a life of less and less and less. The desire to enjoy all the best of what life has to offer is discouraged, even forbidden as a sin against the planet, the nation, the past, ethics, and minorities. From 2020 to 2022, how many political Cassandras and killjoys have shoved their way to the podium to chastise us and promise us the harshest punishments? We've had too much fun and now we have to pay! In this fire-and-brimstone spirit Nicolas Hulot, the former Minister for Ecology in France, pronounced in March 2020 that Covid was "nature's ultimatum" before the final annihilation. This is nothing but encouragement to retreat into ourselves, for the Outside is an abyss. Withdrawing from life is taken for prudence. In this respect, isolationism is just a patriotism of entrenchment. Anyway, no one can live through the many tragedies of our times without a way to blow off some steam.

A door must be either open or shut, said Alfred de Musset. But the rich tension between inside and outside occurs when doors and windows are ajar and enable circulation from one setting to the other. (The same can be said of borders, which ideally exist to better connect people.) One may prefer the elegance of assumed risk to a paralyzing angst. What makes us strong is not shrinking back but confronting challenge

and adversity head-on. To the dogmatism of open and shut, one should prefer porousness, the happy medium between moderation and bravura that only creative collisions enable. The charm of existence is always to be found in the collision between several spheres. As Victor Segalen wrote, "I had to choose between the hammer and the bell; what I remember now is mainly the sound they made."

It will take either a lot of talent or a powerful desire to continue to coexist in harmony with our fellow humans to push back the zealots of decadence and the worshippers of the apocalypse. What is needed is a commitment to renaissance, a serious desire to forge the future. Until recently, it was unclear that the West was still capable of it. Then Putin unwittingly brought many Westerners to their senses. Russia's war in Ukraine caught old Europe off guard. Winded from the pandemic, and under the impression that an insipid universal peace had become the norm, it has nonetheless reacted with admirable unanimity and resolve. Europe did not roll over. We were expecting Munich and we got a collective Churchill. In a matter of days Europe emerged from its long sleep-walk that started when the Berlin Wall fell. Populations can drift into numbness but they can also wake up, and reemerge strengthened from the worst ordeals, and offer commendable examples of resurrection. We are stronger than we think, and our enemies are weaker than they believe.

But let us remain cautious. War and disease teach ambiguous lessons that awaken as many as they cut down. Will the extraordinary solidarity that the international community has shown since the Russian army's invasion of Ukraine, the explosive shock of this attack, survive the test of time, the rise in oil and gas prices, our thousand everyday worries, or the terror of a nuclear threat? Freedom often

201

comes at an uncomfortably high price. It is a struggle fought on multiple fronts in which endurance and perseverance are the virtues required.

Who will prevail? The advocates of renunciation or the forces of audacity? Meanwhile Oblomov waits in the wings, asking no more of life than a sofa.

JEAN DE LA FONTAINE

# The Deer Seeing Himself in the Water

In the clear water of a spring,
A Deer gazing at himself one day
Praised the beauty of his antlers
And could hardly bear the sight
Of his slender legs,
Whose shape he saw vanish in the waters.
"What a disproportion between my feet and my head!"
He said, grieving when seeing their shadow,
"My forehead reaches the top of the highest bushes,
My feet are unworthy of me."
While he is speaking like this,
A bloodhound makes him run away;
He tries to save himself;
Into the forest he bolts;
His antlers, a vulnerable ornament,
Impeding him at every moment,
Hinder the use of his feet,
Which his days depend upon.
He then relents, and curses the gifts
Which the Heavens make him every year.

We value the beautiful, we despise the useful;
And beauty often destroys us.
This Deer blames his feet that render him agile;
He esteems the antlers that do him harm.

# *Two Goats*

As soon as the Goats have grazed,
A certain sense of independence
Makes them seek out fortune; off they go
　　　To the parts of the pasture
　　　Least frequented by humans.
There, if there is a place without roads or paths,
A cliff, a mountain with precipices,
That is where these Ladies walk away their whims;
Nothing can stop this climbing animal.
　　　Two Goats, then, taking liberties,
　　　Both of them having credentials,
Left the lower meadows, each going her way.
The one going toward the other quite by chance.
A stream is encountered, and for a bridge a plank.
Two Weasels abreast could hardly have crossed
　　　　　This bridge;
Besides, the swift water and the deep creek
Must have made these Amazons tremble with fear.
Despite so many dangers, one of these beings
Sets foot on the plank, and the other does the same.
I imagine seeing, with Louis the Great,
　　　Philippe of Spain approaching
　　　On the Isle de la Conférence.

Thus, step-by-step,
  Nose-to-nose, our Adventuresses,
  Who, both being very haughty,
Half-way across the bridge refused to yield
To one another. They could boast having
Among their race (as the History is told)
One particular Goat whose merits were peerless,
Whom Polyphemus gave to Galatea,
  And the other, the goat Amalthea,
  By whom Jupiter was nursed.
Neither backing away — they fell together;
  Both tumbled into the water.
 Such accidents are not unusual
 On the road to Fortune.

# The Animals Sick from the Plague

An evil that spread terror,
An evil that the Heavens in their fury
Invented to punish the crimes of the earth,
The Plague (we must call it by its name),
Able to replenish in one day the river Acheron,
Made war against animals.
They didn't all die, but all were struck:
You didn't see any of them busy
Looking for some support of a dying life;
No food aroused their desire;
Neither Wolves nor Foxes watched for
Their sweet and innocent prey.
The Turtledoves fled away from one another:
No more love, therefore no more joy.
The Lion called for advice, and said: "My dear friends,
I believe that the Heavens allowed
This misfortune for our sins;
That the guiltiest among us must
Sacrifice themselves to the blows of heavenly wrath,
Perhaps it will achieve a collective healing.
History teaches us that in such crises
We make similar sacrifices:
So let's not flatter ourselves; let's consider without indulgence
The state of our conscience.
In my case, to satisfy my greedy appetites
I devoured many sheep.

What had they done to me? Nothing at all.
It even happened sometimes that I ate
      The Shepherd.
I will therefore sacrifice myself, if need be; but I think
It's good that all accuse themselves as I have:
For we must wish that in all justice
      The guiltiest perishes.
      "— Sire," said the Fox, "you are too generous;
Your scruples show too much nobility.
Well, to eat sheep, a foolish race,
Is it a sin? No, no. You, my Lord,
      By eating them, you really honored them.
      And as for the Shepherd, we can say
      That he was deserving all evils,
Being one of those who impose
      A false power over the animals."
Thus said the Fox, and to flattering applause.
      They didn't dare delve too deeply
Into the less pardonable offenses of the Tiger,
      Nor of the Bear, nor of the other beasts.
All the quarrelsome beings, even the sheep dogs,
Were, according to them, little saints.
The Donkey came in his turn and said: "I remember
      That in passing a Monks' meadow —
The hunger, the moment, the soft grass, and I think
      Some devil also pushing me —

I mowed from this meadow the width of my tongue.
I had no right to do so, since we must speak frankly."
Upon these words, they shouted against the ass.
A somewhat clerical Wolf proved with his harangue
That they should repudiate this wretched animal,
This scab, this mange, from whom all their evil came.
His trifle was judged a hanging case.
Eating other people's grass! What an abominable crime!
       Nothing but death could pay
For his infamy: they made him grasp this.
Depending on whether you are powerful or miserable,
Courts will pronounce you white or black.

# The Coach and the Fly

On a steep, sandy, arduous trail,
One from all sides exposed to the Sun,
    Six sturdy horses pulled a Coach.
Women, a Monk, old men—all got off.
The team was sweating, snorting, spent.
A Fly arrives, and gets near the horses;
Claims to be urging them with her buzzing;
Stings one, stings the other, and thinks all the while
    That she drives the contraption;
Sits down on the pole, on the Driver's nose;
    As soon as the chariot makes its way,
    And she sees the people walking,
She takes all the credit for herself;
Comes and goes, dashes about; it's as if she were
A General going to each position
To make his men advance, and hasten victory.
    The Fly, in this mutual need,
Complains that she acts alone; and that she must do
        all the work;
That nobody helps the horses out of their predicament.
    The Monk recites his Breviary;
He certainly took his time! a woman sang;
This wasn't really a time for singing!
Lady Fly goes on singing to their ears
    and undertakes a hundred follies.
After a lot of effort, the Coach reaches the summit.

"Let's take a break now," the Fly says.
"I've done so much that our folk are finally on flat ground.
Now, you Gentleman Horses, thank me for my trouble."

Thus, some people, pretending to please,
Interfere with things:
    They pretend to be everywhere indispensable,
    And, being intrusive, must be expelled.

# The Rat and the Oyster

A Rat living in a field, a Rat with a small brain,
has one day had enough of the paternal Gods.
He abandons the field, the grain, and the stubble,
Quits his burrow to roam the countryside.
      As soon as he is outside of his home:
"How vast and wide is the world!" he says.
Here are the Apennines, and here the Caucasus."
The least molehill was a mountain in his view.
After a few days, the traveler arrives
In a certain district where Tethys had left
Many Oysters on a shore; and our Rat, at first
Thought he saw, in seeing them, tall ships.
"My father was indeed a poor fellow," he says,
"He didn't dare travel, being extremely fearful.
For myself, I've already seen the maritime empire;
I've crossed deserts, but we didn't drink."
From a certain pedant, the Rat took these details
      And blathered about them,
Not being one of those Rats who gnawing on books
      Become learned up to their teeth.
    Among so many Oysters closed tight,
One had opened itself, and yawning in the Sun,
      Delighted by a mild Zephyr,
Sniffed the air, breathed, spread out,
White, plump, and, to the eye, incomparable.

As soon as the Rat sees, from quite a distance,

                                      this yawning Oyster:

"What am I perceiving?" he says, "It must be some

                                      delicious food;

And, if I'm not misled by the color,

I must feast today, or never."

Whereupon Mr. Rat, full of anticipation,

Gets near the shell, extends his neck a little,

Feels trapped as in a snare; for the Oyster suddenly

Closes. And this is what comes of ignorance.

Our Fable contains more than one lesson.

        We see first of all

That those who have no experience of the world

Are by the slightest things amazed;

                And also we can learn from it that:

                The taker may also be taken.

*Translated by Henri Cole and Claire Malroux*

212

JONATHAN BASKIN

# Sheila Heti and The Fight for Art

On the fourth page of *Pure Colour*, the fourth and most recent
novel by the Canadian writer Sheila Heti, it is proposed that
there are three kinds of beings on the face of the earth. They
are each a different kind of "critic," tasked with helping God
to improve upon His "first draft" of the universe. There are
birds who "consider the world as if from a distance" and are
interested in beauty above all. There are fish who "critique
from the middle" and are consumed by the "condition of the
many." And there are bears who "do not have a pragmatic way
of thinking" and are "deeply consumed with their own." The
three main characters in the novel track with the three types:

Mira, the art critic and main character, is a bird; Mira's father, whose death takes up the middle part of the novel, is a bear; and Mira's romantic interest and colleague at a school for art critics, Annie, is a fish.

The bird, the bear, and the fish are the basis for an inquiry into different value systems and the ways of perceiving the world that follow from them. The schema itself evokes a competition-to-the-death: birds and bears both eat fish. But the competition Heti is interested in occurs in the social world, not the natural one. There conflict need not be fatal, but it remains a significant and even a necessary aspect of social life in modern secular societies. For what defines the three types is more than a matter of personality, or sensibility. It concerns what the philosopher Charles Taylor calls "strong evaluations": that is, the kind of choices and commitments that individuals living in those societies make to express "the kind of beings we are or want to be."

Heti has spoken of writing *Pure Colour* during the Trump years, and of it being her way of responding to the ambient conviction that it was "frivolous" to be an artist during such a politically charged time. It is appropriate, then, that the central conflict in the book is between Mira, the artistic sensibility, and Annie, the political one. To be sure, the virtues of the fish are not dismissed, and toward the end of the novel Annie offers Mira an impersonal kind of comfort (perhaps the only kind she is capable of offering). Through Mira's eyes, Heti acknowledges that fish can be driven by a true and beautiful compassion for others, and that sometimes they are the ones who "see the whole picture most clearly." The novel nevertheless traces a deep and often hostile incompatibility between the worldviews of the bird and the fish. Mira, who sees beauty in the world just as it is, calls Annie a "fixer"

because she is always telling people her "own ideas about things; about relationships and the psyche and the world of people, and what it meant to be in a family... meddling in the structure that had been given to humans, as old as a tree." Toward the end of the book, she envisions finding Annie in the small town where she has gone to help people "repair their collective delusions" and telling her that fixers are "the wrong thing to be." Annie listens "politely, with a face of cold marble." Then she tells Mira that she is just repeating patriarchal talking points she learned from her father. "*I still think it's wrong to be a fixer*," says Mira. "*That's rich for you to say!*," responds Annie "*you, who have never tried to fix anything!*" (Italics Mira's.)

The majority of Heti's fiction, and all three of her novels, beginning with *How Should a Person Be?* in 2012, have been published during a decade in which strong evaluations have trended in one direction: toward that of the fixers. Far from standing for all ways of caring about the "condition of the many" — that is, of engaging in politics — the fixer names an ethos that has become conspicuous on the progressive left in recent years: it appears in Annie's character as a kind of therapeutic moralism, which takes little notice of the compromise and contestation traditionally thought of as intrinsic to political life. Like many who call for the breaking down of every border and convention, Annie conceives of the lines delineating communities — whether biological, like the family, or political, like the state — as arbitrary and meretricious; all that stands in the way of her utopia is the ignorance and laziness of those who have not read the right books or learned the most up-to-date vocabulary. In her claim that Mira's criticism is merely the result of her having internalized the patriarchal claims of her father, it is easy to hear the

215

**Sheila Heti and The Fight for Art**

moralists' characteristic skepticism that any defensible value system besides their own is even possible, much less something to be consciously cultivated.

Much has been made in recent years about the problem of political polarization, but just as distinctive of the period — perhaps more distinctive, since polarization in American politics is perennial, and inevitable — has been the accompanying encroachment of the ethos of the fixers across the categories of left-liberal society and culture. This includes the categories of art and literature, much as it might seem that aesthetic values would preclude the utilitarian bias at the heart of therapeutic moralism. Dispiritingly, the most common response of contemporary novelists to the encroachment of this ethos has been to submit their manuscripts dutifully to the panels of fixers for judgment, approval and, occasionally, a surely justified censure. "Our art has become exhaustively political, but it is no longer discernibly subversive," observed the writer Greg Jackson about the literature of the Trump years, "It is what major cultural institutions, foundations, and media organizations find congenial."

Heti, while feeling the same pressures as other artists, has chosen a different tack, of which *Pure Colour* is only the most explicit example. In each of her novels, she constructs a coliseum wherein the bearers of different strong evaluations do battle. The battle is not really a battle; it is more like a conversation, and the setting is of course not a coliseum; rather, the characters talk in bars and hair salons, at poetry readings, and inside a leaf. They talk about grief, beauty, friendship, finitude, blowjobs, the soul, the intimacy of cutting hair, and the ecstasy of buying the perfectly colored lamp. They make jokes and ask a lot of earnest open-ended questions, of each other and sometimes of the universe. But the casual or whimsical quality

of these dialogues ought not distract us from the fact that each of them has a winner, and in each the winner is art.

It may seem like no surprise that Heti, an artist, prefers art. This is why it is so important to read Heti's fiction as itself in conversation with the moralization of culture that her critics and commentators have more often fallen victim to than managed to identify as one of her main targets. Heti does not ignore therapeutic moralism so much as she engages it within her fiction for what it is, or should be, to the artist: a stumbling block to the creation of genuine art. Perhaps we can learn something from her example about how to emerge from this long season of aesthetic retreat.

As with so many other things, the Trump presidency accelerated in both speed and vulgarity a process that was already underway in literary culture. Heti, who published her early short stories in *McSweeneys*, and the first excerpt from what would become her first novel in *n+1*, began writing in the early 2000s, at what can now be seen as a transitional moment for art and culture. It was not entirely true, as some alleged, that postmodernism ended with 9/11, but it was the case that, for a variety of reasons, a new social seriousness seemed to enter into the literary world around that time. Almost a decade before 9/11, David Foster Wallace had already announced the exhaustion of postmodern irony and alienation, calling for fiction writers to return their attention to the "desperate questions" of human experience. Along with several other writers, musicians, and filmmakers calling for a program of "new sincerity" in art and culture, he would become an unacknowledged legislator of the coming age of conviction.

But what should artists be sincere about? This is a question Wallace never got around to fully answering before he hanged himself in his California home in 2008. A suggestion that was to prove appealing to the novelists of the following generation, however, had already appeared three years earlier in Benjamin Kunkel's novel *Indecision*. Kunkel was one of the founders of *n+1*, a magazine that played a not insignificant part in bringing political sincerity back into fashion on the young left — in part, as Kunkel's novel indicates, at the direct expense of aesthetics. The narrator of *Indecision* is Dwight B. Wilmerding, a 28-year-old pharmaceutical worker who wanders between jobs, romantic entanglements, and self-conceptions, once remarking that he feels "like a scrap of sociology blown into its designated corner of the world." Then, in a surprise ending, Dwight cures his ambivalence and apathy — and also his romantic frustrations — by moving with a new girlfriend to Ecuador and becoming a "democratic socialist" doing public relations for oppressed workers. It is a reversal of the classic structure of the *bildungsroman*: whereas the artist's development typically culminates with him learning to speak for himself, Dwight's ends with him training his voice to serve his political commitments.

Kunkel showed how seriously he took his novel's ending when, in subsequent years, he abandoned fiction and devoted himself to writing long essays on Marxism and political economy. His shift was indicative of a move by many of his generation's novelists, or would-be novelists, into the genre of the political or sociological essay. Some, like Jonathan Safran Foer, known for writing two bathetic novels about the Holocaust and 9/11, produced two bathetic tracts on animal abuse and climate change. Others, like the founder of *McSweeneys*, Dave Eggers, started nonprofits, or advertised

their new literary projects as an aid to humanitarian undertakings, whether in post-civil war Sudan or post-Katrina New Orleans. Although they embraced a very different politics than Kunkel (as he dove into the history of Marxist criticism of liberalism, they took their cues from progressive NGOs and Nicholas Kristof), these writers followed his example in disciplining aesthetic ambition to sincere political conviction.

Heti, too, was interested in sincerity, but she pursued it in a different key. She was part of a group of writers who turned to "autofiction" — a genre that blends autobiography and fiction, as the name indicates — as a way to give their novels the impression of having stripped away all pretense and artificiality. Of course, autofiction is still fiction: not everything in it can be assumed to be true, and what appears in an autofictional novel is there because the author wants it to be. Still, the form allowed some writers who had grown disillusioned with the conventions of realism to make a correction in the opposite direction of the postmodern distancing techniques that had proliferated in the 1990s; instead of pulling away, they moved closer in. It was his break with conventional form, said the Norwegian writer Karl Ove Knausgaard, that allowed him to go to the "inner core of existence," no matter how "small and ugly" were the things he found there.

That observation is lifted from a review that Heti wrote in 2014 of the second book of Knausgaard's *My Struggle*, his six-volume "autobiographical novel." For Heti, the draw of Knausgaard's project was the way it pushed beyond "our romantic stories about our lives," as well as the "consensual safety that fiction brings with it, the presumably ethical veil behind which writers protect themselves from their family and friends." Where "conventional novels make of life something it is not," Knausgaard had gone "beyond dignity"

to create a "realism that is really real." The project can be seen as a classically modernist one of using literary form to connect the social and the historical to the personal, and therefore to locate the potential for authenticity in an individual life. But whereas for the early twentieth-century modernists this process had involved elaborate formal and stylistic experiments, the autofictionists of the 2010s eschewed plot and scene setting, gravitating instead toward a style that was casual and conversational, at times even sloppy, in hopes of offering relief from the onslaught of artificiality and "artful" messaging in the broader culture. A corollary could be found in the image that each group conjured of the artist: Joyce's godly figure, "paring his fingernails" above his "invisible" creation, gives way in Knausgaard and Heti to the author as the fully implicated, sometimes shambolic center of their own story, a non-genius who is constantly remonstrating with themselves for not being a better person, or a more committed artist. Indeed, one of the recurring themes in the autofiction of Knausgaard and Heti is the — often extremely undignified — struggle of trying to write for a living "in an age," as Heti puts it, "where no one believes it's God's work." It was a form, in other words, for producing novels that were sincere not about humanitarianism, or social change, but about writing.

Heti's early short stories, many of them fairy-tale-like parables, collected in *The Middle Stories*, and her early novella, *Ticknor*, written from the point of view of the Boston Brahmin biographer George Ticknor, gave evidence of her flexibility as a stylist — when she wants to write refined prose, she can — and for making the ordinary stuff of social life into a kind of absurdist theater. Yet it was not until *How Should a Person Be?*, her own "novel from life," published in 2012, that the themes

that were to consume her mature fiction come fully into focus. Chief among these themes is the struggle to write amid the multiplying calls for the writer to submit to extrinsic moral and ideological imperatives.

The inciting incident of the novel is the narrator, also named Sheila, being asked to write a play for a "feminist theater company" in Toronto. Initially balking at the request, Sheila is relieved to find out the play need not be "feminist" so long as it is "about women." But Sheila's confusion at the requirement, made by one of the cultural institutions in her city, that her art serve a political agenda — even though it is an agenda she supports — offers a preview of the conflict between aesthetics and politics that occurs over and over in the novel, both between characters and in the conversations they conduct with themselves. Sheila's friend Margaux, a talented painter, "sometimes felt bad and confused that she had not gone into politics." Sheila's friend Ben says he has always wanted to be a theater director but, following a trip to South Africa, is no longer "convinced this is a good use of one's time." Perhaps he should be an activist, or write something that "evolves into actual engagement in the world." (Ben declares that art is a "narcissistic activity," to which Margaux shrewdly responds, "Even activism is very involved with righteousness, you know.")

As for Sheila herself, she admits that for years she had been asking the titular question — how should a person be? — to "everyone I met," finding that "in everyone there was something to envy." At times she fantasizes about becoming a painter, or a religious leader like Moses. Yet the appearance of total openness is deceptive. It is not the case that Sheila is genuinely at a loss about who she should be. Unlike Lena Dunham's *Girls*, the popular TV series to which it was often

221

**Sheila Heti and The Fight for Art**

compared, *How Should a Person Be?* is not a journey in search of the authentic inner self. From its prologue to its conclusion, Sheila knows that she is a writer, and should be writing. "It's time to stop asking questions of other people," she remembers admonishing herself during a trip to France. "It is time to just go into a cocoon and spin your soul."

The comedy and the pathos of the book, and of Heti's enterprise as a whole, are suggested by the narrative deflation that follows this admonition. "But when I got back to the city, I neglected this plan in favor of hanging out with my friends every night of the week, just as I had been doing before I'd left for the Continent." The remainder of the novel would not exist had Sheila actually stayed in her cocoon. We follow her as she goes to poetry readings, cuts hair at a hair salon, travels to New York in hopes of becoming famous, fucks a sexual virtuoso named Israel for weeks at a time, becomes obsessed with her friend Margaux, then worries that she has ruined everything by taping their conversations without permission, then reconciles with her over email. But for Sheila, unlike for Hannah Horvath or any other character on *Girls*, the calling of the artist never leaves her, and never leaves her alone. The novel lingers over her repeated failure to do "what I knew I had to do — leave the world for my room and emerge with the moon, something upon which the reflected light of my experience and knowledge could be seen: a true work of art, a real play." Not the difficulty of choosing one's path, but the difficulty of staying on the path that one has chosen, when that path is the path of art — this is Heti's most persistent theme.

222

But why should one choose the path of art? Not every fiction writer in the 2010s — or even all of those who wrote autofiction — had the same answer, and between 2012 and 2018, when Heti would publish her second novel, *Motherhood,* many seemed to lack answers to the basic question of how anyone could justify choosing art over therapeutic moralism. For reasons of sensibility, training, and perhaps of ego, these writers were not willing, as Eggers and Safran Foer had been, to renounce artistic ambition for political advocacy. But neither did they want to be judged guilty of neglecting the moral urgency of social movements such as Occupy Wall Street and Black Lives Matter, #MeToo, and (eventually) the "Resistance" to Trumpism. What to do?

Especially for those who tended toward autofiction, the goal often became to represent this autobiographical tension in their art. In his novel *10:04*, set in New York during the Occupy protests, Ben Lerner promised to take his readers on a journey "from irony to sincerity," though the narrator's halfhearted embrace of political activism is signified by his willingness to allow a protester to eat and shower at his house before watching him exit the subway at Wall Street on his way uptown for an art exhibition. By Lerner's next novel, *The Topeka School*, published in 2019, it was clear that the sincerity being promised would be applied quite literally to progressive activism. (The book ends with the narrator taking hold of the "people's mic" at a rally against ICE.) Sally Rooney's novel, *Beautiful World Where Are You*, juxtaposes the desires of its two young protagonists, a successful novelist and an assistant editor at a literary magazine, for romance, beauty, and spiritual fulfillment against their guilt about all the people "ground to death in horrific ways" while they went about their lunch breaks. In Christine Smallwood's *The Life of the Mind*, the adjunct professor protagonist, having sidestepped an environ-

mental canvasser on her way to the subway, imagines several fruitless conversations with the "raft children" of the future, who have little patience for her defense that her "personality is all wrong for cooperative action." In Rumaam Alam's *Leave the World Behind*, a family dices garlic and prepares book reviews in the Hamptons while a never-specified catastrophe closes in on them, perceived only in fragmented news reports and cryptic text message alerts. (The point, said a reviewer in the *New York Times*, is that "faced with the end of the world, you wouldn't do a damn thing.")

It is not quite right to call these novels propagandistic: to the extent they advance a political program, it is taken to be so obvious and obligatory as to render any attempt at persuasion superfluous. I am not sure it is right even to call them political. They are certainly politically correct. But their predominant weather pattern is not moral certainty; it is ambivalence. Ambivalence not about the rightness of their political beliefs, but about the rightness of their decision to go on writing fiction in light of those beliefs. They bear witness to the steady advance of political moralism across the categories of left-liberal culture and, progressively, into the minds of the artists themselves.

The ambivalence of these novels doubtless reflected a genuine structure of feeling for many intellectuals and artists during the Trump years. In interviews, the writers often affected a weary wisdom about the trap of "dogmatic" art, insisting that *of course* they knew the difference between literature and agitprop. Yet they were just as careful to deny that art should ever aspire to be above politics, and when they were not writing novels they could reliably be found spreading petitions to stop gentrification in Brooklyn, signing their names to open letters opposing Trump's candidacy for president, or writing op-eds assailing MFA programs

for being insufficiently politicized. In the shadow of these books, moreover, there flourished a less ambivalent genre, one far less worried about presenting art as a form of glorified sociology or amateur activism. The controversy in 2020 over the "immigration novel" *American Dirt*, by Jeanine Cummings, focused on the author's misrepresentations of her identity while the scandal of the book's aesthetic nullity went largely unreported; the novelist Lauren Groff, writing in *The New York Times Book Review*, even praised the novel for being "too urgent" in its moral mission for niceties such as humor, "joy in language," or "characters who feel real." On the (slightly) more literary side was Kristen Roupenian's short story "Cat Person," in 2017, which strained to blame patriarchy for a college student's uncomfortable sexual experience with an overweight older man, and became the most shared short story in the history of *The New Yorker*.

Arriving in the middle of the Trump years and on the heels of the ferment of #MeToo, which had contributed to the virality of fiction such as "Cat Person," Heti's *Motherhood* is simultaneously her greatest novel and her most perversely misunderstood. The narrator is, again like Heti, a 37-year old writer living in Toronto, in this case deciding whether to have a child. Like *How Should a Person Be?*, the book was often taken as a statement of ambivalence, for understandable reasons. The protagonist really does appear to be paralyzed by indecision. Yet also like *How Should a Person Be?*, *Motherhood* is ultimately less an ambivalent novel than an agonistic one. This time the temptation faced by the artist is not political commitment, but the creation of new life. The guiding question is not whether it is justifiable, or prudent, or morally responsible, for a woman to have a child today, but what decision will allow the narrator of the book to keep faith with her "actual life."

The fulcrum of this decision is understood from the beginning to be the narrator's commitment to being an artist. "One can either be a great artist and a mediocre parent," her partner Miles tells her, "or the reverse, but not great at both, because both art and parenthood take all one's time and attention." The narrator resents the zero-sum nature of this evaluation, but nothing in the book refutes its force. That it is perfectly possible to both raise a child and write novels is beside the point. "Mother" and "artist" are here the names of contradictory ways of being in the world, and each demands, like the monotheistic god, a full and undivided fealty. Miles only says explicitly what a younger version of the narrator had once felt with no less certainty:

> I remember being twenty and seeing several writers on a literary panel on stage — both women and men. They said that of course writing was important to them, but their children were more important. I felt so put off. They seemed so unserious to me. I never wanted to be like that—to have something in my life that was more important than writing. Why would they do that to themselves?

It is easy to miss, due to the companionability of Heti's prose, how oppositional this perspective is to the prevailing common-sense view that life in our time is — or should be — a negotiation between different roles to which one can, with the right intentions and time management skills, give equal weight and meaning. Perhaps some of the book's critics — many of whom betrayed irritation with Heti's insistence on drawing such stark dichotomies — were not wrong to feel judged by it. But the judgment was not for whatever choice the writer might

make — mother or artist? — but for hiding from themselves the depth of the necessary conflict between two different kinds of ultimate commitment. Following a visit to a fertility clinic, the narrator considers another practical way of delaying her decision: she can freeze her eggs. But she judges that this would be like "freezing my indecision," a sign of weakness. Her goal is to get to the other side of her indecision, not to prolong or mitigate it. But unlike the narrator in Kunkel's *Indecision*, she will get to the other side not by committing to democratic socialism, but by committing — or recommitting — to art.

That there is never much doubt the narrator will choose art over being a mother, and has chosen it before the novel even begins, is therefore not a weakness of *Motherhood*, as I have heard many readers contend; it is the backdrop for its central drama. The story has its analogue not in sociological essays about work-life balance, a woman's right to be childless, or the morality of giving birth in the age of climate change — none of which have much bearing on the narrator's final decision — but in the spiritual autobiographies of monks triumphing over the temptations of sex or lucre. As if to literalize the agonistic metaphor, the narrator compares her wrestling with motherhood to Jacob wrestling with the angel in the Old Testament. To "survive" this wrestling, to have her "life spared," is not only to resist becoming a mother, but to continue on as an artist. And the novel not only represents this struggle, it is the result of this struggle. "I know the longer I work on this book, the less likely it is I will have a child. Perhaps what I'm trying to do in writing this is build a raft that will carry me just so long and so far, that my questions can no longer be asked."

The recurrence of the prayer to stop asking questions from Heti's first novel indicates the strength of the artist's aspiration

to find peace from the perplexities that inevitably cause her to question the ultimate value of her own activity. The fact that the questions do not stop reflects the impossibility, not to mention the inadvisability, of that aspiration ever being fully satisfied. The cocoon in which the artist spins her soul is not a monastery, and no artist could survive as an artist if she lived locked away from the world's problems for good. Heti often imagines this dynamic in terms of trying to find the right "distance" from which to view her life. If submission to the social roles of the mother or the activist represents one kind of threat to the life of the modern artist, retreat from worldly temptations represents an equal and opposite threat: on one side, the artist risks disappearing into society, on the other, disappearing from it.

*Motherhood* is Heti's finest novel so far — one that deserves to be considered not as part of the exploding contemporary literature on motherhood, but as a literary parable in the meditative modernist tradition inaugurated by *The Trial* — in part because she achieves the perfect distance from her subject-matter. The narrator of the novel is close enough to make the personal stakes of the choice she has before her seem real and vital, while she is also far enough away to invest those stakes with an impersonal dimension that outstrips any merely subjective or sociological significance. The style in which she decides the content of her "actual life" indicates the inescapably aesthetic aspect of the choices we all make to shape the composition of our lives as a whole.

*Motherhood* also represents an advance in Heti's thinking about art. The advance comes because Heti takes the temptation of motherhood so much more seriously than she does the

temptation of politics. In contending with the good of creating new life, far more than in contending with the (more ambiguous, in Heti's estimation) good of therapeutic moralism, the artist is compelled to offer an articulation of the equal or greater good of creating new art. And it is in and through the wrestling match between art and motherhood that a new note enters Heti's fiction, one only barely detectable in *How Should a Person Be?*. In *Motherhood*, Heti is inspired to articulate why art can be not only an authentic, a creative, and a beautiful activity, but also a reverent one.

Early on, the narrator tells us her mother had "cried for forty days and forty nights" when she was born, and that the current book "can be called a success if, after reading it, my mother stops crying for good." The narrator's mother, born to Holocaust survivors and portrayed as having conflicted feelings about motherhood herself, had always wanted her daughter to be "a dutiful, humble girl." But the mother and the daughter have different strong evaluations; they do not agree on the highest things. "She wanted me to be a doctor, like her," writes the narrator, "when all I had ever cared for was art. She didn't see what there was to care for in art." The novel becomes a referendum on whether the narrator can communicate what there is to care for in art to the non-artist who is her mother. Whereas some women feel that they owe their mothers a grandchild, she comes to believe that what she owes her mother is the novel she is writing. "What is wrong with living your life for a mother, instead of a son or daughter?" the narrator asks, and then answers:

> There can be nothing wrong in it. If my desire is to write, and for the writing to defend, and for the defense to really live — not for one day, but a thousand days, or ten

**Sheila Heti and The Fight for Art**

thousand days — that is no less a viable human aspiration than having a child with your mind set on eternity. Art is eternity backwards. Art is written for one's ancestors, even if those ancestors are elected, like our literary mothers and fathers are. We write for them. Children are eternity forwards. My sense of eternity is backwards through time. The further back in time I can go, the deeper into eternity I feel I can pierce.

*Motherhood* is not, it turns out, a book about a future daughter, but about a current one. In the novel's final pages, the narrator describes emailing the manuscript of the book to her mother "in great fear and trepidation." Then she goes out for a walk and falls down a set of wooden steps. Her mother responds the next morning, blessing the book as "magical."

The definition of art as "eternity backwards" is not casual; it returns in *Pure Colour*, where Heti reprises the role of artist-as-daughter, this time through Mira's relation to her dying father. Heti does suggest a conflict between being a daughter and being an artist, in a poignant scene where Mira, sitting next to her father's sickbed, reflects on how she has never been able to love him with the same devotion and certainty with which she loves books. Still, we can infer that Heti does not feel the roles of artist and daughter to be completely incompatible, as she does the roles of artist and mother, or artist and activist. Why? Perhaps it is because being a daughter is backward-looking, an orientation toward one's parents and through them to the "ancestors," which is also how Heti pictures art. Motherhood and political activism are, on the other hand, both forward-looking ("eternity forwards"). Whereas the one values the present as the richly inherited product of the past — and thus worthy of remembrance and aesthetic appreciation, if not of

awe — the other devalues the present as a (deficient) precursor to a better future, a condition that Heti associates in *Motherhood* with women who are viewed not as Kantian "ends in themselves" but as merely a "passageway through which a man might come."

But is it true that art is really backward-looking? The claim may seem surprising. Heti writes in a modern tradition characterized by formal experimentation and often associated with Ezra Pound's dictum to "make it new." Indeed, the preponderance of the advanced literary criticism of the mid-twentieth century was an attempt to cement an alliance between modernist art and leftist, often revolutionary, politics. The apex of this genre came with Theodor Adorno's essays on Kafka and Beckett, which held that such literature compelled the individual to come to a full understanding of the unbearability of life in modern capitalist society and thus be inspired to rise up against it.

It is worth noting that, for Adorno, what gave these books their political potential was not any explicit political "engagement" by their authors; it was, rather, their commitment to portraying the world exactly as they experienced it, as artists. Yet however great its interpretive power (and Adorno's was very great), this style of criticism tended to ignore another important strand in modernist art, which had always been oriented at least as much toward the past as toward the future. The formal innovations undertaken by many modernist writers were intended to preserve those immaterial substances — whether one called it life itself, the remembrance of things past, or the stream of consciousness — that they perceived as being under threat in a rapidly secularizing, industrializing world. One critic described *Motherhood* as a "talmudic text," a judgment that might seem to find confirmation in Heti's

acknowledgement that her writing has been influenced by Judaic traditions of debate and questioning. At the same time, the narrator of *Motherhood* admits that, though she "badly wanted to be religious," she knows that "God is not true." Heti can be said to be working in the drift of those modernists who saw their art as the secular vessel for inquiries and energies they could no longer take seriously within a religious framework. The point of making it new was often to preserve something old. "In contrast with those whom we have called materialists," wrote Virginia Woolf in her essay "Modern Fiction," "Mr. Joyce is spiritual."

When the narrator's mother in *Motherhood* calls her book "magical," she gives another name to what the modernists hoped their artworks could keep from being washed away by the waves of modern disenchantment. Yet if *Motherhood* is on the one hand Heti's most convincing statement of her commitment to art as against politics, parenthood, or medicine, it is also a statement that attempts to incorporate her mother's wish that she become a "humble girl." This implies that art, like the religion it has endeavored to replace, is not necessarily humble, but that it can learn to be. The way it learns to be humble is through the agonistic contest with other ways of being. Agonism, as a form of struggle, implies respect and even reverence for one's opponents, as Jacob had for the angel. It means continuously asking how a person should be, not because we lack conviction about the answer but because our convictions will benefit from being perpetually tried and tested against all the available answers. Agonistic art models a way of contending, honorably but also honestly, with the sharp clashes between good and good that occur inevitably in the course of a modern life.

So Heti's agonistic novels show how our own convictions — whether we are birds, bears, or fish — benefit from the struggle to assert themselves against the alternatives that animate those around us. But by choosing in her most recent novel, and the one written directly after the confused response to *Motherhood*, to make her main character an art critic rather than an artist, I think Heti means also to suggest something about what it takes for the artist in particular to make herself understood. Her work broaches the important if rarely asked question of why the cultivation of an aesthetically literate public for art — a public capable of appreciating artworks not merely as a pretext for the discussion of culture and politics — should matter to us today.

In interviews about *Pure Colour*, Heti has mentioned a book called *Manet and His Critics* by George Heard Hamilton, which she finds herself "always coming back to." Hamilton's book is a study of the critical response to Manet's paintings in his time. Much of this response was mocking and dismissive, on the grounds that Manet's art was narcissistic and undignified, failing the standards of aesthetic inspiration set by his predecessors. Early in *Pure Colour*, Mira describes a lecture by an "old professor" at her school who, sounding like some of the critics in Hamilton's study, impugns Manet for choosing a "ridiculous subject matter" and making art that did not edify or "lift up" the viewer. Heti herself has faced similar kinds of criticism, but *Manet and His Critics* can be consulted for clues not only to Heti's view of her critics, but also for her view of herself. Manet, as his great literary defenders Baudelaire and Zola insisted, was one of the earliest exemplars of a modernist sensibility that was in the process of emancipating itself from

233

the dictates of both romantic and religious art. Against the demand that his art offer its audience some higher inspiration, Zola recognizes that the modern artist's job was only "to seek and to see for himself." Here one can hear the echo of Heti's discussion of Knausgaard's enterprise, and by extension her own, as one of finding a form to depict the "inner core" of their experience, no matter how "small and ugly" were the things one might find there.

That a viewer whose taste has been shaped by conventional standards will have difficulty initially comprehending the virtues of such writing, or painting, explains why the critic becomes such an important mediating figure between the modern artist and the society that both produces and is likely to (at first) disclaim her. The point is not that ordinary people are incapable of appreciating modern art; as the example of Manet shows, they are sometimes better able to appreciate it in the long run than are all but a few critics. Yet the role of the critic in the artist's own time is still significant. It can prepare the way in the broader public for the cultivation of the values and the virtues that are internal to art as a distinctive practice and a meaningful human activity, or it can discourage them. According to Hamilton, Manet's critics mostly did the latter, often merely "reiterating the public sentiments" rather than doing anything to "clarify the situation." The lesson is worth keeping in mind as we struggle to emerge from a period in which our book reviewers, literary prize committees, and publishing houses have too often, rather than showing what it means to make judgments informed by aesthetic criteria, merely reiterated and amplified public sentiments that have nothing whatsoever to do with the internal values of art.

Late in *Pure Colour*, driving to see Annie and tell her it is wrong to be a fixer, Mira thinks about Manet. She reflects

234

especially on his still-life *Asparagus*, appreciating all the things that her professor had denounced: "the simplicity of his expression, the lightness of his touch, the muteness of his colors, how minor a thing an asparagus is." Beginning by recognizing the qualities that are internal to the painting — color, proportion, and brushstroke — she works her way out from there to the style of character that the craftsmanship reveals: "the perfect balance between carefulness and carelessness." Then she moves to consider, true to form, the way of being of the creature who had been able to create and invest its soul in such a thing. In contrast to the fixer, who is always "complaining of being tired," an artist is "driven to make art by the spirit inside them, making an artwork like a signal or flare calling out, beckoning its kin to come near," she writes, "That is why an artist never tires of their task."

It reveals something about our estrangement from a potent aesthetic vocabulary that even Heti's most thoughtful and sympathetic critics so often praise her as a philosopher or a mystic, as opposed to the quietly crusading artist she has always insisted she is. There are philosophical and mystical elements in all of Heti's fiction, and much can be gained from examining them; certainly, this is more productive than reading her as a sociological essayist or an ambivalent memoirist. But there is a reason that Heti titled her novel *Pure Colour* as opposed to *Pure Reason*, and a reason that the deity she imagines is compared to a painter, who is "most proud of creation as an aesthetic thing." This is not Moses's God, it is Manet's. And it is for this God, especially in times of political temptation, that the sincere artist stubbornly and reverently fights.

**Sheila Heti and The Fight for Art**

ISAIAH BERLIN *and*
ADAM MICHNIK

# *"I Want to be Able to Say Anything I Wish to Say"*

*The following conversation took place in Russian in 1995 at Headington House, Isaiah Berlin's home near Oxford.*

**ADAM MICHNIK**: What do you consider yourself to be: an Englishman, a Jew, or a Russian?

**ISAIAH BERLIN**: I have lived here for seventy years now and people see me as an Englishman. After all, Oxford is the essence of Britishness. But though I have become a bit Anglicized, I am still a Russian Jew. I am a Jew simply because one cannot cease

being a Jew, not because I cultivate a Jewish culture or a Jewish tradition. Those are important things; however, we Jews have paid too high a price for them. If I were sure that by drinking this cup of coffee I could, just like that, turn all Jews into Danes, I would do it. I don't know of a single Jew, converted or not, who is free of anxiety; it is as if all Jews feel a vague sense of unease. There are millions of Jews in the world whose children grow up with such a feeling.

Assimilation was not successful. Many Jews cannot assimilate. They are a minority, and minorities suffer, and they strive to be better than the majority. If one lives in a foreign country and doesn't like it there, one can go back to the country one left, either one's own or the one that one's parents left. Only Jews cannot do this, because there is no such country.

**ADAM MICHNIK**: And Israel?

**ISAIAH BERLIN**: For those who were newcomers there, it was not home. True, those Jews who were born in Israel have their home. But Arabs, their enemies, are there too. They force them into war. Then perhaps it is better to live in New York? In any case, I would not be able to live in Israel. I would be unhappy there.

237

**ADAM MICHNIK**: You were born in 1909 in Riga. Leszek Kołakowski, your Oxford friend, calls you in jest "The Great Son of the Latvian Nation."

**ISAIAH BERLIN**: Let's just say that I am a peculiar kind of Latvian, and that there are no other Latvians like me. I know only a few Latvian words, '*Kur tu teci, kur tu teci, gailiti mans?*', which means, 'Where are you going, where are you going, my little rooster?' — from a Latvian folk song. And '*Cik maksā?*', 'How much is it?' That's all. But my mother knew Latvian. My nanny taught her.

**ADAM MICHNIK**: You come from a well-to-do intellectual family.

**ISAIAH BERLIN**: My father was the adopted grandson of Isaiah Berlin, who purchased some land in 1862. During the reign of Tsar Alexander II, Jews could buy land. And when the railroads were built, the price of land went up. Berlin became a millionaire. His only [adopted] son married the daughter of a Hasidic rabbi. Because a Jew must be either a learned rabbi or a wealthy man, the sons of wealthy men married the daughters of rabbis. Isaiah Berlin did not have any children, so he adopted my grandfather, the son of his sister-in-law. His sister-in-law was really poor. She ran a small shop while her husband spent entire days in the synagogue.

We lived in Riga, and my father owned forests and sawmills. Timber and planks went west, and my father went with them. He spoke English, French, and German — he had quite a way with his clients. Everything went well and then 1914 came. The Germans were victorious at Tannenberg and it looked as if they might enter Riga. Jews preferred them to the Russians if only because anti-Semitism among Germans was not as overt as in Russia. But my family feared that they would be cut off from their forests, and they went deep into Russia, to a village that belonged to my father's firm.

There were peasants there who cut the wood, the old landowner who was slowly dying, and public servants — officers who had not made it to the front, and their ladies in long muslin dresses. In a word, this was the Russia of Turgenev. We picked mushrooms and blueberries in a huge wood. From a child's point of view, this was an absolute paradise. From there, we moved to Petrograd.

**ADAM MICHNIK**: And there you witnessed the 1917 revolution?

**ISAIAH BERLIN:** Yes. I remember my father took me out onto a balcony of our house. We lived at that time on Vasilevsky Island, and I saw people with banners that read "Down with the Tsar," "All Power to the Duma," "Down with War." The crowd was not large and suddenly soldiers appeared. My father said: "Soon blood will spill. We'd better not watch." Then the soldiers started to mingle with the crowd and father said: "It's the revolution." The first revolution, the February one, was liberal, and my parents liked it. Aunts and uncles went to the rallies and were entranced. "Kerensky's wonderful! Lvov's wonderful! What extraordinary people!"

In the summer, we went to a small town called Staraya Russa. When we came back to Petrograd in September, I saw the posters of the Provisional Government. It had a multitude of parties — you cannot imagine how many of them there were. I saw young people who were tearing down posters and painting the hammer and sickle in their place. I liked that. My father was not enthusiastic. In general, in our circles, no one, at first, saw anything remarkable about this second revolution. The elevator wasn't working. Newspapers were not being printed. Half the shops were closed. There were leaders of some sort. Everyone had heard of Lenin and Trotsky. They were always mentioned together as though they were some kind of company or other.

**ADAM MICHNIK:** Lenin and Trotsky Inc.

**ISAIAH BERLIN:** Indeed. I believe that Lenin was a fanatic, a dangerous one, though an honest man. Trotsky, however — a terrible hoodlum. And he had to be hanged. Why? I was never able to understand. Perhaps because he was a Jew and one could expect the worst from him.

There was a strike and the trams were not running. At first

239

the tram drivers' union did not support the Bolsheviks, but the situation changed gradually until it turned around completely. At the time we were already living in one room, because there was nothing to heat the apartment with. There was only peat. Food was in short supply. I remember standing for hours in line wearing gigantic valenki — soft felt boots — waiting with the adults for I don't know what. I didn't go to school.

My father supplied timber for railroads — under the Tsar, under the Provisional Government, and under the Bolsheviks. No one would touch us. My father was summoned to Section no. 2 at the offices of the Cheka [the secret police] but then he was released. Yet he feared and hated Communism, and he decided to leave. We left in 1920 in a completely legal manner. Since my father was an Anglophile, he decided that we should go to England.

**ADAM MICHNIK:** To London?

**ISAIAH BERLIN:** No. A friend of my father's, an Englishman, told him, "Mr. Berlin, we Englishmen do not like towns. We like to live in the bosom of nature." So my father found a house in a suburb some distance from London, a village in the truest sense of the word, in the middle of nowhere. There I went to school. The only English I knew was a poem, "Daisy, Daisy ..." and I recited it in a horrible Russian accent. According to my mother, I used to come home from school crying. But after a month I was already speaking English. Around New Year's Eve, I acted in an old English play, *Babes in the Wood*: that is, I became Anglicized.

**ADAM MICHNIK:** And then you studied at Oxford?

**ISAIAH BERLIN:** I was there for four years, and I graduated from the faculty of ancient and contemporary philosophy and [ancient] history. I enrolled at Corpus Christi College. My

grandfather in Riga, a pious Jew, could not understand how I could study in a place with such a name.

**ADAM MICHNIK:** Weren't you ever religious?

**ISAIAH BERLIN:** My family was not observant. My parents went to synagogue the same way people go to Anglican church: five, six times a year. When pious Jewish boys went home on Friday afternoon — when the Sabbath began — I remained at school. But I knew I was a Jew. I knew the Bible, and I could read it in Hebrew.

**ADAM MICHNIK:** How about Yiddish?

**ISAIAH BERLIN:** My grandfather and grandmother spoke "the jargon," as it was called at the time, and my parents used it in their own circle. I don't speak or read Yiddish, but I understand about every other word.

**ADAM MICHNIK:** Joseph Brodsky, in his essay commemorating your eightieth birthday, wrote that he owed his mental health in large part to people belonging to the Oxford class of 1930. He had in mind you and the poets Stephen Spender and W. H. Auden. Unlike you, those two were very leftist. Spender even belonged to the Communist Party, although he was soon expelled for doubting the guilt of the defendants in the Stalinist trials.

**ISAIAH BERLIN:** But he wasn't really a Communist. He wrote a book about Communists, not a good one. I asked him then, "Why not write a book about us instead?" He said he wanted to start out with something strong, authentic.

Auden in those days did not acknowledge any traditional norms. He believed, for example, that anyone who made it into history and was not married was a homosexual. "Kant?" I asked him. "Yes, he too, as well as Jung and Descartes.

Probably the same with Diaghilev and Stravinsky." He was a fanatic about this.

Auden followed his lover to Spain during the civil war. When he couldn't find him, he went to the Minister of International Affairs and asked, "Do you know where my friend Tony [Hyndman] is?" General Franco's troops were positioned at the border, but Auden was oblivious to it. He visited the chief of the Communist Party, who was actually a worker, and said, "The Party should adopt a decisive stance on homosexuality." He was told, "Please get out. At once! You want to tear the Party to pieces." Can you imagine this worker talking with Auden about the Communist Party line on homosexuality? They threw him out and so he did not even need to resign from the Party officially. This was the end of his Party career, in 1938. But, again, Auden was never really a Communist.

**ADAM MICHNIK:** And did you go to Spain?

**ISAIAH BERLIN:** No. But I collected money to send packages there. I signed petitions. And I might even have taken part in some kind of rally in support of the Republican government. I was neither a member of the Party nor even a sympathizer.

**ADAM MICHNIK:** In all your essays, one can see a love for the Enlightenment. What, according to you, is the connection between the cult of the mind, Jacobinism, the Reign of Terror, and the Revolution?

**ISAIAH BERLIN:** Jacobinism in some way derives from Enlightenment thought. The great French intellectuals of the eighteenth century believed in the objective laws of social evolution. They thought that once we discovered them, we would live according to them. And those who did not obey the laws and, through their own ignorance, caused themselves pain, would be isolated. Jacobins thought that the world was

drowning in darkness and backwardness, of which it should be cleansed, and that people who were opposed to this must be destroyed. This is the consequence of fanatical rationalism.

**ADAM MICHNIK:** In some sense, Robespierre and the guillotine are a peculiar consequence of the Age of Enlightenment.

**ISAIAH BERLIN:** The philosophers of the Enlightenment were, on the whole, decent people, for example Holbach, the Encyclopedist. They were against cruelty, against violence, against obscurantism. Against the Church. And in the end, all their opposition led to the Great Terror and the guillotine. Auden told me at one point that there is a straight road leading from Rousseau to the Gulag. But here he exaggerated.

**ADAM MICHNIK:** On the other hand, you saw a clear precursor to totalitarianism in Joseph de Maistre, a conservative.

**ISAIAH BERLIN:** The world, according to him, is incurably sinful. From the fact that man is the only animal that kills the members of its own species, he concluded that man should be ruled with an iron fist, and for that one needs an authority beyond questioning. This is already fascism.

**ADAM MICHNIK:** Can you conceive of conditions under which the Church could defend liberal values?

243

**ISAIAH BERLIN:** Yes, it does so from time to time. But that is not its nature. Custine was right to hold that those who agree with a liberal Catholicism betray it, although of course there are liberal Catholics.

**ADAM MICHNIK:** It seems that in Catholicism there is a conflict between values and freedom.

**ISAIAH BERLIN:** I would not rule it out. Christianity does not allow stomping over men; nonetheless, Christians always try.

This goes back to the Church Fathers. Augustine was the first to decide that one could apply torture to heretics.

**ADAM MICHNIK:** And what was the intellectual climate in England in the 1930s?

**ISAIAH BERLIN:** There are no intellectuals in England. There are intellectuals in Russia and in Catholic countries, in Italy and in France, because the intelligentsia was born out of the dominance of the clergy in public life. No one in England would say, "The Anglican Church is our enemy." Likewise in Sweden, no one would say, "Lutherans are terrible people."

Cultural life in England was under the influence not of Communism but of the left. Who wasn't a leftist? Evelyn Waugh is an exception and he was even more than conservative. He was a fascist sympathizer although he didn't advertise it. But he contributed to a magazine that published writers from the extreme right with fascist sympathies.

**ADAM MICHNIK:** And T. S. Eliot?

**ISAIAH BERLIN:** He was a pleasant, placid, slightly conservative poet. While he was greatly respected, he was much further to the right than many realized.

Towards the end of the war, the poet Archibald MacLeish, who was the director of the Library of Congress, visited England, and wrote an article for the *Times* about the need to rebuild the libraries destroyed by the fascists. Three days later the *Times* published a letter from Eliot saying, "My friend Archibald MacLeish holds that fascists allegedly destroyed some libraries. National Socialism exists but it is entirely different from the regime which reigned until recently in Italy and still exists in Spain." According to him, fascists were decent people. They destroyed Europe? This can't be! Europe for him was destroyed not by fascists but by National Socialists.

I knew Eliot personally. He was an anti-Semite, though no worse than others of this kind. After the war, in an article commemorating the twenty-fifth anniversary of the [Hebrew] University of Jerusalem, I wrote: "Jews, of course, are hard to put up with, but one has to tolerate them in a democracy. Plato and Eliot do not agree with that." Someone sent this article to Eliot. I was in the States at the time, at Bryn Mawr College, and Eliot, who had also lectured there, sent me a very polite letter. "I hope your bedroom is more comfortable than mine was. As far as I can recall, the central heating works pretty badly. I hope it is not too noisy at night and that you are able to sleep peacefully." And finally: "What you wrote about me is not true. I have nothing against Jews. I am a poet, not an anthropologist. Racial matters do not interest me. The only thing I have against Jews is that they have not converted. They could have converted to Christianity at the time of the Roman Empire, but they didn't."

I responded: "Dear Sir, you should not think that Judaism is just a religion. You cannot say 'an atheistic Catholic' or 'a Godless Baptist,' but you can say 'a Godless black man' or 'a Godless Jew.' Everyone knows that being Jewish does not imply only going to synagogue. It is something more."

He responded: "I understand you, but you are wrong. Racial matters do not interest me. I have nothing against Jews in Palestine. Anywhere else they will have trouble. When we have more time, we should continue this interesting correspondence."

He had been sending me books to review for his journal, the *Criterion*, but after this exchange of letters he became somewhat reserved and our relations cooled. But as a poet, he was a genius.

**ADAM MICHNIK:** What did you think about the future, back in the 1930s?

**ISAIAH BERLIN:** That there would be war. All young men like Spender and Auden wrote as if there was a bomb nearby ready to explode at any moment. As if they expected some sort of disaster, something terrible. As if something was approaching that would consume them. Consume all of Europe.

**ADAM MICHNIK:** You left Oxford and philosophy for the duration of World War II, joined the diplomatic service, and were sent to the British Embassy in Washington.

**ISAIAH BERLIN:** I went there in 1941. My task was to get America involved in the war, and in the end I succeeded!

**ADAM MICHNIK:** Perhaps the Japanese helped you a little.

**ISAIAH BERLIN:** Certainly. They attacked Pearl Harbor. But there was no agreement between Japan and the Third Reich to fight together. Japan did not have to invade America, but it did. America, and the Catholic Church in particular, did not want to fight at all. Could Roosevelt have avoided the war with Germany? Maybe yes and maybe no.

**ADAM MICHNIK:** Were you ever afraid that Hitler would win the war?

**ISAIAH BERLIN:** Certainly I was. But the English were not; their main shortcoming is a lack of imagination. Frenchmen calculated that Germany would win, hence they surrendered. But Englishmen simply could not imagine that foreign soldiers could put their feet on their soil. That is why they were not nervous and did not panic.

Neville Chamberlain did not like Hitler and Nazism, but for him Russia and anti-Communism were decisive. Chamberlain thought: it's too bad about Jews, it's unfortunate that

246

Hitler is obsessed with them, but what can one do? After all, he is fighting Communism, and that is what is important.

This is what many people at the top thought. Most others were unconcerned about such things. For many of them, it was hard to believe that there would be war. If it were not for a leader like Churchill, Germany would have occupied England. Somebody else in his place might have proposed to bargain with Hitler. Like Stalin in 1939, he would have thought that it was possible to bargain, for example using Mussolini as an intermediary. It was Churchill who was against this. No matter what others said, he did what he wanted.

I have always believed in the role of the individual in history. If Churchill had been struck by a falling brick at some point and Halifax had become prime minister, he would have made a deal with Hitler. For a year nothing would have happened, and then Germany would have suddenly invaded England.

**ADAM MICHNIK**: I have heard that Churchill liked reading your war reports from Washington.

**ISAIAH BERLIN**: That is a myth. My job was to report on the state of public opinion in the United States and about the power structure in Washington. I was a journalist, a chronicler of political moods. The difference between me and an ordinary correspondent was that my telegrams were in code.

It wasn't hard work. Americans told everyone everything. There were no secrets, other than military secrets of course. Hence it wasn't difficult for me to understand what was going on there. The telegrams I dispatched every week made it to the ministers and were also sent to our ambassadors. Churchill received them as well. Undoubtedly he read them, but I don't think that he talked about them. This much can be said: he

knew who I was. His wife, however, had heard of an American songwriter named Irving Berlin, who had given a lot of money to a charitable fund for British children. So when Churchill said that he would like to meet Berlin, his wife thought of Irving. And here began the misunderstandings.

**ADAM MICHNIK**: Misunderstandings?

**ISAIAH BERLIN**: When they met, the following conversation took place. Churchill said, thinking of my reports: "What, among the recent reports you have sent, is the most important?" Berlin, not understanding a thing, said, "I suppose *White Christmas*." Churchill, thinking that he was dealing with a crazy man who, to top it off, spoke with an American accent, said, "What do you mean?" Silence. Churchill's wife: "We are extremely grateful to you. You do such important things, and now this generous gift." Churchill, not understanding a thing, said, "What kind of gift?" Silence. Churchill: "Are you going to participate in this year's election?" Berlin: "You know, sir, until now I never took part in the elections, but now I am not sure about anything." Churchill: "When do you think the war will end?" Berlin: "Mr. Prime Minister, when I get back to the United States, I will tell my children and my children's children that the Prime Minister of Great Britain asked me when I thought the war would end." Churchill: "So you're an American?" Berlin: "Yes." Churchill, to his wife: "I told you that this is the wrong Berlin."

**ADAM MICHNIK**: When did you meet Churchill for the first time?

**ISAIAH BERLIN**: I ran into him by chance in the White House when he came to Washington. "What you are doing," he said, "is very important. Please continue." Later, during the Cold War, I met him at a dinner party in London. We did not talk much,

but I remember what he said — that we must decide which to bomb first, Paris or Rome, if the continent is conquered by the Russians. I didn't like Churchill much as a human being, but if it were not for him, none of us would have survived. I, in any case, would not have.

**ADAM MICHNIK:** In your essay "Meetings With Russian Writers" you described your stay in post-war Russia.

**ISAIAH BERLIN:** I was sent to our embassy in Moscow right after the Potsdam Conference in September 1945, and I remained until January 1946. The British did not have an adequate staff, so they decided that I should go because I spoke Russian. They did not want me to stay any longer and they offered me a post in the Ministry of Foreign Affairs. I refused mainly because I don't like to have anything to do with classified information. This presupposes a double life, and I want to be free, I want to be able to say anything I wish to say.

**ADAM MICHNIK:** When you were in Russia, you met Akhmatova and Pasternak.

**ISAIAH BERLIN:** I arrived on the day of an official dinner in our embassy. J. B. Priestley, a leftist writer, a welcome visitor in the Soviet Union, was the guest of honor. If someone thought that Soviet literature was the conscience of the world, he had to be feted. Priestley was a bit out of sorts, however, during this dinner. Perhaps his visits to the collective farms and factories had tired him out. Besides, the Soviet authorities blocked royalties for translations of books, and he liked money. In any case he left early. I took his place between Tairov, the theater director, and Kornei Chukovsky, the literary historian and translator. Sergei Eisenstein sat opposite me. That day I met a few writers who had not been allowed to see foreigners, but I met Akhmatova by accident when I went to Leningrad.

**ADAM MICHNIK**: This, however, was more than an accidental encounter.

**ISAIAH BERLIN**: We spent the whole night in her apartment. Everyone thought that something happened between us. Nothing did. We sat in opposite corners of the room and only talked.

The second time I saw her was right before my departure from Russia. I was returning to England through Leningrad and Finland, so I went to visit her and we talked for some three hours. Then, when she came to Oxford to receive an honorary degree, we spent a week together, but she was angry at me. According to her, there was some mystical connection between us, a spiritual connection, and we should suffer together, though staying apart. And I had permitted myself a vulgar act: I got married. I invited Akhmatova to dinner and she completely froze out my wife. She spoke nicely to me, but I know that she never forgave me — she was a Russian legend, and I had deserted her.

**ADAM MICHNIK**: You also wrote about your meeting with Pasternak.

**ISAIAH BERLIN**: Yes. I went to visit him in his dacha in Peredelkino, and we talked for a long time. Pasternak was an anti-Semite.

**ADAM MICHNIK**: In what way?

**ISAIAH BERLIN**: At least in the sense that whenever I said the word "Jew," he shuddered. He knew that he was a Jew and he did not deny it. Heine said somewhere that the Jewish religion is not a religion but a misfortune, and that is what it was for Pasternak, because he would like to have been a blonde, blue-eyed Sadko, a Slavic poet. His anti-Semitism is evident

even in *Doctor Zhivago*. That's why Ben-Gurion did not want him to be translated into Hebrew.

**ADAM MICHNIK:** You had no illusions about the Soviet Union, yet you never spoke about Communism in hysterical terms.

**ISAIAH BERLIN:** In Russia, I was followed openly by NKVD plainclothesmen. They did not want to spy on me, merely to intimidate me. I felt that all the Russians I met were simply suffocating. I thought: What should I have done had I not emigrated? Shot myself in the head.

I knew that Stalin was waging the Cold War, that he imprisoned and even murdered Russian prisoners of war who came from Germany. It was clear that we couldn't even begin to think about peace, that there could be only something in between: neither peace nor war. However, I did not support the proponents of Cold War rhetoric. I saw it up close, for I was in the States in 1949 when Senator McCarthy was out of control.

I did not want to think like the professional anti-Communists, because they thought only about how to mount a defense against Russia. But I never thought that Russia would actually go to war, unless the Soviet leaders sensed a weakness in their opponent. Perhaps if the French Communists had come to power, the Soviets might have come to their aid, and maybe even have occupied France. Luckily for us it never happened. I don't know why, but I was not afraid of it.

Even after the Cuban Missile crisis — I was at Harvard then — I did not think that it would come to war — although more than a few Americans believed that World War III was around the corner.

**ADAM MICHNIK:** What did you think about the future of Communism back in the 1950s?

**ISAIAH BERLIN:** In his memoir Spender gives an account of

our conversation at the time. He asked me what was the most pleasant thing that could happen in my life. The end of the Soviet Union, I told him, but of course we will not live to see it.

Sometime later, I was sitting at a dinner next to Mrs Thatcher. She asked me: "You know everything about Russia. Please tell me when will this terrible regime end?" And I responded that in a place where the secret police number three million, only war can topple a regime. "What pessimism!" she said, very irritated. "How can you judge the situation so badly? How can you even say such things?" Offended, she grew silent. Luckily, it was I who was wrong.

I have an old childhood friend who is a member of the Communist Party and a professor of history. Two years ago, I asked him, "What is going on with the Russian Revolution now?" "Not much," he answered: "uncertain country, uncertain times, uncertain people." You were not saying that during the last seventy-five years, I said. And he said: "Just you wait, there will be nationalism in Russia. And this will be worse than Stalinism."

**ADAM MICHNIK:** And what do you see as the sources of nationalism?

**ISAIAH BERLIN:** There is a theory that when you take peasants, who have for generations lived in villages, away from a traditional and patriarchal way of life, and transplant them to the city, they won't any longer have anything to believe in, hence they begin to believe in the nation. But the Germans were nationalists already in 1807, when there were no peasants in the factories. Nationalism, by the way, is a German invention. I think that in the final analysis nationalism is a result of harm inflicted. Germans held a deep grudge against the French for the harm they inflicted on them.

**ADAM MICHNIK:** Do you think that the nineteenth-century divisions between the left and the right hold true today?

**ISAIAH BERLIN:** In my opinion, yes.

**ADAM MICHNIK:** Perhaps there is another alternative, such as Popper's open society and closed society.

**ISAIAH BERLIN:** But it's all the same. The open society means liberalism. And the closed, conservatism. Conservatives in Russia are old Communists who want to preserve what was there.

**ADAM MICHNIK:** Solzhenitsyn, too, is an opponent of liberalism.

**ISAIAH BERLIN:** You know who Solzhenitsyn reminds me of? An Old Believer. Have you seen *Khovanshchina* by Mussorgsky? You will find there a climate of opposition to everything that is new and liberal. Solzhenitsyn is a monarchist by nature. He wants the Tsar back. He wants the Old Russia with the Tsarist officialdom, the chinovniks. His conservatism and traditionalism are very nostalgic.

**ADAM MICHNIK:** What do you think of the wave of conservatism rolling over the world?

**ISAIAH BERLIN:** It is a reaction against the failure of liberalism. People become conservative because it is something new for them. Take the United States: they elected conservatives to the Congress, even though they are political hooligans. The same holds for England. Here we have something called the New Right, who are awful people. But the whole post-war liberal world gave people nothing in which one could strongly believe. They need some kind of flame, and because reason does not give it, they were enveloped by boredom and a feeling that life has no meaning. I believe that boredom is the main reason

why people go to war or get involved in revolution. The main reason for the events of 1968 was that the students got bored.

However, young Poles may not like my advice — that compromise is unavoidable, that there is only so much freedom and so much equality; so much happiness and so much independence; so much democracy and so much tradition. One has to keep things in proportion, or else nothing will hold together. Everything will collapse and you will have to start from the beginning. What young person would want to march under these slogans?

**ADAM MICHNIK:** On one hand, we want tolerance, freedom, pluralism; on the other, if we are to fight for our goals we need consistency, courage. This is the paradox of toleration. If I were tolerant —

**ISAIAH BERLIN:** — you would be sitting with your arms crossed, doing nothing. This is the old story that conservatives speak of: "You liberals believe that there can be different points of view, so when you are the majority, you forbid us nothing. And then we gain the advantage, the scales tip, and we can indeed block you."

The idea that there is a paradise of some sort that we will reach in the end, either a liberal paradise or some other one, is an illusion. There are values which people believe in and you have to fight for these very things. Victory will never occur because certain fundamental values are mutually exclusive. The ideal world is impossible to attain. We must, however, do everything to approximate it.

URI TZVI GREENBERG

# The Poem of the
# Beautiful Landscapes

Why are the landscapes beautiful, and the approaches to
                                    the forest at twilight
drawn to the melody of the pipes warming in your breast,
and the bluish puddle on the other side of the railroad tracks
make the tune in your heart tremble and the body yearn
                                    to step over its banks
as if once, on a childhood evening, it walked there...?

Because every landscape in the world has its souls that
                                    were joined to it
by the finest desires and the sweetness of the heart's exaltation
in the days when love rose as if blooming spring and
                                    summer together,
and also in the days of a late-summer tear glistening in the
                                    mystery of parting...
and the ripened fruit reddening in the gardens...

No landscape is beautiful for itself, in its forest and its river
                                    and its well.
It takes its beauty, in all its facets and luscious scents,
                                    abundantly
from the souls who walk within it the walks of longing,
and from the jubilation in the blood and the living lyreness
                                    of the body...

With this weave the beautiful souls embroidered
                                    this empyrean
and stamped it with its verdant hues and poured wines
                                    of myrrh
into the feathery softness of its clouds.

If not for wounds of love
even unto the gift of blood and the ascension in flames
for the sake of family, or the honor of throne and temple,
                            or the sanctity of a liberation,
would there be such twilights morning and evening,
with the smell and the taste of must mingled in them?

If not for the grace of bodies and the ideas sprouting in
                            the heart and the head
about what is beyond them in the world,
would there be luxuriant trees such as these, or their fruit,
                                    or their birds' nests?

If not for the gaze of craving eyes with which all of
                            heaven once swelled
when lovers met, when the heart was lifted to the sky,
would there be such cubits of water on the other side of
                            the railroad tracks?

And if not for our incarnations before birth, now vanished
                                    from our minds,
if not for the recollection of the existence of marvelous
                                    bodies in a second reality
which the concepts of our language today cannot capture,
in which we rested in our cribs as all the moon's soul spilled
                                    onto their little posts...
in which we grew to the height of fathers' and mothers' knees
until our shoulders became tall, and equal to them...
in which we journeyed to the end of everything precious
                                    and enchanting,
in which we ate and drank foods and drinks
more pleasing than the foods and the drinks here and now
and we wore clothes woven in a way we do not weave today
whose aroma our nostrils sometimes catch from the
                                    garment of a rare man,
a soul-friend, who has been cast into our midst as if by
                                    a miracle....

Without all this, would there be any desire in the world,
would any heart rejoice at the end of the day anywhere
                                    in the world?
Would we set out in great ships from one end of the sea
                                    to the other
and tears form in our eyes as if recalling an obscure thing
                                    and its fragrance?

Truly the power of the desire that attacks us suddenly
                                          in the present
is owed to the memory-scents of vistas more beautiful than
                                          all beauty:
when we stroll on boardwalks along the canals in the evening
or on the warm spreading paths through a red
                                          mulberry forest,
or in the view, filled with desire, through the window
                                          of a train
of a small railway station in a field outside a town....

Scent-memories of distant furrowed scenes
which we inhabited in our previous wanderings
and loved with the love of youth: for all the wines and
                                          all the colors
and all the odors of the flowering landscapes and
                                          all the melodies
of all the instruments were to be found...there.

So that whoever inhales it, in its sweetness, for a moment
                                          has the sensation
of a rendezvous with a woman who is late, who was
                                          no longer expected
but like a miracle has arrived, in the torrid dusk,
                                          redolent of the forest.

In those landscapes our utterances were like musical notes,
we can still hear a hint of them sometimes in the
                                        most exquisite songs
and sometimes in the voice of a woman who is with
                                                someone else
but in those landscapes was with us, she was ours —

We slept in other kinds of nocturnal beds
made of wood that grows in no garden here,
we wore clothes of a different fabric
that our melancholy and discriminating hands
                                        occasionally discover
when they brush against someone's sleeve: a precious
                                miraculous event in the present....

If not for those landscapes, what would our life be now?

                        *Translated by Leon Wieseltier*

# DAVID THOMSON

# *Cross Purposes: Polanski and Huston*

We have to understand how movies have taught us to feel. That spell is always waiting to take us beneath the tracery of storyline so that we may plunge into the pit of what the story is about. And why we are breathless to see what happens while wondering if we will ever escape the pit. The picture business says this is fun for all, but lasting spells are more complicated than that.

It is evening, dusk, at one of the better homes in Beverly Hills. We are in the garden, by a pond. Our guy is there early, waiting, smoking a cigarette. We like this fellow a lot, though we know by now that he can be a chump. He is waiting for the bad man, the pivot of the mystery that our chump has been

exploring. And because he got there early, we feel his superior position, and share in it.

This is added to when the man he has called to the meeting arrives. This second man is older, not far short of elderly; he leans on a cane and his eyesight is not what it was. So then our guy nails the old man, tells him everything he knows. And what he knows is terrible, including the way the older man had raped his own daughter and become father to his grandchild.

There is talk between the two of them, stealthy and maneuvering, so it seems. But something else emerges in the way the older man declines, in his urbane and polite way, to be ashamed or apologetic. The meeting is not quite what the chump anticipated. Noah Cross is a monster, but there is something serene about him that is entrancing. Really, that is the word. For in the way he admits his crimes and his ambition, this hideous man becomes immaculate. If someone talks sense grammatically in a movie for a couple of sentences in a row, there's a chance he'll have us by the throat.

"I don't blame myself," Cross says. "You see, Mr. Gittes, most people never have to face the fact that at the right time and right place, they're capable of anything."

There you are, it's not even two sentences. But he has us at "Mr. Gittes," the smoky disdain in "most people," and the authority we adore. It's why we are there in the movie dark, because it is a process, a séance, in which we want to pretend that *we* could do anything. The chump is really very appealing: it's Jack Nicholson, after all — has anyone ever been more lovable? But Noah Cross doesn't bother to be even likeable. He has too much command to be needy. That serenity of his comes from running the show. And all our lives at the movies we have been in awe of the show and the way life starts turning over on the screen, better than we have ever known it and

understanding our hopeless dream — of being like *that*.

You have to admit to what you are buying into in *Chinatown*. Far from just a clever film noir and a cool 1937, it's the heart of darkness, and we know that it's the heart because that is where we live. The conclusion of that movie has evil taking over the town, without a hint of mercy or escape for that daughter and granddaughter. That was a point of dispute between the screenwriter of the film, Robert Towne, and its director, Roman Polanski. Towne had wanted her to get away. Polanski won that argument and took charge of the story. Why not? He knew that being in control was the point of the game. That's what lost children dream of.

John Huston (the man doing Noah Cross) was born in Nevada, Missouri, in 1907, an only child, the son of the actor Walter Huston. His parents divorced when he was young, and he traveled with his father, touring in theater, and watching horse races with his mother. He adored his father but had troubles with his mother, and a good deal of ill-health, though it was said that he was a very strong, athletic boy with a willful turn of mind. Like, don't get in his way.

He was put in boarding schools, but he believed in learning from life. He had a spell as an amateur boxer; he painted and followed opera; he rode horses and he went after girls. He was a man of the world, and men soon told stories about his adventurous gambling spirit and his recklessness. But some observed that he had a hard, cold streak in him, and a way of needling other people. He had a languid, dreamy way of talking, with a tough laugh. He could go from seeming ugly to inhabiting sunlight, and he seemed to relish that volatility.

He saw so much theatre that he absorbed acting as a way of life, and he took it for granted that theatricality always triumphed over the actual.

He went to Mexico for a time and became attached to that country's cavalry in an unofficial way. He married and seems to have urged his wife and himself into alcohol. He was in Los Angeles, keeping company with his father. But also as a way of thinking about getting into pictures. In his early twenties, he had stories published in *Esquire* and *American Mercury*.

It was in 1933 that he nearly came to grief. He was in an affair with the actress Zita Johann, and he was drunk while driving her; there was a crash and she damaged her lovely face on the windscreen. Then a few months later, in a car with another woman, off Sunset Boulevard, he struck a pedestrian, and she was knocked thirty feet in the impact. She was killed and it was apparent that Huston had been drinking. Her name was Tosca Roulien, and she was a dancer. He said she had just stepped into the road so that he had never seen her.

This was ugly stuff and his father moved in to help the son. Nothing is clear now, but the story went that Walter went to Louis B. Mayer, who put pressure on the D. A. so the case was buried. But there were angry pieces in the press and charges for damages. Huston said later that he was traumatized, and he was sent away to London to get out of the heat.

That was long ago, when Hollywood was a secure kingdom with its own law and order, when a boss could smother scandal if it suited him. And John was reckoned to be a talent with a future: he would one day do pictures for Mr. Mayer at MGM. It would seem artificial to get indignant over this, all these years later, but it happened in a Hollywood where so much was glorified and so much was covered up. As if one could get away with anything.

**Cross Purposes: Polanski and Huston**

John Huston came back from Europe and he was soon putting himself about as a very good screenwriter. He had a knack for knowing how stories could work on screen; it was not hard, with his easy-going drawl, and his visionary eyes, to persuade the system that he could be a director. So he slid his way into being in charge of *The Maltese Falcon*, with Humphrey Bogart, Mary Astor, Sydney Greenstreet, Peter Lorre and Elisha Cook Jr. Tough deal. That Dashiell Hammett material had failed twice before as movies, so it was a wonder that Huston made it a home run, creamy with talk and innuendo, without any hint of strain, just letting his arms move through the necessary semi-circle and watching the baseball go 410 feet into the sunlight and the crowd.

All his life John Huston could do home runs like that, making it look easy: you can see the lovely arc of the hit in *The Treasure of the Sierra Madre, The Asphalt Jungle, The African Queen, Fat City, The Man Who Would Be King, Prizzi's Honor* and then *The Dead,* at the end of his life, when he sat there in charge but dependent on an oxygen machine.

That's not many home runs, you may say, and it is true enough that Huston also got into some bold but uncertain literary adaptations, films no one else would have attempted — *The Red Badge of Courage, Moby Dick, The Roots of Heaven, Reflections in a Golden Eye, Wise Blood, Under the Volcano*. Not to mention several films where no one seemed to be directing them — *We Were Strangers, The Barbarian and the Geisha, The Misfits, The Bible, Sinful Davey, The Mackintosh Man, Phobia, Victory, Annie*. That's a lot of striking out. But Huston had a batter's attitude: that if you hit around .300 you were a king. The hell with the auteur theory. A director knew what

audiences took for granted: that most pictures were dead long before arrival on the screen. So you forgot about them the way Ted Williams could take an o for 4 and feel fine about tomorrow.

And no one ever said John Huston shouldn't be getting away with this, because quite clearly he *was* getting away with it, in the steady faith that "most people" were stuffed and stupid. He didn't care.

Noah Cross in *Chinatown* was another home run (bases loaded), and the best mainstream picture that Huston ever touched. I have never lost the feeling that, in all his crazed and turbulent life, Roman Polanski had held on and stayed patient in the intuition that one day he'd get someone like John Huston telling Mr Gitttes how the world worked. Every scrappy, diminutive Polish French Jew on the run is waiting for that pitch to hit.

This is a piece about Roman Polanski, you guessed as much, and you might as well face it. The rest has been setting you up.

He was born in Paris in 1933, that special year in Huston's life. His given name at first was Raymond Liebling, and you likely know that his life was terrible, so that you had to come to terms with his insolent smile and the way he carried on. When he was four the father moved them back to his home in Poland, with every good intention, and so they entered on scenes of ultimate dismay. The mother died in Auschwitz. He barely survived the Krakow ghetto or years living on the run, being underground, hiding, lying and doing all the unmentionable things survivors have to do while still looking

the camera in the eye at the end of it all and saying, yes, we came through and everything will be all right now, when you know that very little will be all right, or was ever meant to be. "Most people..." He never had self-pity.

After the war Polanski was in Poland, and he went to film school in an age of furious creativity and brave opposition to Communist authority. He made some brilliant, surreal short films, notably *Two Men and a Wardrobe* (1958), and he did a graduation project, *Knife in the Water*, that is so expert you know the kid had something in his bones and blood, a lack of sentimentality, let's say, that had nothing to do with what a school might have taught him.

He then made his masterpieces: *Repulsion* in 1965 and *Cul de Sac* in 1966, low-budget, black and white pictures based in Britain, the one where a stunned Catherine Deneuve is going mad in a South Kensington flat, and the other where her sister, Francoise Dorleac, watches a group of absurd men turning stupid on a wild shore of northern England. The grasp of psychological cruelty, the pressures of disturbance, the claustrophobia, have never been surpassed in cinema.

They are still the best things he has ever done, curiously detached from an age when so many New Wave filmmakers were rejoicing at how wonderful cinema could be. Those two films are a macabre, surreal hell, and the hopeless vision they embody is as close to lyrical despair as respectable art house cinema has ever been. It's not just that Polanski doesn't like people; he never feels a need to admire them. That is unusual in photography. The use of Deneuve in *Repulsion* is like a steady condemnation of her numb beauty. The emotional violence creeps up on you, and the superb last shot is like a trap closing.

Polanski was viewed as "a character," with an uncanny ability to get his startling films made. He asserted himself, like a

tiny man with a knife. But he was easily bored and he began to make films that had less concentration — *The Fearless Vampire Killers, What?,* and even *Rosemary's Baby.* That last one was a famous hit and a turning point, and the result of commercial acumen (Robert Evans at Paramount) seizing on the darkness of those British films, finding another female victim (Mia Farrow), and turning the result into a deadpan wow, a macabre screwball comedy, *Bringing Up Baby* but don't look now. The film asked us to believe in the Devil, whereas Polanski had always known that people played that part without horns or brimstone. Malice was enough.

But Satanic rites were in the air. Polanski's hectic momentum never stopped. You can say it was rotten luck, and there is a kind of bad luck and good that taunts chronic gamblers. What happened to Sharon Tate was not Polanski's fault, but it was part of a recklessness that consumed his world. She was his second wife, an intense beauty but not much of an actress, and she was stabbed fifteen times (when eight months pregnant) on Cielo Drive in the hills above Los Angeles. Some said that August 1969 night was the end of the age, but it was one more spasm in the jittery life of Roman Polanski. And if you watch *Repulsion* again now, it's hard not to wonder whether those Manson girls had seen it and thought it to be their own movie.

And then a few years later he made *Chinatown,* and told Robert Towne that it would be fatuous to give the picture any comfort in its ending. Towne was on the side of Jake Gittes (Jack Nicholson was one of his best friends). But it's clear now that Polanski was especially drawn to the insouciance and the power of Noah Cross. He knew that was the way the picture world functioned. I mean not just the operational systems in Hollywood, but the secret dynamic in how pictures appealed

**Cross Purposes: Polanski and Huston**

to us. We are talking about a moment where the bad guys and the ordinary devils were taking over the machine.

If you want a demonstration of that, just look at *The Two Jakes*. It was a sequel that Towne wrote and meant to direct, the further adventures of Jake Gittes. But the project came apart for Hollywood reasons, and it ended up being directed none too well by Nicholson. Yet what doomed that follow-up was very simple: it didn't have Noah Cross this time. And Cross had been as vital in 1974 as Harry Lime in *The Third Man* — another charming monster, one of the first on screen.

Then something else happened. On March 10, 1977, at the home of Jack Nicholson in Beverly Hills, Polanski drugged and raped the thirteen-year-old Samantha Galley. No one has denied what happened, though the atmosphere of the occasion has varied in the telling and the imagining. Polanski had been taking the girl's picture for *Vogue* magazine and he got into a dramatic swirl where he did the kind of thing people do not do. But which in the age of movies we think about.

In his memoir, *Roman,* published in 1984, Polanski described the scene in a chillingly sensual way: "Then, very gently, I began to kiss and caress her. After this had gone on for some time I led her over to the couch... She spread herself and I entered her. She wasn't unresponsive. Yet, when I asked if she was liking it, she resorted to her favorite expression: 'It's all right.'"

It was unforgivable but casual, and that account is unnerving. He has apologized, and the grown Samantha Galley has sought to dismiss the incident or excuse it because its impact was relatively minor next to the years of publicity that came down. Polanski was arrested and charged. He

268

went for forty days into psychiatric observation and lawyers strove to rearrange the technicalities that had been broken. The charge was reduced from rape to unlawful sex with a minor. Polanski believed there was a binding agreement in place whereby he would get off with time served and a fine or community service. But then he gathered that the judge in the case was going to break the deal, so that he would be put away for a long time to satisfy public shock and vengeance. He likely felt that he had been on the run for much of his life, so he jumped bail and took off for Paris. He lives there still, with his third wife, Emmanuelle Seigner, and their two children. He is eighty-eight, but I haven't heard that he walks with a cane yet.

I don't intend to argue that Polanski is a wronged sweetheart, or a great director. I take the view that his work in exile (albeit in his old hometown) is seldom interesting, or up to his younger self: *Tess, Pirates, Frantic, Bitter Moon, Death and the Maiden, The Ninth Gate,* and even *The Pianist.* The last of those is very well done: Adrien Brody got the best actor Oscar, and Polanski was given the best director Oscar. But I think it's a rather routine Holocaust picture, too eager to be respectable, a weepie, and without the hellishness that was alive in *Repulsion.* In Paris, he had lost touch with danger, or risk.

Just to underline the absurdity: twenty-five years after the scandal of what had happened near Jack Nicholson's pool, the Academy of Motion Picture Arts and Sciences honored Roman Polanski for *The Pianist,* though he was not there in person to accept his Oscar as best director. Indeed, as far as we know, Polanski has never returned to the United States, though I put it that way just because I can imagine him being tempted by the reckless gamble of some secret revisiting.

No, that didn't happen; it's just another movie. And it's more

unlikely now in the changed climate in which "Hollywood" is trying to repair itself in our eyes, no matter that it suspects it no longer exists. But in the new orthodoxy of cancellation, Polanski has been rejected from his Academy membership. There have also been claims from a number of other women that he had assaulted and raped them over the years.

After *The Pianist*, Polanski made several more unsatisfactory films — *Oliver Twist, The Ghost Writer, Carnage, Venus in Furs, Based on a True Story. The Ghost Writer* had some fans from the faint intrigue that it might refer to Tony Blair, but it became harder over these years to maintain that Roman Polanski was an interesting director, let alone an auteur.

So it was more a curiosity, I think, than vindication that in 2019 he delivered a really good and rather old-fashioned film, *An Officer and a Spy.* This is a retelling of the Dreyfus case, though the film's central character is Colonel Georges Picquart, the man who did so much to disprove the initial findings against Alfred Dreyfus.

Some critics have suggested that the film is Polanski's attempt to say his case resembles that of Dreyfus, but I don't feel that in the film in any way. Instead, we have a conventional reexamination of the case, with Jean Dujardin very good and steady as Picquart. When I say old-fashioned, I am trying to suggest an interest in history that goes beyond costume and decor into the formality and hypocrisy of a French military structure that ganged up against not just Dreyfus, but also against the possibility of admitting error. It is a film that trusts its story enough not to apply a thick sardonic jam. But this bleakness is there, not far from cynicism, and a trust in the

pettiness of most men. It's a subject that might have attracted the fond, mocking eye of John Huston. And Polanski did it at eighty-five. Such energy comes only from feeling alone.

The film won the Grand Jury Prize at the Venice Film Festival and then a Cesar for best director, though Polanski did not attend that ceremony because of protests. As yet the film has had no release in the United States or many other countries, no matter that it is a far better picture than so many of the movies that have been boosted in the last few years. I offer it to you in the company of *Chinatown*, as a fine, grown-up entertainment. I think you'd be impressed.

Not that a career is overturned by one good picture after so many years. Not that Noah Cross's granddaughter is going to forget her complicated family tree. But if you appreciate stories of double standards or hypocrisy, you should bear in mind the fact that if you want to stream a Polanski film tonight, you are free to do so, for whatever small charge is imposed. That goes back to *Repulsion*, to *Chinatown*, and to the fascinating *The Tenant* (where Polanski played the victimized lead), but it includes the movies the director has made since the great scandal. In a similar way, Harvey Weinstein is now in prison and in obloquy, and plainly he deserves both. But tonight you can see any and all the films that he brought to the screen, a list that includes *Shakespeare in Love, The English Patient, The Wings of the Dove, The Reader* and *My Week with Marilyn.*

So really it seems odd that *An Officer and a Spy* is picked out for a Devil's Island confinement. I can see Noah Cross smiling at the joke.

271

So how do you feel about all this? I don't know what I think — I feel like Jake Gittes at the end of *Chinatown*, fit to be led away to some quiet retreat where the overwhelmed may watch the light come and go. I believe *An Officer and a Spy* is a very good film, and one that would do no harm except to the armor of unrelenting moral dignity and the refusal to forgive and forget. I think Roman Polanski behaved hideously — I daresay his faults were more than we will ever know. But he was part of his time, just as he had been so desperate in the early 1940s and so driven beyond the normal state of childhood. I suspect that the plea deal from 1977 was misguided, though I have little doubt that the judge in the case was in grave error in planning to abandon the deal. Inasmuch as he was a gambler, and taught to be that by the savage unfairness of his times, Polanski had the misfortune to live on into an age of retribution and reform. Whereas John Huston took his last breath as a hero and a credit to the movies. I can hear him laughing in the way his father laughs at the end of *The Treasure of the Sierra Madre,* when all the precious gold dust blows away in the wind.

That's the feeling I have been getting at here by picking on words and a dark knowingness from 1974. If you have spent your life thinking about the movies, and being with moviemakers, you cannot overlook the habit of the art and the business to be exploitative, cruel, corrupt, and deeply damaging to the society that grew up adoring moving pictures. That's not just the measure of what we can call unfair practices, on the casting couch and at the box office, the history of theft, rape, and the alienation of education. It is just as much the ethos that has been created for us. The mythology of white male supremacy, justice and happy endings, when so many movies were exultant in the enactment of impure power.

Those things have to be corrected, but the issues are so

deep-seated that I'm not sure we can still have the movies once we abandon all the unfairness and the impropriety. It is a medium founded in dishonesty.

That's why I have asked you to take note of Noah Cross, that easygoing version of the Devil, so calm and collected, as urbane and amusing as John Huston, no longer sure how much money he has but lucid on the reason for having it. He is a very political figure, because his evil and his calm are pledged to one worthy thing: "The future, Mr. Gittes."

Cross was not alone in 1974. That was the brief last age of glory in American pictures, and much of it was devoted to making terrible people beguiling. Cross stands between Michael Corleone and Travis Bickle. The latter is deranged, violent, and horribly dangerous, but *Taxi Driver* cannot disown him. In the same way, Michael in the two parts of *The Godfather* is much more than a criminal boss. He is presidential, a touchstone of order and organization, a model of bleak reliability. So we are ready to pay homage to him.

Those three characters stand for a moment in movies when we were finally in allegiance to very bad men who could run the show, and they were all three of them surrogates for their directors and emblems of how the world was going to have to work. It wouldn't be long before we got a leader who really believed he was a figure in a movie, awful yet lovable, and repeating favorite lines about what he could get away with.

**Cross Purposes: Polanski and Huston**

# HELEN VENDLER

# *How to Talk to God*

Batter my heart, three-person'd God; for You
As yet but knock, breathe, shine, and seek to mend;
That I may rise and stand, o'erthrow me, and bend
Your force to break, blow, burn, and make me new.
I, like an usurped town, to another due,
Labor to admit You, but O, to no end;
Reason, Your viceroy in me, me should defend,
But is captiv'd, and proves weak or untrue.
Yet dearly I love you, and would be lovèd fain,
But am betroth'd unto your enemy.
Divorce me, untie or break that knot again;
Take me to you, imprison me, for I,
Except you enthrall me, never shall be free,
Nor ever chaste, except you ravish me.

<div align="right"><em>John Donne</em></div>

Can "old" poems, written in a vanished culture, be rescued for a contemporary reader, or will their brilliance be lost? I will fasten my hope here on John Donne's spectacular fourteenth sonnet of his *Holy Sonnets*, published posthumously in 1633. But

what are we rescuing in such a case? A statement? A fragment of autobiography? A portrait? Yeats, the finest poet of the twentieth century, offers an answer that seems to me the true one: a lyric poem is a simulacrum of a succession of human moods, conducting us through their rapid transitions and self-contradictions. The melody of the poem enters the reader invisibly, as if it were a transfusion. Yeats, an intense absorber of English poetry from the fourteenth century to the twentieth, had to ask himself, for his own instruction, what it was about certain past poems that made them endure. Since the passage of time tends to make prose — essays, sermons, philosophies, manifestos — decay, why should we prize past poems at all? Is a poem published in 1633 as outmoded for us as the theology or the science of its era?

Yeats argues that only one trait of human life is universal and recurrent in all human beings: the experiencing of moods over a lifetime. Our general terms for emotions are boring: "I'm depressed," "I was so glad." Experiencing a mood, however, is not boring at all: it is enlivening; it tells us that we are alive. (Robert Lowell observed in a letter that "a poem is an event, not the record of an event.") Yeats dismisses both intellectual culture and natural phenomena as fundamental sources for poetry, claiming instead that only the moods are eternal, always formidably present everywhere and in all times, and recognized by each generation of human beings. The moods are "fire-born," generated not from the material levels of earth, water, and air, but from a deathless fire, the invisible energy that sustains life. The moods are neither calm nor obedient: to the soul they are "a rout," an ever-present and uncontrollable throng of disturbing visitors. Here is Yeats's tiny two-beat poem on that overpowering and rebellious and memorable throng:

**How to Talk to God**

## The Moods

Time drops in decay
Like a candle burnt out;
And the mountains and woods
Have their day, have their day;    .
What one in the rout
Of the fire-born moods
Has fallen away?

Answer: not one. Not a single mood, Yeats believes, has ever been lost from the repertory of personal consciousness, whether registered in human beings or reflected in poems. Contemporary readers recognize without effort every mood in Shakespeare's sonnets: moods of infatuation, love, disgust, dismay, anger, wonder, meditation; moods sublime and shameful, trivial and tragic, coursing surprisingly in and through our own veins. In "Poem," Elizabeth Bishop wrote, on seeing an old painting, "Heavens, I recognize the place, I know it!" She had been there before.

To Yeats, a lyric poem exists because of the poet's felt compulsion to trace the contour of the complex, invisible, shifting, alarming, and passionate moods constantly pressing on human beings from infancy on, and continuing (unceasing in variety and unpredictable in evolution) until death. The fierce obligation to animate the human moods on paper through a template of sonic form is an urgent one to poets, but they find the task an almost impossible one, since moods are so distinctly shaded in idiosyncratic fashion. My mood of melancholy may bear a "family resemblance" to yours, but it will manifest itself, linguistically speaking, in a different pacing, an unfamiliar scene, a new minor key, legato in lieu of

staccato, syncopated rather than regular — and if its conceptual and melodic expression in language does not become an experience for the reader, the poem has failed as the unique internal energy-transfer it must aim to become.

To rescue a lyric poem of the Western past is to feel how deeply we have already encountered its human moods, although this may be the first time we have seen them illustrated in just this shading, at just this pace, with just this degree of unnerving precision. Poets exhibit a set of moods indescribable by any generality. In a poem we watch a blurred interior contour take on a distinct face, which turns out to be our own: "Heavens, I recognize the place!" At that point we can voice the words as if they have been born in us. The poets may be making distinctions that we have never made, but as soon as the words create a dynamic life in us, we are struck by their accuracy. Shakespeare, for instance, will offer a taunting definition of a certain inscrutable form of behavior, and complex though it is, we shiver and recognize the species of persons who toy with the emotions of others while themselves remaining, in a chilling sense, impeccable. Such a definition, in its obliqueness, is far from one we could have composed ourselves, but as we read Sonnet 94, we miserably recognize Shakespeare's portrait of such seducers —

> They that have power to hurt but will do none,
> Who do not do the thing they most do show,
> Who, moving others, are themselves as stone,
> Unmovèd, cold, and to temptation slow...

The pain in the lines transmits a lover's struggle to express — but in an abstract and impersonal form — his shameful infatuation with a narcissistic deceiver. The sonnet's oblique conceal-

ment of the intrinsic nature and actions of such a person requires us to struggle, like the lover, to ascertain the truth. Recognition of our parallel struggle awakens the poem in us.

Donne's Holy Sonnet 14, like Shakespeare's Sonnet 94, creates within us the experience of a disturbed sufferer. And it therefore provokes puzzled questions: why, instead of simply addressing God as a single deity, do I (as Donne's speaker, henceforth referred to as "D" to distinguish him from Donne the author) feel called upon by my predicament to address all three "Persons" of the Christian Trinity, Father, Son, and Holy Spirit, only to revert to a single God after I no longer "need" the Trinity? A modern reader may be unlikely to recall the two contested Christian concepts acted out within the poem: is a human being a creature predestined by a Calvinist God to eternal damnation or salvation, or is he its more humane opposite, a person endowed by the Creator with free will? Modernity has naturalized "predestination" as ordinary causality (historical, biological, psychoanalytic), and as the theology of creation drops out of the modern debate, the reality of "free will" becomes uncertain. Yet the ancient opposition of determinism and free will persists equally in the modern mind: can I free myself from addiction by sheer will? If not, is there any other recourse? D, finding himself inextricably addicted to promiscuity, seeks external aid to cure him. Today D might look for psychological or medical help, but in seventeenth-century England he calls on God.

As past eras drop away, not only do past concepts (the Trinity, predestination) become extinct, but also, for non-Latinists, there occurs the effacement of etymological

278

meaning. The original English readers of Donne's circulating manuscripts were highly educated Christians for whom Latin was almost as familiar as English. Such readers would have known that the Latin noun *spiritus* (as in "the Holy Spirit") is, in English translation, "the breath," which, when converted to a verb ("to breathe") and intensified — as D demands — becomes the poem's "blow." Similarly, the Christian reader would have seen the pun by which the Son of God is said to be the Sun. Donne the theologian (see his extravagant later sermons) has perhaps experienced, and certainly analyzed, the complicated and conflicting emotions surging through the speaker of Holy Sonnet 14: the speaker knows the redemptive promise of a virtuous life, but is aware as well of the troubling guilt of persistent wrongdoing, the unrelenting fear of continued sexual addiction, and the defensive excuses usually offered by the addicted.

Yet almost all commentators have believed (as we can see from the exhausting number of their remarks quoted in the 2008 *Donne Variorum*) that Donne's speaker is "praying" to God. That description seems dubious to me. Do we know what Donne would consider a prayer acceptable to God? Yes, we do: in Holy Sonnet 7, a repentant sinner, recalling Saint Paul's consoling words, "Where sin abounded, grace did much more abound" (*Romans* 5:20) can feel hope for his own salvation. Imagining the dead on Judgment Day, stationed "there" in the afterlife (when it has become too late to repent), the sinner prays as a penitent, "here" on "lowly ground," that he will he be "taught "by God how to repent in time:

279

> But let them [the dead] sleep, Lord, and me mourn a space;
> For, if above all these, my sins abound,
> 'Tis late to ask abundance of thy grace

**How to Talk to God**

When we are there. Here on this lowly ground,
Teach me how to repent; for that's as good
As if thou hadst sealed my pardon with thy blood.

This speaker's humble "Teach me how to repent" sounds nothing like D's insistent imperatives hurled at God's ear. Donne-the-composing-author would of course have recognized the difference between the penitent speaker's acceptable "prayer" (an acknowledgment of sin, with a plea to be instructed in virtue by God) and D's persistent (and improper) reproaches blaming God for His insufficient effectiveness. Still addicted, still unrepentant, D rails at his putative savior.

Readers with a hazy sense that any speech addressing God can be called a "prayer" have not understood that no acceptable prayer can reproach God (who is perfect) or can suggest (to a divinity who is eternal) that he alter his actions in time. Rather, a believer's prayers address a God who is ever benevolent and ever the same. But "As yet" — says D (intemperately calling for an improved future from his silent God) "You / As yet but knock." Christopher Hitchens sardonically remarked in *Mortality* that the person who prays "is the one who thinks that god has arranged matters all wrong, but who also thinks that he can instruct god how to put them right." That epigram exactly sums up what is expressed in the first twelve lines of Donne's sonnet, while in the last two lines D will discover — in the cleverest way — an acceptable alternative to propose: D will retain the helplessness he has maintained throughout; and God will bring him to salvation without external force.

Most readers have assumed that it is the "real Donne" — the historical authorial one — who speaks Holy Sonnet 14; he certainly speaks *in propria persona* within other sonnets. The commentators quoted in the *Donne Variorum* consistently mistake D's actual speech-acts by employing in their paraphrases — besides the actual word "pray" — a number of synonyms: "Donne" *entreats, beseeches, implores, pleads,* and so on. But the speaker of the poem does *not* perform these religiously acceptable acts: rather, he demands, he reproaches, he insists, he complains, and he consistently represents himself as a victim of God's inadequate assistance. And is it credible that the authorial Donne is here speaking as "himself," when the impertinent D apparently does not understand the legitimate ways to address God and the reverent posture suitable for acceptable prayer? (Even the pious person about to pronounce a prayer has to beg God to find it acceptable.) It is the visible disharmony between the Donne who writes the other *Holy Sonnets* and the protesting "D" who speaks "Batter my heart" that compels a necessary distinction between author and speaker. This is always an awkward procedure because our instinct is to merge the author and the "I" of the poem, but it becomes necessary to separate them whenever there is a discrepancy (as when Donne speaks as a woman in "Break of Day").

The historical Donne, author and courtier, was raised during the Reformation in an intensely Roman Catholic family, but later took orders in the English Church and eventually became Dean of St. Paul's in London. Expert from youth in the diction of faith, he would not have seriously entertained D's notion that he can harangue God on how to better His actions, nor would he have characterized D's successive ultimatums as "prayers." D's expostulations to God arrive as a torrent of imperatives beginning with explosive b's: *batter,*

**How to Talk to God**

*bend, break, blow, burn,* and again *break.* These are not words of entreaty but words of offended entitlement. In one of Donne's strokes of authorial wit, he exposes the self-serving reason for D's triple mustering (in his battle against Satan) of all three Persons of the Trinity, Father, Son, and Holy Spirit. Resentfully, D has been reflecting "There are three of Them: why are They not more efficacious in battling the enemy? Surely the divine Persons have more available power than Satan!" But the Trinity disappears from the poem when D recognizes how improbable it is that he, the sinner, will receive supernatural reinforcements: he re-imagines the military battle as a single combat with Satan; and once he drops the Trinitarian summons, D always addresses God in the singular (revealing that it was a matter of temporary military expediency to summon the three Persons in his first lines).

In his mood of rebellion, D demands more successful actions by all three Persons. Yes, God the Father created him, but His creature (now addicted to disobedience and sinful sexual expression) has come to grief. God *must* (commands D) create a replacement for D's "old" self and make a whole "new" human being; it would be a mistake on God's part merely to *mend* the old one. Since God the Son is (punningly) the Sun, he has the power to *burn,* to consume the "old" self utterly, making room for the "new" one; certainly he can do better than merely *shine.* God the Holy Spirit has so far merely deigned to *breathe,* instead he should *blow,* as he did in the guise of a "rushing mighty wind" when the apostles came together after Christ's ascension into heaven: "And when the day of Pentecost was fully come, [the apostles] were all with one accord in one place. And suddenly there came a sound from heaven as of a rushing mighty wind, and it filled all the house where they were sitting" (*Acts* 2).

But in spite of D's rising decibels, each person of the Trinity has continued mildly in known ways. God the Father merely *mends* the damaged being; God the Son will do no more than *knock* at the door of the heart, not *batter* it nor *burn* it with fire; and God the Holy Spirit gently *breathes*, will not *blow* the heart's door open. In Donne's emphatic arrangement of D's excited verbs, the desired act always pushes itself into place before the current one:

batter <----------------knock
blow <----------------breathe
burn <----------------shine
make new <----------------seek to mend
break <----------------seek to mend
bend your force <----------------knock
break <----------------seek to mend

God's gentle present actions in the second column are "feminized" by their "weakness" vis-à-vis the powerful and explosive masculinity of all the "b" words in the first column. In an impatient argument, D urges his "masculine" verbs on the Trinity as a set of actions preferable to those "weak" ones that God has so far been resorting to. "Batter" the speaker's heart — with what? A "battering ram," the weapon that can conquer a city at the end of a siege. D irritably repudiates the feeble single "knock" in favor of troop action. (He has thereby explained his invoking of all three Persons of the Trinity, since a battering ram must be wielded by more than one attacker.) The satisfying resonance of the repeated "b's" exposes the speaker's exultation at having piled up (in prospect) so many reinforcements of his army. As D blames God for his own helpless continuation in a sinful state, he does not shame

**How to Talk to God**

himself by naming his sins, but rather implies that God could nullify any and all sins if He would exert some energetic force.

Abandoning the hope of a Trinity-staffed battle, after the silent absence of the summoned Persons, D has decided on single combat — a duel with Satan. He imagines himself, in a plaintive simile, not as an actor in battle, but as the victim of an unnamed usurper of the throne of his own terrain: "I, like an usurped town..." His mood becomes one of self-excuse, as he releases a vague explanatory flashback (but one lacking many crucial details): "Once I was a well-governed city, ruled by God's viceroy, Reason. Then a wicked usurper assumed [but how?] the throne of the viceroy." The blurred narrative of victimization continues: Reason, the absent viceroy, is now a captive [but whose, and why?]. "The usurpation must have happened" [says D, blaming the viceroy] either because Reason was weak and is now imprisoned or — a far worse concluding speculation — that God's viceroy has turned traitor, has been "untrue," and is now a minion of Satan. D claims that his own strong efforts to admit God to the "usurped" city have been frustrated by Reason's traitorous secession. Would the authorial Donne think to deceive God by such a tale? Of course not. It is the speaker who resorts to self-excuse, revealing himself as a hypocrite, once again blaming others (if not God, then Satan) for his plight.

As D continues his narrative into the immediate present, Donne-the-author turns the sonnet in a different direction, changing his rhyme scheme to alert his reader. The first eight lines (rhyming *abbaabba*) had created, in "embraced rhymes," the octave of an "Italian" sonnet, but the closing six lines adopt

a "Shakespearean" sestet, an alternately rhymed quatrain plus a couplet (*cdcdee*). Such a hybrid form announces a fundamental change in mood from octave to sestet, but we are not yet aware what it may be, although we feel the mood change as the speaker voices a single dejected admission: "Yet dearly I love you." Still sinning, D quickly takes on a false pathos, asserting in self-defense that although he loves God dearly, and is eager to be loved in return, yet he has waked to find himself dismayingly "betrothed" to God's enemy, Satan. How can that have happened, apparently without his conscious knowledge? D has voluntarily (if bafflingly) "tied the knot" — as the colloquial phrase has it — in a solemn public promise to marry. By some sorcery, D tells God, he has been betrayed into a contract with a seductive unnamed "enemy." As usual, D never imputes any agency or blame to himself for his condition: the betrothal has merely "happened." (Donne discloses D's attitude by the passive voice of "*am betrothed*," rather than "I betrothed myself.")

Donne-the-author must now reveal that D, even after admitting the fact of the sinful betrothal, believes that he cannot extract himself from it, and has not changed his expectation that it is God's responsibility to free him. Donne points out this truth by D's voluntary return to the violence of his initial address to God (with the telling repetition of his earlier injunction, *break*, implying that he is still reproaching God's inertia). *Divorce me!* he cries, from the promised marriage (appealing to the Jewish law permitting such action); *untie* or *break* that quasi-marital Gordian *knot* of betrothal. The pitch of the voice rises ever higher as the sinner's mood worsens. In protest against his apparent helplessness. D bursts out (the vowel echoing the doubly resounding *break*), "Take me to you, imprison me." In this histrionic climax, D unwittingly parallels the action he says he desires ("Imprison me") with

285

Satan's action as he (supposedly) imprisoned God's defeated and "captiv'd" viceroy. When a speaker — even unconsciously — wants God to reproduce an action by Satan, that speaker is emphatically not the authorial Donne but rather an imagined (and faulty) sexual sinner.

Although the poem has been composed of a string of verbs of demand, God has responded to none of them (not even to the "milder" suggestion of *untie*) and D's despair has not yet been alleviated by any merciful act. Casting hither and yon for a verb which will move God to save him, D has so far run through a thesaurus of imperatives, always maintaining his own innocence, always making others responsible for his sin or professing ignorance of its cause. Does D sound here like a man praying? "A broken and a contrite heart, O God, thou wilt not despise," says the Psalmist. Has D, up to this point, manifested a mood either heartbroken or contrite? To the contrary, he has remained wronged and accusatory. He has, in short, not been "praying" (or "entreating" or "imploring" or "beseeching" or "pleading") at all; he has been rebuking God as too mild in his solicitations of the heart, too weak to prevent the usurpation of the heart-town by Satan, and even too timid to untie the betrothal-knot.

Though remaining wholly passive, D — after the bitter mood in which he scourges God's inertia — is enabled to discover verbs which *will* change his state, *will* embody the necessary conditions for his restoration to virtue. As before, he expects God to be the active agent of his salvation. However, in the most linguistically "magical" move of the poem, D is rescued by the ability of his former language to mutate. Donne-the-author succeeds in letting D keep his desired passivity as he investigates the possibilities of salvation through etymology and grammar. Language saves

286

D by presenting inspiring new verbs to him, translations into metaphor of his earlier literal claims. "Imprison me!" he has cried, and language (through its authorial tutor, Donne) whispers to him, "You know, there *are* other versions of the words you are thinking of using: for 'imprison' you could more aptly say *'enthrall,'* since a 'thrall' is a prisoner, and "enthralled" means "(voluntarily) imprisoned by enchantment." The Muse of Language offers an additional counsel: "And for the forcible 'rape' (which must have preceded your unwilled 'betrothal' to Satan) you could more properly ask God to 'ravish' you; the word indeed issues from the same root as 'rape' — *rapere* — but like 'rapt' and 'rapture' is metaphorical." At this moment, transmitting the revelations of the Muse of Language, Donne the poet feels, twice, the joy of the *mot juste:*

> for I,
> Except You enthrall me, never shall be free,
> Nor ever chaste, except you ravish me.

The words "free" and "chaste" cast a light backwards, summing up the whole preceding narrative. By naming the virtues he desires — to be "free" and "chaste" — D confesses his hitherto unnamed sins, which are an enslavement to wrongdoing and sexual promiscuity.

287

~≋~

But how was the magical revelation of the "right language" induced in D the sinner? It was, I think, by the one truth in D's outburst at the turning-point indicated by the changing of the rhyme-scheme: at that moment D recalls a deep past attachment to God, one still present in memory, which he longs to

rediscover. The subduing of mood and the drop of voice in his admission "Yet I love You, and would be lovèd fain" measure D's subsequent despair when he feels himself unloved and in danger of damnation. That he has remembered, amid his frantic demands, his past happiness when he felt loved by God suggests that in his exhaustion he is taking stock of the better past as well as the wretched present.

In his blasting cascade of imperatives, D has been driven into a corner where his vocabulary of wrath is exhausted. Recalling his last mood of happiness, turning his face at last to the God he has been excoriating, remembering the past state in which he loved and was loved before sex and rebellion possessed him, and implicitly confessing his sins and his desire to be free and chaste, he hopes to regain equilibrium in a final "steady state": "I can be free only when you enthrall me; I can be chaste only when you ravish me." With "ravish" Donne is invoking the metaphorical sense of "rapere" — to abduct, to carry away — as he does in the Holy Sonnet on his wife's death. Quoting St. Paul's recollection of "a man" (probably himself) who was "caught up to the third heaven" (*Corinthians* 12:2), Donne remarks in Holy Sonnet 17 of his young wife that her soul was "early into heaven ravishèd."

In the mind of D, as he remembers his happier state, God's goodness and beauty replace the rival claims of a putatively adult independence and putatively passionate sexual experience. Donne-the-author arranges the final "Shakespearean" couplet in the figure called chiasmus, or "crossing." In this figure of speech (which always implies a speaker's intellectual control of his earlier affliction), the etymologically metaphorical verbs become the "outside" brackets, while the "inside" brackets are the adjectives of longed-for virtue — enthrall:-free::chaste:ravish. Chiasmus is always a figure of forethought,

showing the conscious close of emotional distress. Using "linear" terms of the conditions of his salvation, D would say, "Unless You enthrall and ravish me, I will never be free and chaste." Chiasmus, using "bracketing" terms, "locks" the "solution" into the completeness of coming full circle, ratified by the happy discovery of the two metaphorical verbs permitting D to solve his despair while allowing him to regain — without carrying out any activities to save himself — the feeling of being loved by God.

I can imagine that Donne's whole poem was generated by his delighted discovery of the particular properties and the grammatical parallels of the verbs "enthrall" and "ravish." Both verbs require a direct object, and as Donne constructs a scene in which "God" is the agent of these verbs, while D is the direct object, the poet obtains the psychological continuation of his speaker's desire for passivity. If D were to speak here in the first person, he would have to render the facts in the *passive* voice: "I am enthralled by You": "I am ravished by you." Rather, the Son's radiant presence (as the "Sun") is indeed the agent, but not by an act of exerted force: rather, the divine light diffuses itself eternally without needing to effect any isolated action in time. When D laments "Yet I love you" in his bafflement, he has not yet realized that God requires nothing of him except to bask in the "Sun's" shining warmth (erasing his angry wish that God should "burn" him). War — the first metaphorical axis of D's sinful state — miraculously, in the warmth of God's uninterrupted "shining," recedes from memory; and Love — the second axis — mutates from erotic addiction to *agape* or Christian love, charity.

Granted, to understand "Batter my heart" in this century, the modern reader has to search out some aspects of Christianity in an encyclopedia and check the etymologies of two

crucial verbs in a dictionary. But the reader is repaid by being thrust through an electric sequence of tumultuous moods, enacting them in person and experiencing them as virtual events. No other poem will transfuse agitation into the reader in exactly these dimensions, this angry and disturbed and excited doubts of one's own will as a reliable agent of virtue, followed by the vivid sensation that God will not refuse salvation, but will, by a steady infusion of light, transform spiritual passivity into a cherished mutuality of enthralled self and ravished soul. The linguistic journey through moods so violently conducted and so exquisitely rewarded makes the reader see the speaker of the poem as a recognizable mirror of human anxiety and human sensibility. Anxiety and sensibility, never absent from the psyche, will arouse in readers, in the moment of immense final relief of the poem, a voice almost four hundred years old, making a faithful traversal of their own personal troubled and chaotic — but universal and timeless — moods of shame, perplexity, anger, resentment, and love.

DEVIN JOHNSTON

# *Bière de Garde*

How good it is, to sip a beer
outdoors, with winter drawing near,
above the wreckage of a meal.

How good, before the bill comes due,
to watch a copper light gleam through
an ale infused with chanterelle

and trust yourself to only those
sensations of the tongue and nose,
what's felt, and how it makes you feel.

A sip held in the mouth evokes
a golden bloom among the oaks
and water drawn up from a well

one afternoon spent near the source
of happiness, atop a horse
that now stands idle in its stall.

These days you keep too much inside,
but once you foraged far and wide
through pastures north of Carbondale.

How fine, that you have faintly caught
a sour note of apricot
so deep in the cloudy dregs of fall,

the past in what has come to pass,
and cradle in your palm a glass
of *once*, a final swig of ale.

# Beulah Land

*Going home* means anywhere
but here, putting aside
worn grays
for the bright amber
of a fall morning.
No more counting days
in the clack and steam of laundry.

With the hush of brakes
a Greyhound bus
glides beneath the trees
and past a shuttered smelter.
Grisaille shadows.
Chains of geese.
A swath of sheepish sunlight

on foothills south of Zion.
As day dims
the windows turn
to mirrors,
and the coach hums
with quiet conversation,
murmurs into cell phones.

How might freedom feel
after seven years away?

Vibrations through
the bootheel,
with a cardboard box
and bus fare
to any place but here.

# Last Song

*after Guiraut Riquier*

It's for the best that I stop singing.
Songs should come from happiness,
and lately I've felt less and less
inspired, with my horizon shrinking.
When I recall my darkest days
and contemplate a world ablaze
and dread extinctions of tomorrow,
who could wonder at my sorrow?

My fire dwindled long ago.
I rake the ashes, fitting muse
for crafting esoteric blues
from scraps of what I feel and know:
at dusk, a woodcock on the wing
tumbles into early spring,
and yet in verse such things express
a feeling of belatedness.

These days, authorities dismiss
the subtle circuitries of rhyme
as relics of another time
or quaint devices that persist
on shelves of kitsch and curios.
Why not attempt a work in prose —
a memoir to mythologize
my progress through a world of lies?

We live with gaps, hypocrisies,
and flights of happiness brought low,
estranged from what we feel and know.
As every instrument agrees,
we live in seasons out of sync,
a February on the brink
of never, snow extinguishing
the first magnolia blossoming.

This dread has tainted everything:
each dawn I come to consciousness
in panic, prickles of distress,
and clench my teeth. Why would I sing?
Towhees still propose a slow
familiar tune, but no words follow;
this ache of feeling finds no phrase,
no means by which to mourn or praise.

# After Wyatt

They slip away, those creatures who
once caught my eye and ventured near,
near enough to smell of snow
as cold lingered in their fur
and breath warmed my sleeping ear;
who ate an apple from my hand
and lounged in sunlight, unconstrained.

Such old affections slip away,
all but one, *la douce dolor*:
she leaned above me as I lay
stretched out on the kitchen floor,
caught within her net of hair;
then quickened by a passing mood,
she softly asked, *Does that feel good?*

She lingered in my consciousness
when I awoke, a bit confused
to find her gone, the place a mess,
and emptiness come home to roost.
I wonder if she'd be amused
to see me settled down, and if
she still pursues that wayward life.

# CELESTE MARCUS

## *Mortifying*

Thirty-five minutes into the movie *The Piano Teacher*, there occurs an indelible scene. In a dim bathroom cluttered with drugstore label sprays, lotions, and other feeble concoctions designed to fend off decay, a middle-aged woman in a silk robe briskly zips open her pocketbook and removes a folded slip of paper, which she unfolds to reveal a razor blade. Armed with this instrument, she turns around, slips off her flip flops, opens her robe, and sits on the edge of her bathtub with her legs splayed. She moves resolutely but without authority, with a kind of robotic resolve, as if she were complying rather than presiding, mechanically obeying an inner necessity. The

camera displays her in profile. A pink hand mirror rests on a ledge by the tub among bottles of various shapes and sizes. She snatches up the glass and holds it out between her knees with one hand, still gripping the blade in the other. Then Erika Kohut, the piano teacher, leans forward intently, carefully adjusts the mirror until she appears satisfied with her view, moves the knife towards her groin, and slices inside herself several times with strained and steady force. A curtain of flat auburn hair conceals all her face except her lips, which are puckered perhaps in pain, perhaps in concentration. She breathes heavily, apparently exerting great effort. Rivulets of crimson liquid spill out of her and into the porcelain basin. Then the mutilation is halted abruptly by banality. "Erika, dinner is ready!" her aging mother, with whom she lives in a cramped apartment, summons her from the other room. "Coming, Mother!" replies the dutiful daughter while snatching a thick menstrual pad from an open bag beside her and pressing it to the wounds between her legs.

It has been reported that at the press screening for *The Piano Teacher* at the Cannes Film Festival in 2001, members of the audience guffawed at this scene. Their laughter in response to the self-mutilation just witnessed was as sickening as it was unwarranted — significantly more discomfiting than the blood in the bathtub. If the director, Michael Haneke, had intended the mortification to be funny — he does in fact have a profoundly twisted sense of humor — he should not have cast Isabelle Huppert as Erika. Huppert possesses a ferality which somehow does not mitigate her natural sophistication. And in the scene in the bathroom Huppert is feral in precisely the way that a woman's hatred of her own womanhood is feral.

Yes: a woman's hatred of her own womanhood. It exists, it snarls in our bellies; and Huppert's peerless performance

is among its rare open expressions. She brilliantly communicates in the bathroom scene the gravity of her ferocious behavior. Owing to her marrow-deep conviction, conscious or not, of the significance of that drawn blood, the savagery that Erika Kohut perpetrates against herself is exhilarating. I do not mean to deny that it is also grotesque, revolting, and wrenching. And yet it is at the same time emphatically thrilling in the way that it is always thrilling when a person acts openly upon a perplexing, wounding, and unacknowledged truth. The blood is a shibboleth and the truth that it communicates extends beyond the inner torments of this piano teacher. Her action is symptomatic of the cruel reality that there is a long tradition — longer than most contemporary women know — of womanly self-mortification. Those streams of crimson encapsulate a common and time-honored and baffling compulsion: a woman's compulsion to attack herself.

What accounts for this propensity is a mystery, but the evidence for the compulsion is plentiful. Of course, most women, or more women, casually contract or stunt themselves rather than slice and starve themselves. But the slicing and the starving are hardly unheard of, and they are manifestations of the same proclivities, and are emphatically more common in women than men. Women are three to four times more likely to suffer from anorexia and bulimia and to cut than men are. Those numbers are strikingly reminiscent of another grizzly statistic: men are four times more likely to be murdered and to commit murder than women. It would seem that men brutalize one another and women brutalize themselves. (There are holes in such generalizations, of course.) In his learned and compas-

sionate book *Cutters*, the psychotherapist Steven Levenkron describes these tendencies so well he seems to explain them:

> In the case of girls, they will absorb the blame for most behaviors directed against them. Whether it's a natural component inherent to femininity, a sense of physical helplessness, or a combination of both, disorders of self-harm, for the most part, affect girls and women. These include cutting, anorexia, bulimia, and other self-harming behaviors. Males, for the most part, tend to externalize blame and emotional discomfort by acting out on others, from street fights to rapes and homicide... While we see crossovers in both genders, the patterns favor the classic models for aggression.

In ordinary places such as locker rooms, sidewalks, and shopping centers, or in moments of intimate confidence, if you have been paying attention, you will have caught glimpses of forearms riddled with slashes of pale pink flesh, or dark red grooves, thick and deep. The character is familiar: the "fucked up" over-achiever; the type-A freak with a 5.00 GPA and a razor blade in her backpack; or a calorie counter pulled up on her iPhone.

"Fucked up" is hardly a useful clinical description or a worthy literary appellation, but it is the term that, shamefully, often comes to mind. The reason is that generally we have not bothered to consider her charitably or deeply. We have squandered abundant opportunities to develop compassion for her. To outsiders she seems crazy, even selfish, depriving herself of the sustenance offered her, and forcing her friends and family to agonize over her poor choices. But strictly speaking she has not made choices, and her actions were not

catalyzed by mere melodrama. Of all mental illnesses, eating disorders have the highest mortality rate. Between five and ten percent of people who suffer from anorexia die within ten years of developing the disease, and roughly twenty percent die within twenty years. Patients admitted to hospitals for anorexia or bulimia are told outright that they will likely come back, that escape from their own mental cells is practically impossible. Hope is extinguished in these personal purgatories. Yet the contemporary discussion about female self-harm is tinctured with a maddening unseriousness. In the popular imagination the bony, bleeding, scarred young girls are considered hysterical, even ridiculous. "Fucked up" is a terribly unimpressive thing to be.

The general discussion of these disorders curdles with glibness bordering on contempt in the medical profession as well. When Levenkron first discovered that one of his patients had resorted to self-mutilation, he asked colleagues if they had encountered similar cases. His fellow psychotherapists would respond with chilling disinterest: "Oh yeah, another cutter. They're pretty sick cookies." This blasé attitude about cutting and other instances of analogous self-harm is baffling, given the carnage. Perhaps that is the reason so little is known about why women do this to themselves. The platitudinous explanations generally given are as satisfying as celery sticks. It is endlessly repeated that these girls are motivated by a need for control. But what, exactly, have they been deluded into believing that they can control through self-harm? Starvation saps a person of the energy to think clearly, so perhaps they are ceding control as much as gaining it. This so-called explanation is simply a description of a symptom the cause of which remains mysterious and unexamined.

It is also said that their violent self-mortifications are owed

302

to a pathological desire to be skinny. Perhaps that accounts for some of the violence, but it cannot account for all of it. Women have been starving themselves for far longer than thigh gaps and jutting collarbones have been in vogue. In her classic study *Holy Feast and Holy Fast*, the medievalist scholar Caroline Walker Bynum shows that since the medieval centuries food and fasting have been central to female spirituality:

> Although women were only about 18 percent of those canonized or revered as saints between 1000 and 17000, they were 30 percent of those in whose lives extreme austerities were a central aspect of holiness and over 50 percent of those in whose lives illness (often brought on by fasting and other penitential practices) was the major factor in reputation for sanctity... most males who were revered for fasting fit into one model of sanctity — the hermit saint (usually a layman) — and this was hardly the most popular male model, whereas fasting characterized female saints generally. Between late antiquity and the fifteenth century there are at least thirty cases of women who were reputed to eat nothing at all except the eucharist, but I have been able to find only one or possibly two male examples of such behavior before the well-publicized fifteenth-century case of the hermit Nicholas Flüe.

The earliest known examples of food-avoidant female saints occur in the Low Countries in the late 1100s. Mary of Oignies was born in 1170, and was renowned for practicing extreme asceticism. She ate no meat, hardly any fish, and subsisted largely on vegetables and bits of bread so old and coarse that the morsels would draw blood while scraping the roof of her mouth. Her biographer, James of Vitry, asked her how it was

possible that her fasts and her frantic sobs (she cried when meditating on Christ) did not cause crushing headaches. She answered: "These tears are my feast; they are my bread day and night; they... feed my mind rather than emptying and afflicting my head, they bring satiety to my soul." Many female saints experienced communion with God as food itself, and during ritualistic intervals they could not stomach ordinary food. Upon receiving an unconsecrated host, Mary of Oignies vomited and then washed her mouth to obliterate the aftertaste. During the last year of her life, Margaret of Ypres (1216-1237) could swallow nothing but the eucharist. Juliana of Cornillon (c.1192–1258) practiced extreme fasting and as a teenager craved the eucharist and preferred prayer to food. When her caretakers endeavored to persuade her to eat, she insisted that "I want better and more beautiful food."

These women, and there were many more, are our spiritual ancestors. Of course, not every teenager who starves herself is straining for spiritual transcendence, but they aren't merely maladjusted adolescents, either. Something significant and deep is at work. It is a mistake to consider these two types, the starving saint and the scarred woman, as essentially distinct. What they share is fundamental: womanhood.

Erika Kohut, broken and brazen, cuts at her womanhood directly. She attacks the inheritance that coerces her to raise the blade. Women often torment their bodies, but it is rare for a woman to acknowledge through this peculiar violence that her womanliness itself inspires this brutality. Something about womanhood, some obscure quality or conditioning, predisposes her to conceive of herself as an enemy, or as a prison — something to be tamed, or wrestled into submission. In that gut-twisting scene Erika attempts female castration, as if trying to break free from a self-sabotaging parasite that lives in

and off her. Her attempt is strikingly ineffectual. She does not exhibit relief the way cutters do when physical pain, delicious as dopamine, releases them from psychic torture. But Erika is attempting an impossible exorcism. She does not evidence relief because relief is not attainable. (Elsewhere in the film her continued difficulties as a woman are made crushingly clear.) There is no effective method for disentangling the strains of self that are harmless from those that she must expel. For there are — enmeshed, inextricable — two selves: the self attacking and the self attacked; the girl whose body has grown beyond girlhood and rebelled against her, and the woman. They are inseparable; a single life.

Erika Kohut's violence is freakish because of its extremity and its brutality. But there is a cornucopia of related behaviors to which we have become inured. Erika radically exemplifies something grotesquely ordinary. Women tend or are taught to contract themselves, to starve or mutilate their bodies or their minds. Shrinking is a woman's business. Constant social and cultural training, implied and overt, prepares us to take up this self-undermining practice. It is painful to blunt ourselves, but it keeps us from operating at full strength, and that is a possibility we fear and cannot countenance. Women have been taught not to permit themselves to be intimidating. To paraphrase Colette, a female genius indulges in self-denial.

Not all women carry razor blades in their pocketbooks, of course. But the extraordinary can teach us about the ordinary. It is useful to study the extreme cases, the freaks, the fanatics, the swollen iterations, to better understand the rest. In *The Varieties of Religious Experience*, William James considers only religious extremists in order to understand the religious temperament. His reasoning is compelling: inflamed essences and hyperbolic expressions are useful because in them the

essential is exaggerated in a manner that makes it easier to detect and therefore to understand all the instances of a type: "we learn most about a thing when we view it under a microscope, as it were, in its most exaggerated form." Erika's attack is exaggerated, but her exaggeration makes manifest what is commonly the case.

But why is it commonly the case? What is it about the prospect of womanhood that inspires such fear and repulsion, a terror so great that a girl would choose to deprive her body of the energies that would catalyze and sustain menstruation, breast development, childbearing hips, and flowing hair? Where does the horror come from? Is it justified?

In 1954, five years after *The Second Sex*, Simone de Beauvoir wrote a novel that was never published in her lifetime. It appeared only a few years ago and was translated into English by Sandra Smith in 2021. It is titled *Inseparable*, and in it Beauvoir tells the profoundly affecting story of a remarkable young girl, Andrée, through the eyes of her beloved friend Sylvie. As Andrée matures, her exceptionalism grows more apparent. This becomes increasingly unbearable for those around her, particularly her mother, an exacting Catholic woman who can tolerate erratic or conspicuous behavior in young girls, but not in young women. This story schools us in an age-old truth about the history of womanhood in society: it is a terrible thing for a woman to be special. Andrée deserves a prominent place in the annals of womanly mortification.

Andrée Gallard and Sylvie Lepage meet in school in Paris when they are both nine years old — still young enough for

Andrée's gifts not to inspire envy or contempt. She is easy to admire, evidently precocious, irreverent but too young yet to be perceived as impudent or intimidating. There is a gripping, unsettling aura about her. She isn't socialized the way the other girls in her class are, she "didn't use the tone of voice she should have when talking to a teacher... [and] she walked with the confidence of an adult."

Andrée introduces herself to Sylvie by explaining that she had started school a year late because two summers earlier she had been "burnt to a crisp" while roasting potatoes over a campfire. Her dress caught fire and the flesh on her thigh was burned straight through to the bone. Andrée tells this story with an air of impatience, bored at having repeated it so many times. Throughout the novel she demonstrates this same inhuman (or superhuman) disregard for physical pain — a warning that she is capable of seriously damaging her own body. She lacks the fear of physical suffering that paralyzes healthy, ordinary people. Madame Gallard relays another example of the same disregard when she tells "the story of Andrée's martyrdom" to Sylvie's mother:

> The cracked skin, enormous blisters, paraffin-coated dressings, Andrée's delirium, her courage, how one of her little friends had kicked her while they were playing a game and had reopened her wounds — she'd made such an effort not to scream that she'd fainted.

The extremity of this story inspires admiration and even awe in Sylvie, who feels suddenly as if nothing remotely interesting or important has ever happened to her.

Sylvie had been a model student, top of her class in her first year. She maintains her perfect record, but she studies and

reveres the contempt that Andrée harbors for the platitudinous and respectable ideas that the teachers at their conservative school spoon down the young girls' throats. Throughout the long year spent lying flat on her back while her charred flesh bubbled and grew back, Andrée had read voraciously and developed opinions about fictional and historical figures and eras about which Sylvie knew very little. "Many of these opinions were subversive, but given her young age, the novices forgave her. 'That child has personality,' they said at school." But how long before "personality" becomes "problematic"? How long until a forceful girl becomes a troublesome teenager, and then a dangerous woman?

Sylvie's love for her friend is pure, deep, and clean of jealousy or intimidation, as genuine friendship always is. She is aware that Andrée is exceptional, different in kind, that she possesses a power Sylvie cannot understand, and she revels in that knowledge.

> What gave her the greatest prestige in my eyes were certain unique characteristics whose meanings I never understood: when [Andrée] looked at a peach or an orchid, or if anyone simply said either word in front of her, Andrée would shudder and her arms would break out in goosebumps; those were the times when the heavenly gift she'd received — and which I marveled at so much — would manifest itself in the most disconcerting way: it was character. I secretly told myself that Andrée was one of those child prodigies whose lives would later be recounted in books.

After summer vacation, when she and Andrée are separated for the first time since their meeting, Sylvie suddenly realizes

that Andrée has inspired such intense love in her that she cannot bear to live without her. It is the most mature experience her young life has so far afforded.

As the two girls grow, Sylvie's love remains the only love which Andrée will ever receive that deepens rather than weakens as she becomes more formidable. Already by their second year together, the teachers have grown weary of Andrée's wit and transgressiveness. She has by now recovered from the burns and is spirited and healthy. The stronger and more vivacious she becomes, the less likable she is. That first year she was manifestly weak, physically compromised, and this feebleness made it easier for others to conceive of her as needy rather than threatening. By now their concern has evaporated, and so has their patience. "They found her contradictory, ironic, prideful; they reproached her for making snide remarks. They never succeeded in catching her being downright insolent because Andrée carefully kept her distance, and that was perhaps what irritated them the most." Generally, when young girls behave badly, their teachers depend on their mothers to rebuke them, to sound alarms about reputation and to instill within them the importance of appearances. But Madame Gallard indulges Andrée, and so there was little the teachers could do.

Unlike Sylvie's mother, Madame Gallard does not put much stock in the opinions of the schoolteachers. She does not hector Andrée about what the neighbors might think if they see her walking about the streets alone, or whether the other little girls call her odd or rude. At first it seems that Madame Gallard is much more permissive than the mothers Sylvie has come to know in Paris, but eventually Sylvie recognizes with foreboding that "her smile hid a trap," and that Andrée's evident freedom came at a price. Andrée is the second of seven children and is expected to care for her younger siblings and to partici-

pate in endless religious and familial duties, all enshrouded in piety. The social responsibilities that other girls her age must fulfill are in her case dwarfed by something of greater significance: God's will and the sacrifices that it necessitates.

Andrée willingly makes these sacrifices, which are fueled by the love that she feels for her family generally and her mother above all. That love is ferocious. The intensity of her filial passion is commensurate with the rest of her burning spirit, and greater than her mother can conceive or even deserve. For, tragically, Madame Gallard loves Andrée the way she believes a good Catholic mother ought to love one and all of her children, rather than in a way that is particular to Andrée and reflective of her difference, her impressive peculiarity. Andrée knows this, and it breaks her heart. She will be punished by a society that cannot tolerate exceptionalism in women — a punishment often exacted by other women.

Madame Gallard knows that as Andrée gets older, her independence will shrink. She permits her freedoms early, when they are unimportant, and when they will not hinder her from submitting to tradition and loyalty. When Andrée reaches adulthood she will be expected to marry a man of her parents' choosing, and renounce the individuality that she had been at liberty to cultivate. But Andrée understands none of this. In their second year of school, when her responsibilities to her family had only just begun to intensify, she tells Sylvie that she is "tired of being a child." She imagines that the tightening fetters are features of childhood, and so she longs for adulthood. But she has it backwards: they will get tighter as she gets older, the more womanly she becomes, the farther she develops from prepubescent innocence. She is not afraid yet, but she will be.

The parable of the strong young woman and her unjust destiny continues. Sylvie has an epiphany about the terms of Andree's existence when she observes her in her father's library in the country. There, amid the complete works of Joseph de Maistre, the writings of Louis Veuillot, and the photographs of Andrée's bearded ancestors, Sylvie sees clearly for the first time that Andrée is shackled in place by the inherited past: "Amid all those austere gentlemen, Andrée seemed out of place, too young, too delicate, and, especially, too alive.... I had often envied Andrée's independence; suddenly, she seemed a lot less free than I was. Behind her, she had this past; and around her, this large house, this enormous family: a prison whose exits were carefully guarded." Andree's vigorous soulfulness suddenly seems too weak to withstand the pressures of tradition and the expectations of family. Andrée never stood a chance.

Achingly, Sylvie recognizes that Andrée is complicit in her own imprisonment. In Steven Levenkron's book, he describes a precocious daughter who is dispossessed of her own childhood because her parents expect her to shoulder parental obligations at a young age. Such a child believes that if she fails to play the role set for her, she will forfeit her parents' affection. The child internalizes the anger that should be healthily directed at the parent, for fear of squandering the dregs of love that have been allotted to her. This case describes Andrée well. She longs for a larger horizon and at the same time believes that her aspirations are treasonous and sinful. She plays both mother and child in the tribunals of her imagination, both rebelling and scolding herself for her rebellion.

Sylvie goes on to study philosophy at the Sorbonne. There she befriends the brilliant Pascal Blondel, whom she introduces to Andrée, and the two immediately kindle to one another. He is the first believing Catholic who has succeeded in

311

earning Andrée's admiration and who does not encourage her to abandon her gifts in the name of religious zeal. Hungry for assurances that her powers are not essentially wicked, Andrée applies Pascal's forgiving theology like balm to her inflamed and confused self-conception: "'If He has granted us His gifts, it's so that we will use them,' [Pascal] often told her. These words filled Andrée with enthusiasm; you would have thought that an enormous weight had been lifted from her shoulders."

Andrée had absorbed from her environment the conviction that the expression of her individuality was itself a sin. She, like Simone Weil, another brilliant woman who attended the Sorbonne at the same time Simone de Beauvoir did, believed that humility was the highest calling and a religious responsibility. "Humility is the refusal to exist outside God," Weil wrote. "It is the queen of virtues. The self is only the shadow which sin and error cast by stopping the light of God, and I take this shadow for a being. Even if we could be like God it would be better to be like muck which obeys God."(Dying in exile in a London hospital in the summer of 1943, Weil starved herself to death, though there is some debate about whether her refusal to eat was an expression of solidarity with occupied France or the result of illness.) This form of faith, which similarly torments Andrée, is not gendered. Pascal, too, believes that hubris is a sin. But though philosophical belief is universal, the personal interpretation of it and its absorption into an individual psyche is particular; and so Andree's relationship with the problem of humility and hubris differs from Pascal's. Unlike him, Andrée is predisposed to interpret her gifts themselves as hubristic, as deplorable indulgences of pride, and to hold herself accountable to God for every instance of their cultivation. It is difficult for her, as it is difficult for many women, to justify aspirations to excellence and distinction. Andrée reminds herself often that her mother

never does anything for herself but dedicates all her time to others, and she believes that it is her duty to do the same. (This is reminiscent of the medieval women saints in Bynum's study, for whom feeding and healing others comprise the essence of their religious devotion.) Andrée suspects that she is capable of greatness, and that consciousness itself is, in her mind, incriminating. She longs to live fully and to renounce absolutely — both with equal vehemence.

These internal contradictions will tear Andrée to pieces, and she will respond to them the way women so often have responded to them. When Sylvie visits her in the summer, she notices immediately that Andrée has grown very thin. One of the young Gallard sisters murmurs to Sylvie that "Mama tells her off, but she doesn't eat a thing." Andrée's duties have metastasized beyond bearable proportions, and they have succeeded in crushing her spirit. She confesses to Sylvie that she prays every night that she will die in her sleep. Andrée reports that Madame Gallard has discovered that she is in love with Pascal. Sylvie is not worried, insisting that Madame Gallard will find Pascal beyond reproach since he is a Catholic, but Andrée explains despairingly: "a love match is suspicious."

Meanwhile the social responsibilities that Andrée had more or less evaded have at last been demanded of her at full force. Andrée bakes pies, sets and clears tables, takes the twins on outings, and makes small talk at parties. Madame Gallard trains her daughters, the way women have always trained one another, to keep things running, to plug the interstices, to conduct the business that men neither notice nor think to perform, and to do it in a whisper. These standards are imposed upon women by other women for the sake of men. And the competence that results, the gentle and practical intelligence, the tasteful self-restraint, is wholly devoid of prestige. Andrée

must cultivate it, but she will not be honored for it. This is training for a life darting from event to event, paying respects at funerals, organizing charity sales, birthing, calming, and marrying off children, setting guests at ease, and facilitating or performing cleanups — a life of manners and mores, a life of duties, not victories. There is no glory in this work, and it is all that is permitted of her. With each task, each tender directive, it is pounded into Andrée's battered heart that if she loves her family truly and responsibly then she must renounce herself. It is a poisonous, merciless lesson.

Andrée despises the mindless labor, she has contempt for her own station, but she loves her mother and so plays the role to perfection for as long as she can bear it. Finally, though, the moment of violent self-mortification arrives. One day towards the end of the summer, she is instructed to chop wood before taking her sisters on an outing — a task that she dreads. In the shed she deliberately cuts her foot with the ax, certain that the wound will deliver her from the asphyxiating chores. "I couldn't stand it anymore," she whispers to Sylvie.

A few days into her convalescence, Madame Gallard reports that she will not oppose her relationship with Pascal as long as the two get engaged immediately. Pascal refuses, arguing that they are too young to speak of an engagement. Madame Gallard decrees that Andrée cannot remain in Paris and mandates a two-year-long exile to Oxford, far away from Sylvie's influence and Pascal's stimulations. Pascal concurs, and tells Andrée that her desire to be in the same city as him is an expression of corporeal weakness, that it is sinful. Andrée, ever susceptible to accusations of sin and shame, internalizes his castigation and repeats it to Sylvie like a dutiful marionette: "They're right, and I know that very well. I know very well that yielding to the flesh is a sin: I must avoid the temptations

314

of the flesh. We must be brave enough to face the facts." Sylvie listens with swelling horror. She knows that Andrée cannot bear such a prolonged separation from the people she loves.

A week or so before her scheduled eviction, Andrée visits Pascal's house and asks to speak to his father. In a feverish fit she begs him to accept her, not to hate her, and asks again and again why he is against her. Pascal, who recognizes her voice from the other room, calls a taxi to take Andrée to the hospital. Madame Gallard forwards a telegram to Sylvie the next day explaining that Andrée has been delirious all night. Four days later she dies. The last thing she said to her mother was, "There's a problem child in every family: and that's me." Andrée is buried in her family cemetery in the country, to decay for eternity alongside the bones of her triumphant ancestors. Sylvie attends the funeral, paying respects for the last time to the greatest love of her life. She notices bitterly that Andrée's "grave was covered in white flowers. In some strange way, I understood that Andrée had died, suffocated by that whiteness. Before leaving to catch my train, I placed three red roses on top of those pristine flowers."

*Inseparable* is based on the true story of Simone de Beauvoir and her closest childhood friend, Elisabeth Lacoin. Elisabeth Lacoin, or Zaza, as Simone called her, died two weeks before her nineteenth birthday, after falling in love with Maurice Merleau-Ponty, a fellow student to whom Simone had introduced her. According to Zaza's doctors, she died of viral encephalitis, but the circumstances of her death were just as mysterious as those of Andrée's in the novel. In the introduction to *Insepa-rable*, Beauvoir's adopted daughter Sylvie Le Bon de Beauvoir confides that if one were to ask Simone what had caused Zaza's

death, she would have said that "Zaza died because she was extraordinary. She was assassinated; her death was a spiritual crime." Simone recounts Zaza's story in her autobiographical work *Memoirs of a Dutiful Daughter*, but *Inseparable* is the only book dedicated entirely to Zaza's tragedy.

It is difficult for a young girl to forgive herself for being extraordinary. It is difficult for an extraordinary woman to spare herself. The conflicting loyalties that strangle Zaza are familiar. They are structurally the same as the contradictory conceptions of proper femininity that revive like multi-headed hydras in every generation, preying on the special ones, the ambitious ones, the glittering ones, the odd ones, the high achievers who long for control over their own fate, for the authority to grant themselves permission, or the authority to snuff out the elements within them that rebel. Thwarted in their spirits, they overpower themselves; they are quick studies, trained through guilt to become self-saboteurs.

Is it outrageous to draw parallels between Zaza's short life and the lives of contemporary women? After all, since her burial in that dusty graveyard there have been several tsunamis' worth of feminist victories. Haven't we made progress? Or, as an exasperated interlocutor put it to me recently, "what more can feminists possibly want?" (This remark was made before a woman's right to choose was imperiled.) Isn't the fate of Andrée and Zaza a thing of the past? Is a woman who is afraid of womanhood merely a coward, or out of touch? Have the emaciated adolescents lining the high school hallways not gotten the memo? Shouldn't they just see a doctor? Didn't they hear about #MeToo, and wasn't #MeToo the most recent in a long sequence of battle cries, each one a little more triumphant than the last? Why on earth are we still talking about this?

These questions betray a fundamental misunderstanding.

Feminism is a political movement. It operates primarily in a single realm of human life — the political realm. The nerve endings and muscles that it has developed are effectual or not, clumsy or not, exacting or not, within that realm. The movement ought to be judged according to the progress it has eked out through political means. But most of life takes place outside the realm of politics, and so there are many realms of life in which feminism has no teeth. Second-wave feminism insisted that "the personal is political," and the Women's Liberation Movement adopted that slogan because it wanted to persuade women to draw political conclusions from their own grim experiences. Yet that slogan, like all slogans, was intended more to be effective than to be truthful. History has proven it wrong. Since the 1960s political liberation has strengthened, but personal liberation remains illusory. The reason is simple: the emancipation of the soul from its inherited demons cannot be accomplished by Congress or the courts.

The personal is not reducible to, or contingent upon, the political. Today (and for all time) this bifurcation hermetically seals off the realms in which a woman is encouraged to be an aggressive Girl Boss from the realms in which she is shamed (by herself as much as anyone else) for asserting her autonomy. In *The Second Sex,* Beauvoir lucidly described this confounding inevitability:

317

> The advantage man enjoys and which manifests itself
> from childhood onward is that his vocation as a human
> being in no way contradicts his destiny as a male... for a
> woman to accomplish her femininity, she is required to
> be object and prey; that is, she must renounce her claims
> as a sovereign subject. This is the conflict that singularly
> characterizes the situation of the emancipated woman.

**Mortifying**

> She refuses to confine herself to her role as a female
> because she does not want to mutilate herself; but it
> would also be a mutilation to repudiate her sex.

Women who battle to smash the glass ceiling by day (and are feted for doing so) find themselves mysteriously compliant when confronted with a Tinder date's odious demands and expectations. Suddenly these women cannot permit themselves to disappoint a stranger. (There was more dignity in complying physically with God's demands, or in disappointing Him.) In these two realms, they are trying to fulfill contradictory roles: the role that feminism set for them, and the role that their womanhood imposes on them. Feminism is emphatically not the same thing as womanhood.

And so it should not surprise us, it should not strike us as antiquated, that a daughter of the twenty-first century is just as likely as Elisabeth Lacoin to extinguish herself. Why hasn't feminism taught her otherwise? Because that is not what feminism can do. Feminism can advocate for equal pay, but it cannot convince the women in the boardroom that they deserve to be there. The movement cannot teach a woman to like or admire or respect herself. It cannot eliminate from the consciousness of a young girl the stifling certainty that achieving proper womanhood will always mean developing a virtuosic capacity for self-denial, for self-abnegation, for self-mortification. Each new generation of girls is remorselessly inducted into this repressive sisterhood. Failing to equip ourselves, our daughters, and our sisters, with the capacity for emancipation, for inner emancipation, is not a feminist failing: it is a human one.

# LEON WIESELTIER

# *The War Has Happened*

*It is a dreary world, gentlemen.*

GOGOL

The most consequential event of our time, I pray, will be the
heroism of the Ukrainians. Here are men and women fight-
ing and dying for liberal democracy. It was beginning to seem
as if such a thing were no longer possible. Worse, no longer
desirable. Here in the West, Jeshurun waxed fat and kicked. We
have just been through years of contempt for liberal democ-
racy, and the great disparagement is hardly over. We have been
told that everything bad in our age is the fault of liberalism, or
worse, neo-liberalism, whatever that is. It has been blamed for
just about all the unhappiness in the world; and so the peddlers
of a new happiness gloatingly call themselves post-liberal, on

all sides of the rotted ideological spectrum. Sometimes one has to rub one's eyes in disbelief at the intensity of the hatred for liberal democracy: do these fools really understand what they are saying? And then Vladimir Putin, with perfect candor about his lack of scruple and an inhuman absence of shame, attacked Ukraine. The question of his motivation is murky, like everything about this dead little man; there are those who attribute his war to strategic considerations and those who attribute it to mystical ones. Yet Putin's objective could hardly be more plain: it is to stop the spread of liberal democracy, which in recent years has been exhilaratingly identified with the political evolution of Ukraine. Like his Soviet predecessors, Putin fears nothing more than sharing a border with freedom, which has a way of getting through barbed wire.

One of the most striking features of the discussion about the war in Ukraine is how little the anti-liberal left and the anti-liberal right have contributed to it. The left does not support Russia, of course; but it does not support American support for Ukraine either, at least not with its customary relish. What the Ukrainians can expect from the progressives is an airlift of thoughts and prayers. I suspect that what really outrages them about Putin's invasion, even more than its war crimes, is that it might beget an increase in the American defense budget; or worse, a revival of "the Washington foreign policy establishment" and "the Washington elite," by which they mean anybody who holds a view contrary to theirs. This is populism as national security policy. In recent decades progressives have been more fascinated by Islam's martyrs than by liberalism's martyrs. They certainly do not look favorably upon the new activism of American foreign policy that has been engendered

by the Ukrainian war. In their view, American foreign policy should be nothing more than a commemoration of the Iraq war unto the end of time. Our disgraceful retreat from Afghanistan was celebrated as precisely such a tribute to our post-Iraq wisdom. And now Putin comes along and spoils things. Just when we thought we were out, they pull us back in! (In fact, the conjunction of events was not a coincidence: our flight from Afghanistan made the moment auspicious for the Russian aggression.) In the curious logic of left-wing isolationism, the danger of Putin's imperialism is that it may beget American imperialism, since all American interventions are by definition imperialistic. Putin has played into LBJ's hands, if you see what I mean. And so here is Frantz Fanon, I mean Pankaj Mishra, warning that "Putin's atrocities in Ukraine have now given" that aforesaid establishment "an opportunity to make America seem great again." (No, not seem; *be*.) And here is Glenn Greenwald solemnly reporting Noam Chomsky's remark that "fortunately" there is "one Western statesman of stature" agitating for a diplomatic solution to the war. That saving giant of diplomacy is Donald J. Trump. The spectacle of Chomsky's degeneration is delightful.

As for the post-liberal right, they are stuck with their admiration of Viktor Orban, who is stuck with his admiration of Vladimir Putin. They all deserve each other. In Poland, at least, even the post-liberals, including some of the prophets whom certain American reactionary intellectuals revere, have been clear about their opposition to the Russian war, but then Poland, for the obvious reason, has always been especially wakeful about Russia. Yet even as the horrors in Ukraine abound, the poisonous post-liberal vapors proliferate. A few

months ago I came across a piece by Patrick Deneen, one of the most important thinkers that Hungary has produced, in which he discussed the thought of Augusto del Noce, a twentieth-century Italian Catholic philosopher who wrote probingly about modern atheism, which he interestingly called "natural irreligion." Deneen said that "Del Noce saw further and better than most of his contemporaries that the great totalitarian threat of our age emanated not ultimately from the dictatorships of so-called communist regimes of the Soviet Union or China, but from the unfolding liberal logic of the West." A bit of explication: Stalinist Russia and Maoist China were "so-called communist" because communism, in the teaching of the right-wing post-liberals, was at bottom liberalism. Really. Deneen posted that sentence about the totalitarian threat of the West while Russian troops were massacring Mariupol. They were committing those atrocities, and many others, precisely in the name of the ethnonationalism and the anti-liberalism that these Western reactionaries have been urging upon us. Since the invasion of Ukraine, the writings of these Western ingrates, and for my sins I have read a lot of them, look to me like little more than a symptom of the decadence that they deplore.

The West has found a teacher in Volodymyr Zelensky. He is stripping the banality from the truths that we hold to be self-evident; teaching us what we already know but have demoted to cliché and the inertness of civil religion; refreshing our sense of the beauty of our dispensation, all its current grotesqueries notwithstanding. He is a new kind of contemporary hero: the fighting liberal. He has the authority of his courage. When we assist him in his fight for liberal democracy, we are returning the favor. No such figure has emerged out of Europe since

Havel, though it is doubtful that Havel could have presided over the management of a war. (How is it that both of these moral leaders came from the theater? Rousseau would have been baffled.)

In 2014 I spent many hours in Maidan, the central square of Kyiv, or rather in its ruins. It was the charred scene of one of democracy's finest battles. The place had been instantly turned into a memorial to the protestors who were murdered there. There were candles everywhere, in brightly colored holders that contradicted the bleakness of the scene. There were flowers, photographs, posters, crosses, and yellow-and-blue flags. The pavements were torn up, and tires were piled high in black towers that served as barricades. Fires caused by the government's onslaught had blackened the surrounding buildings, which were also scarred by the bullets of police snipers. There were tents in which demonstrators from the "revolution of dignity" stubbornly lived, refusing to retreat from the scene. It was an honor to stand there. Even secular people have holy grounds. I might as well have been in the streets of Paris in 1871, or at Garibaldi's *spedizione*. The impression was indelible; it melted me and steeled me. Before I went to Kyiv, I believed that I was headed for a city that aspired to be a Western city, and that I was going there to applaud its aspiration. When I arrived in Kyiv, I recognized my mistake. Kyiv already is a Western city. There is nothing aspirational about its openness, its pluralistic vitality, its reforming energy. To be sure, it was still in the middle of a struggle; the old order, authoritarian and corrupt and oligarchic, will not gently quit history's stage. But the forces of freedom — in a place such as Maidan one learns to use those words without irony or sophis-

tication — seemed to be winning. If they had lost, Putin would not have attacked.

Were we prepared, intellectually and operationally, for Putin's war in Ukraine? We must consider this question carefully, because we are not headed for a halcyon age. In our conflicted country, there has been only a single consensus in recent decades. It is that the United States should shrink its station in the world, that it must no longer loom so large, that it needs to "reduce its footprint" and "play the long game," that it must adjust its ends to its means, that for itself it must come first (and then brook no seconds), that American leadership is more of a problem for the world than a solution. All the parties, each for their own reasons, concurs in these miniaturizing propositions, which became known as "responsible statecraft." Occasionally they would just come right out and say it, as when the despicable J. D. Vance declared that "I don't really care what happens to Ukraine one way or another." Spoken like a true hillbilly. But there are many other foreign-policy hillbillies, alas, some of them denizens of the Acela corridor and even of Aspen, who harbor a similar indifference to the fate of countries and peoples beyond our borders. Those whose consciences do not permit them to openly express their callousness prefer to call themselves "realists." Realists almost always advocate the same positions as isolationists, except that their op-ed pieces are longer.

The ethical phoniness of realism found its perfect avatar in Barack Obama, who draped Elie Wiesel's language over Henry Kissinger's policies. The war in Ukraine is substantially the

consequence of the moral and strategic timidity of Obama, who opened a strategic vacuum in the Middle East that Putin quickly proceeded to fill and thereby to inaugurate the contemporary (and until then, unlikely) resurgence of Russia. It is important to recognize that the strategic vacuum was made possible by a moral vacuum: if it had been the policy of the United States that, one way or another, with force or without, with allies or without, we would not stand idly by the genocide in Syria, we would have retained a regional position that might have kept Russia at bay. Obama's apologists refer to his timidity as a respect for complexity. As someone who is in the complexity business myself, I can testify that sometimes we abuse the idea. Realists have a condescending way of believing that people who disagree with them are unaware of the facts, that only they, the wised-up members of the panel, know the score. They like to point out that a course of action is difficult and has costs, though usually it is a course of action of which they disapprove on other grounds. Every decisive historical action is difficult and has costs. Even us bloodthirsty interventionists know that. But justice — the word never appears in the discourse of realists, except in their "to be sure" sentences — requires that we not be daunted. We may fail and we may make mistakes, but at least we can live with ourselves; and more important than whether or not we can live with ourselves, since the suffering of others is not primarily about us, other people can live.

In individuals, we regard the unwillingness to help, to come to the rescue, as a flaw of personal character. Is the same selfishness in collective action a flaw of national character? In individuals, we regard the secession from one's surroundings, the withdrawal from effective participation in one's world, as a

**The War Has Happened**

personal disorder. Is the same truncated relationship to reality in the collective a national disorder? Is isolationism psychotic?

Oh, for a little American hubris.

We need to overcome our appetite for futurist indignation. During the years of ISIS, one could not escape the observation, offered always with astonishment, that here was an eighth-century caliphate in the twenty-first century. Amazing! Well, no. Everything that takes place in this moment is of this moment. We must see the entirety of the world in which we live. We chose to regard ISIS as an anachronism because it comforted us. Religious violence, we needed to believe, is not typical of our times, but a relic of earlier times, a florid exception to the Whiggish linearity in which we wallowed. We denied the intractability of history, the persistence with which certain features of human experience survived past the enormous changes that we were busily exalting. We were so dazzled by the discontinuities that we belittled the continuities. History offended our futurist excitement. Obama liked to play the man from the future. He pronounced that the important foreign policy challenges for which we must now prepare ourselves are Ebola and climate change. Meanwhile the world around him was becoming more and more Hobbesian, with aggressions and savageries to match the traditional ones. As he, and a great many other mandarins, enjoyed the globalist cool, the world was turning increasingly local and increasingly Westphalian, which is to say, it was becoming more familiar to those who bother about the past. In his first campaign Obama once said, in one of his many reassurances that the Russians were too

weak for us to worry about them, that "you can't be a twenty-
first century power and act like a twentieth-century dictator-
ship." But you can. In significant ways the twenty-first century
still is the twentieth century. (In our domestic tribulations,
too.) Stephen Kotkin was right when he recently argued, and
showed, that "the Cold War never ended."

After Antonio Gutteres, the Secretary General of the United
Nations, toured Bucha and its bodies, he remarked: "The
war is an absurdity in the twenty-first century. The war is evil."
He was half-right. Bucha is now one of the capitals of modern
barbarism, alongside Urumqi, Rakhine, Aleppo, Srebrenica,
Nyarubuye, Lidice, Guernica, and the rest. But evil is not
absurd, and to call it absurd is to evade its force. Absurdity is
a category of logic and art. Evil is an inalienable feature of the
history made by human beings. It has a logic of its own, which
is why it creates its intellectuals and its mobs. If only falsehood
were always absurd! The war in Ukraine is not absurd, because
it is evil.

One of the reasons that we were intellectually unprepared for
the war in Ukraine is that we spent decades exalting newness
and declaring old things obsolete. Here is another example. In
2010, the Obama administration released its defense budget, a
"reform budget," along with a new security document. Since
many military appropriations were to be cut, people assumed
that the cuts were driven by fiscal considerations. But the cuts
were of a piece with a new conception of national security.
They were driven by historical and strategic concepts. The
document announced that land wars were a thing of the

past, and that henceforth we could accomplish our military objectives mainly with Special Ops and drones. It was a fine document of the anti-Iraq-war ethos, and completely deluded. The new strategy was lauded for its moral superiority: fewer innocent civilians would be killed by such more precisely targeted operations. (Of course this inevitably led to the objection that the lower toll made the use of force more likely, so that limited strikes, too, lacked legitimacy, which by my lights leads directly to the brink of pacifism, or at least to a revival of the Kellogg-Briand nonsense, which anyway was already taking place.) But you cannot conquer territory, or hold territory, or expel an enemy from territory, from the air or like thieves in the night. And here is the war in Ukraine, mile after mile of it, town after town, to disprove all this advanced strategic illusion. We are sending heavy weaponry to the Ukrainians because there is no other way for them to expel the invader. History can be trite, which is how it readies us.

It was stirring to watch the reception of the Ukrainian refugees in Poland and the other Eastern European states. When was the last time that we saw refugees warmly welcomed and no controversy attached to their plight? Then I remembered my Syrian friends and the travails of their community in its own flight. I imagined how they must have felt when they saw all those hugs and smiles in Przemysl and elsewhere. In Europe, you see, Ukrainians are not exactly the other. (That is what scares Putin.) There is nothing wrong with helping people who are like oneself, but it is not the most exacting test of one's compassion.

We wasted so much time in the long prelude to the Russian invasion. While Putin was amassing a vast force near the Ukrainian border, we argued with ourselves about the likelihood of war. Those who contended that war was coming, based on the incontrovertible evidence of Putin's massive preparations for it, were regarded as the hawks, when in fact they were the realists. The doves, though these terms are coarse in these circumstances, insisted upon more diplomacy. They thought that pushing the elevator button again would make it come faster. Diplomacy became a kind of placebo for people who were not in the mood for another conflict that would in some way, hot or cold, involve us. American officials protested that a diplomatic solution was possible even as Putin's tanks started rolling. One of my favorite errors of the Obama administration made its appearance in the Biden administration: the off-ramp. Remember, we have been here before. Putin's current invasion is the third act of his protracted war on Ukraine: in 2014 he stole Crimea, and soon afterward he launched a separatist rebellion in Donetsk and Luzhansk, which in the aftermath of his recent failure to take Kyiv he is now attempting to complete with his own troops. During the Crimean crisis, which strictly speaking was not a crisis at all, since Putin stole it with impunity, Obama kept talking about the need to find Putin an off-ramp, a way out, as if the role of the United States was to be sagaciously helpful to Russia so that it could learn from its mistakes. (I was reminded of this misplaced magnanimity when a Democratic congresswoman recently said that the American task now is "to craft a win for Putin.") But Putin was not looking for the off-ramp. He was, quite plainly, looking for the on-ramp. He found it and he took it. He has been taking the on-ramp in Ukraine for most of a decade. And anyone who knows that there is an on-ramp knows that there

**The War Has Happened**

is an off-ramp. If they do not avail themselves of it, it is because they have a different itinerary in mind. Anyway, the option of turning around and going home is always there: other, equally proud states have done so, such as France and the United States. Putin is in Ukraine because he believes that Ukraine is his, Russia's, its "near abroad," or *Novorussiya*; and that therefore he need not restrain himself from destroying its democratic experiment. "We've sought to provide possible off-ramps to President Putin," Secretary Blinken said in March. "He's the only one who can decide whether or not to take them." But then he added, immediately, and with an admirable alteration in tone: "So far, every time there's been an opportunity to do just that, he's pressed the accelerator and continued down this horrific road that he's been pursuing." Meanwhile the Ukrainians themselves have not bothered about the ramps. They have been courageously attacking the highways.

Re Putin and religion: I was reading a Hebrew poem, published in 1940, about the "Winter War," the Russian invasion of Finland in the previous year, which in some respects reminds one of the Russian invasion of Ukraine. The poet referred to a strange incident that was reported by a newspaper in Stockholm. It appears that Finnish pilots flew sorties over Leningrad in which they dropped hundreds of little Bibles on the city, "because they believed it would have a decisive influence on the spirit of the Red Army." Imagine! Putin, meanwhile, has a Patriarch in his pocket. "We have entered into a struggle that has not a physical, but a metaphysical significance," Kirill has cravenly intoned. The religious heroes of the war in Ukraine are the Ukrainian clerics in the Orthodox Church who have turned against the Muscovite pontiff for being a slaughterer's stooge.

The United States responded slowly to Putin's "special operation" because we were not mentally ready for it. We have caught up, certainly, but it always feels like catch-up. A great power — and we are one, whether we delight in it or not — cannot be always reactive. For a long time now, too much of American foreign policy has consisted in crisis management. In a world accelerated past the point of reflection, this was somewhat inevitable; but still resistance must be offered. The name of that resistance is strategy, or geo-strategy, or grand strategy. A few years after the collapse of the Soviet Union I was sitting with Walter Laqueur, a wise and erudite man, and one of the first analysts to write books about "Putinism" and the rise of the new Russian right, and he remarked that it had been a long time since he had heard the word "strategy" in Washington. "Geo-strategy," he said, "has been replaced by geo-economics." This was certainly true of the booming 1990s, but he was alarmed by more than the economicist interpretation of foreign affairs. His words have haunted me. The meaning of strategy is an infamously complicated subject, and the co-existence within it of empirical and moral elements, of facts and purposes, the integration within a single "intellectual architecture" of all the dimensions of warfare, is hard to pin down. What I mean by it here is only this: a prior understanding of what we want, and why. This understanding must be developed quite consciously as a historical plan, as a program for action and a standard for readiness. It should not be confused with the intellectual frameworks that we possess before events happen. It is, in fact, a challenge to those frameworks, which usually are little more than attitudes or moods or prejudices drawn from recent experience. A strategist is not indifferent to circumstances, but he is not a slave of circumstances either. He has a calling to shape and mold and alter a reprehensible or disadvan-

tageous order, and an intense sensation of agency, and a certain pleasure in the exertion of intelligent will. He is comfortable with the proposition that power exists to be used. He recognizes the difference between flexibility and reactiveness; he is not rigid, but he is also not winging it. The problem, of course, is that a historical plan is a blueprint for time, but time does not stand still. There will be contingencies and emergencies that will allow no delay, if a response is to be effective, and they will require more than impulsiveness and improvisation. If you tarry in response to a genocide, for example, you have not understood the nature of the challenge. Surprise is inevitable, but shock is unforgivable. Our preparedness starts in our imagination. (Obama was a peculiar case: he was good at strategizing, whatever the merits of his strategy, but bad at reacting.)

Does the United States have a grand strategy? In the culture of endless repeal in which our politics now takes place, our partisan seesaws of doing and undoing, can the United States have a grand strategy? One of the primary conditions of strategy is constancy. But is anything that we do any longer durable? The problem is not, as George Kennan and Henry Kissinger liked to insist, democracy, or the impact of domestic opinion upon planning. It is, rather, the debasement of our democracy into what seems to be a permanent condition of unsettledness, our hot-headed unreliability about precedents, our infernal volatility. If we need to reduce the erratic nature of our public life, it is not least because the era is rapidly approaching in which we will find ourselves in great power rivalries of unclear but significant duration. Indeed, the era has already begun. Strategically speaking, the resurgence of Russia may be a sideshow to the ascendancy of China, but sideshows can last gener-

332

ations. The Soviet Union lasted seventy years — a blip in the arc of history, but not in the fate of many millions of people. I am not convinced that we are yet up to the task. The proof is in our platitudes. Until our withdrawal from Afghanistan, we spoke constantly of "the forever war." Of course there was nothing interminable about it, as we eventually demonstrated. The important question was not its length but its wisdom. If a particular use of American force is morally and strategically justified, and there were ferociously different views about Afghanistan, then we must develop a new talent for patience and learn to think (as the economists say) secularly, or else we will condemn our actions to futility from the start. One of the lessons of our retreat from Afghanistan was that America can be waited out. (There is also the matter of costs, but the number of dead Ukrainians and Russians in only the first few months of combat should provide some context for the human costs that we suffered in Afghanistan, which was 2,401 dead in twenty years.) In any event, "the forever war" was swiftly replaced by a new platitude, which is that we must beware of getting into "a new cold war." It is past time to put some intellectual pressure on this slogan. For a start, a cold war is preferable to a hot war. More importantly, our destiny is not entirely up to us: if Russia or China behave towards us (or our allies) in a hostile manner, then we are in a cold war with Russia or China. And so we already find ourselves in two cold wars. We can choose, of course, not to fight them, and hide between our oceans; but thankfully we have not made that choice, even if we are still profoundly uncomfortable with the accurate description of these global realities. Anyway, there is nothing to trouble our sleep about being the most powerful adversary of the most powerful tyrannies. Except that we must not sleep! The term "cold war" has become a term of imprecation, a dysto-

333

pian word, because the Cold War, I mean the one that took place between 1946 and 1991, is erroneously remembered as an unprincipled contest between two deranged nuclear powers who went around the world committing crimes and abuses. It was nothing like that, though we did commit our share of crimes and abuses. It was an honorable struggle against totalitarianism that over many decades was conducted more or less firmly and more or less rationally and in stirring consonance with our principles; and every decent man and woman should tremble at the thought of what life everywhere would have been like if we had lost.

Biden is ringingly correct when he says that the future will be characterized by a struggle between democrats and autocrats. But is this a worldview or a strategy? It all depends on what he does about it.

In *The Atlantic*, where everything can be found, an American historian argues that World War II does not look the same when seen from an Asian standpoint. I do not doubt that this is so. In Asia, quite obviously, the anti-fascist powers were also imperialist powers. The implication of this colossal fact, according to the author of the article, is that we must retire our moral understanding of the war. It was not a war between good and evil. It was "a lethal collision of self-interested rivals." The author even writes admiringly of a notorious Indian nationalist who escaped to Germany and raised an Indian force to fight alongside the Wehrmacht and later alongside Japan against British India. For him, "this wasn't an invasion but a liberation." Good for him. But why should the enlargement of our under-

standing about the Asian theater distort our understanding of the European theater? The Indian viewpoint about the war in South Asia does not refute the European viewpoint about the war in Europe, or the Jewish viewpoint, or the viewpoint of the resistance fighters across Europe who, even in societies rife with collaboration, were animated by the certainty that their enemy was evil. If the experience of Indians was different from the experience of Europeans and Americans, then the experience of Europeans and Americans was different from the experience of Indians. The rule of particularity and partiality applies to all, and the one cannot be used to discredit the other. (And Japan did not exactly fight the war with the impeccability of just war theory.) Yet the moral delegitimation of World War II, like the moral delegitimation of the Cold War, is attempted not only for the sake of a sounder historiography. It has also a policy purpose. The ultimate warrant for the principle of American interventionism, the decisive historical prooftext for the view that American power can be a force for good in the world, is World War II. Take it down and the withdrawalist program for American foreign policy is complete. Persuade people that even "the good war" was a bad war and they can serenely repair to their gardens, where most of them already are.

335

What is the outcome that we seek in Ukraine? An end to the conflict is not a sufficient objective. The most urgent thing about a conflict is not always to end it as soon as you can. (I am not speaking about a nuclear conflict, but the anxiety about nuclear war was skillfully stimulated by Putin to disrupt Western enthusiasm for Ukraine, and in some quarters it worked like a charm.) A "sovereign, independent Ukraine," as Blinken put it, looks to me like the proper goal, though it

is finally the Ukrainians who will formulate the acceptable terms for the cessation of hostilities. If I were them, I would not rest until the removal of every Russian soldier from their soil. When Secretary of Defense Austin declared that "we want to see Russia weakened to the degree it can't do the kinds of things that it has done in invading Ukraine," I cheered. Putin started a vicious and unprovoked war against the civilians of a sovereign state that poses no threat to him except insofar as it seeks to join the community of liberal democratic nations, and thereby he showed himself to be a menace whose capacity for cruelty and recklessness we need no longer speculate about — an active and genuine enemy. In the years prior to his resort to his army, he was tireless in his intrigues and interventions in the democratic processes of the West, which we tolerated. His invasion of Ukraine has also exposed the startling mediocrity of the Russian military. And so Austin was right to suggest that a weak Russia is within our interest and within our grasp, and that we are not ourselves in search of the off-ramp. But Austin's statement disturbed people who regard every expression of American toughness as a slippery slope to Baghdad. In the *New Yorker*, for example, a jittery reporter noted that "U.S. officials now frame America's role in more ambitious terms that border on aggressive." Aggressive! We have vowed not to send a single American soldier to Ukraine. Biden repeated this promise over and over long before the war began. (I wondered why, as a tactical matter, he would make such a promise to Putin. But he was not making it to Putin, he was making it to the progressive wing of his party.) What the Biden administration has splendidly done -- with extraordinary quantities of heavy weaponry, and with intelligence, and with increasingly pitiless sanctions, and with its "ambitious" rhetoric — is display seriousness and steadfastness in its support of a just cause. Given the lameness

of American foreign policy in the Obama and Trump years, this should be a reason for rejoicing. We are not only reacting, we are also acting. It is finally time for an adversary to be nervous about *us*.

The professionals call the problem "escalation control." I do not mean to make light of it. There are risks that we must beware. But surely escalation control cannot mean that we never respond with greater strength, especially in response to an escalation on the other side. There are escalations of degree and escalations of kind, a great many instruments with which to change the course of a conflict or determine its outcome. Not all of them are crazy, and not all of them lead directly to armageddon. We must be prudent, but we must not be played. Even Raymond Aron, the most powerful advocate of prudence in modern times, once remarked that "prudence does not always require either moderation or peace by compromise, or negotiations, or indifference to the internal regimes of enemy states or allies." Aron's variety of prudence, as he demonstrated in his long life of political philosophy and political engagement, was decidedly vertebrate. Too often in recent years American prudence decayed into American passivity. I miss the days when we were feared. They overlapped with the days when we were trusted.

When bad actors anywhere in the world gather to plan an invasion or a repression or an expulsion or a genocide, does anyone at the table intervene with the question, "But wait — how will the Americans respond?" Does the prospect of American power any longer stay any villain's hand?

As a matter of historical record, America has "projected" its power abroad for many reasons, not all of them laudable; but the only state in the modern world that made dictators and murderers think twice, or go slow, or surrender, was the United States. (I exclude the Soviet Union in World War II, because it was a murderous dictatorship that helped to defeat a murderous dictatorship.) If there are to be obstacles or impediments, they will have to come from us.

Closely related to the question of escalating is the question of being "provocative." In the run-up to the war, while we were arguing among ourselves about its likelihood and Putin was gathering his forces, we should have been sending arms to the Ukrainians — sophisticated arms, lethal arms. The realists among us warned that this would provoke Putin. It turned out soon afterward that he required no provocation; he was pre-provoked. The Ukrainians knew this. In truth, any close student of Putin's behavior could have known this. The same hesitation had been expressed in the persistent opposition about the expansion of NATO since the 1990s, which came down to the view that in the name of our national security we need to respect Putin's "perceptions." People used to say the same thing about the Soviet Union — that we needed to understand the subjective roots of its foreign adventures, since it was "expanding because it felt encircled." In a famous sentence of the Long Telegram in 1946, George Kennan suggested that "at bottom of [the] Kremlin's neurotic view of world affairs is [the] traditional and instinctive Russian sense of insecurity." But who was intending then — who is intending now — to attack Russia? Surely there are limits to the therapeutic approach to states and statesmen. How mistaken

do "perceptions" have to be before we cease to respect them in our planning? And if the "perceptions" are fantasies of aggression and domination and extermination, then conflict is more likely, and we must have less forbearance about them. NATO is a purely defensive alliance that was formed when the nations of Western Europe had good reason to organize for their own defense. They still do: it is not a trivial point that none of the countries that Putin has attacked were in NATO. Ukraine poses no military threat to Russia. Neither do Poland and the Baltic states. Meanwhile Putin, by military and cyber and other means, has been attacking countries large and small. Many people have lost their lives to Putin's paranoia, which is a clinical term for "perception." This same hesitation about active American measures in Ukraine was advocated during the debate about American military support for the besieged state in the 2010s. Those of us who argued for the dispatch of lethal weaponry to the Ukrainians were not dreaming that they would march triumphantly into Moscow. (We also had no idea that they would perform as brilliantly on the battle-field as they now have done.) We wished only to raise the costs on Putin's aggressions and to prepare the ground for a polit-ical process. We were accused of irresponsibly poking the bear. But the bear poked us. The unfortunate consequence of such prevarications is that we are often tardy in our opera-tional thinking.

A story about escalation control: Two men have been condemned to death. They are lined up against the wall as the firing squad gets into position. Their hands are bound. Before they are blindfolded, the captain of the firing squad approaches them and asks if they have a last request. One of them asks for a

cigarette. The other turns to him angrily and says, "Don't make waves!"

I was in Paris during the first week of the war. It was the most important week in European history since that delirious week in the autumn of 1989, when the Berlin Wall was brought down. It was, indeed, a kind of mirror image of that week — the antithesis of delirium, which is sobriety. The very air was sober. (In Montparnasse such a change registers rather sharply.) I could feel the European shudder. In conversations with friends and strangers, there was a sudden gravity, a somber acknowledgment that the holiday may be over. A struggle was at hand. In Robert Kagan's terms, Venetians were talking like Martians. The salient emotion was not fear; it was anger, and then determination. The intensity of popular solidarity with Ukraine was palpable. Extraordinary things began to happen. Germany brought to a close the entirety of its post-war national security policy and raised its defense budget. I never believed that anything could morally offend the International Olympic Committee, but even it sought a way to punish Russia. Almost nobody looked back regretfully on the expansion of NATO. NATO acquired a new pride, as people to the east were now sacrificing their lives for their dream of belonging to it. It also acquired a new salience: in the first months of the war it was impossible to avoid the impression that Europe was leading America. This was in part the result of the loss of European confidence in America during the Obama and Trump years, but it was nonetheless wonderful. And even more wonderful was to watch us, the Americans, finally get up to speed. Eventually the Biden administration began to act with a magnificent decisiveness. The magnitude of our assistance to Ukraine, and

its spirit, has been historic. (I wish that we had worked out a transfer of aircraft as well. Maybe we will.) As Stephen Kotkin concluded, "the West has rediscovered its manifold power." At last! And American popular support for our government's efforts has so far been running high in the polls. Who cares about the "performativity" of all the Ukrainian flags one sees in the windows and on the internet? "Performativity" is an important element of culture, and for now American culture is championing the good fight. But for how long? It is never safe to bet on American attention. Still, whereas no society can, or should, be maintained in a permanent condition of apocalyptic excitation, perhaps we will come out of this crisis with a more lasting tension about the enduring realities of the world.

Whenever I visit Ukraine, I mourn, and not only for Ukrainians. My origins are there, and they are bloody. In the summer of 1941, in a forest near Boryslav, in western Ukraine, or Galicia, where my mother's family lived and owned oil wells, a pogrom was committed by local Ukrainians against local Jews, and she, at the age of twenty-two, was among the Jews tasked with collecting the mutilated corpses and arranging for their proper burial. They included her uncle Elimelech. I drove by the forest and past "our" rusted derricks on my way to Schodnica, the small town where her large clan lived, and where, in a makeshift room dug out beneath a barn, she survived the last year or so of the war, under the protection of Poles who had worked for her father in the oil fields. After I satisfied myself that I had located the gentle slope on which her house once stood, and completed my inner convulsions, I went back to Lemberg, or Lviv, where I sought out the high school that she attended. (In Lemberg she saw Josephine Baker!) It took me

two days to realize that I was using an outdated Hapsburg-era map, and that Zygmuntowska Street was now Gogola Street. The head of the school welcomed me warmly and took me to a room where some physical remains of my mother's *gymnasium* — pennants, stationery, and so on — were framed and respectfully exhibited. At a nearby synagogue, once renowned for its murals, I prayed like a good son and then kicked around in the trash — the place was being renovated, I'm not sure for whom. In the trash I discovered a book. When I dusted it off, I was thunderstruck: it was Job — an edition of the Book of Job, two hundred and some pages, published not too far away in Zhitomir in 1872. Its end-pages were covered in Hebrew and Polish scribbles in a beautiful hand, and it came with the commentaries of Rashi and a certain late nineteenth-century rabbi named Shmuel Sternberg from the nearby town of Vinitsiya, who prefaced his commentary with a remarkable introductory essay in which he quarreled with modern non-Jewish Biblical critics as well as medieval Jewish Aristotelians, and displayed enormous literary sensitivity to the sacred text. The hounded volume also came with fire stains and water stains. I rescued it. It is now my Ukrainian Job.

342

Years later, when I went to Kyiv, the same shadows accompanied me. Around the corner from my hotel was a huge equestrian statue of Bogdan Khmelnitsky, the seventeenth-century idol of Ukrainian nationalism and one of the most reviled figures in Jewish history. His successful war against the Poles included some of the most hideous atrocities in the annals of anti-Semitic violence. This is from a Hebrew chronicle of 1648, about what befell Jews in the region of the Dnieper River: "Some of them were flayed and their bodies were thrown to

the dogs. Some of them had their arms and legs cut off and they were thrown onto the roads, where wagons rode over them and horses trampled them. Some of them were buried alive. Children were slaughtered in the arms of their mothers, and many children were torn into pieces like fish. Pregnant women were cut open and watched their fetuses crushed. Other pregnant women were cut open and a live cat was placed in their bellies, which were then sewn back up, and their hands were cut off so that they couldn't remove the cats from their bellies." When I was growing up, I knew Jews for whom "Khmielnitsky" was still a common curse word. And here was the *hetman* on a pedestal, in monumental bronze. To further upset my Jewish heart, I was told that the nineteenth-century building before which the statue stood, painted oddly in pink, was the courthouse in which Mendel Beilis was tried for ritual murder in 1913. Passing the statue and the courthouse, I walked down a steep cobbled street toward the old city, and along the way, directly across from the house where Bulgakov was born, I encountered a stall selling antiques from the Great War, including Nazi helmets and a slightly tattered waistcoat with a yellow star pinned to it. I could have had the yellow star for three hundred dollars. I was more inclined to spit.

343

Yet I was there, along with some like-minded friends and comrades, to offer my support — I gave a few speeches and press conferences — to the noble struggle of the Ukrainians for liberal democracy. There was Khmielnitsky, but here was Maidan. There were moments when it was too much for my mind to hold. The plurality of loyalties can sometimes hurt. I knew all the arguments against the tyranny of collective memory, and against collective responsibility, and against

historical inevitability; and the history of my own people vividly demonstrated the benevolent effects of liberal democracy and its Torah of rights. How can a Jew not support democracy? Yet how can a Jew surrender his skepticism about historical metamorphosis? I made a point of meeting many Ukrainian Jews, old and young, from all walks of Ukrainian life, and asking them for their assessment of their situation. Every one of them, including officials of the community who knew both the government and the democracy movement, responded with unalloyed confidence about the future. They knew the same history that I did, and they lived there. Who was I to contradict them? I had always believed in the possibility of progress, as every member of every minority must, or else they may fulfill their own fatalism. For Jews, there were always only two paths out of the persecuting world: democracy and Zionism. They are the two epic experiments in Jewish emancipation, the two great historical alternatives to the European bargain, which was autocracy punctuated by magnanimity and helplessness punctuated by happiness. I had *yahrzeit* for my father in Kiev, and I found myself reciting the *kaddish* with an unexpected élan. During this war, the embrace of the Ukrainian struggle by American Jews has been thrilling to behold (even the Israeli government, which never misses a chance to seem small, finally got it right); it represents, among other things, a poignant overcoming of memory by morality. The past always provides reasons for ethical relaxation, especially the past of once-oppressed groups, which is rich in occasions for anger; but they are wise who refuse to mistake the betterment of their conditions for a betrayal of their traditions.

Hope, because it is premised on uncertainty, is perfectly

compatible with vigilance; but there is a certain kind of vigilance, an expectation of the worst that crosses the line into morbidity, a prior weariness that is not so much an inference from reality as it is an interpretation of it, that destroys hope. The first requirement for political leadership, and for political participation, is an immunity to despair.

This morning the Director of National Intelligence told Congress that "we assess President Putin is preparing for a prolonged conflict in Ukraine during which he still intends to achieve goals beyond the Donbas." She added, "Putin most likely also judges that Russia has a greater ability and willingness to endure challenges than his adversaries." About this he may not be wrong, at least as regards us. The Ukrainians can give us lessons in how not to relent. The important reckoning now must be with the history of our credulity, with the poverty of our geopolitical imagination, with our national lassitude about what lies out there. The war has happened. Those words, *la guerre a eu lieu,* gave the title to an essay that Merleau-Ponty published in *Les Temps Modernes* in October, 1945. Its subject, in the aftermath of the victory, was the mentality of the French on the eve of the conflict, which in his view left them ill-equipped for the perils of their time. "Events kept making it less and less probable that peace could be maintained," he wrote. "How could we have waited so long to decide to go to war? The reason was that we were not guided by the facts. We had secretly resolved to know nothing of violence and unhappiness as elements of history because we were living in a country too happy and too weak to envisage them. Distrusting the facts had even become a duty for us. We had been taught that wars grow out of misunderstandings which can be cleared up and

accidents which can be averted through patience and courage. We lived in a certain area of peace, experience, and freedom, formed by a combination of exceptional circumstances. We did not know that this was a soil to be defended but thought it the natural lot of men. From our youth we had been used to handling freedom and to living an individual life. How could we have learned to commit our freedom in order to preserve it?" There is pain in the philosopher's words. He is not scoring political points. When he writes that "our standards were still those of peacetime," he is a little elegiac, and he certainly is not mocking happiness and peace. But he is also insisting that a society has cognitive responsibilities. Nothing will determine its fate more than its ability to see clearly, and then not to flinch at what it sees if what it sees is really there. The first readiness is mental readiness.

347

# CONTRIBUTORS

**OKSANA FOROSTYNA** is a Ukrainian writer and translator.

**ROBERT KAGAN** is the Stephen and Barbara Friedman Senior Fellow at the Brookings Institution. His new book, *The Ghost at the Feast: America and the Collapse of World Order, 1900–1941,* will appear this fall.

**JUSTIN E. H. SMITH** is a professor of history and philosophy of science at the University of Paris, and the author among other books of *The Internet Is Not What You Think It Is: A History, A Philosophy, A Warning.*

**DARYNA GLADUM** is a Ukrainian poet, translator, and performance artist. Her book of poems, *To Hack a Tree,* was published in Kyiv in 2017.

**LESYK PANASIUK** is a Ukrainian poet, translator, designer, and performance artist, and is the author of several books of poetry.

**VALZHYNA MORT** is a Belarusian-American poet. Her most recent book, *Music for the Dead and Resurrected,* recently was awarded the International Griffin Prize.

**JAROSLAW ANDERS** is the author most recently of *Between Fire and Sleep: Essays on Modern Polish Poetry and Prose.*

**ELLIOT ACKERMAN'S** new book, *The Fifth Act: America's End in Afghanistan,* will be published this summer.

**JAMES WOLCOTT** is the author of *Critical Mass: Four Decades of Essays, Reviews, Hand Grenades and Hurrahs.*

**WILLIAM DERESIEWICZ'S** new book *The End of Solitude: Selected Essays on Culture* will be published in August.

**PASCAL BRUCKNER** is a French writer and the author, among other books, of *A Brief Eternity: The Philosophy of Longevity.* **JENNIFER GORE** is a translator who lives in Washington, DC.

JEAN DE LA FONTAINE, the author of *The Fables*, was born in 1621 and died in 1695. HENRI COLE is an American poet and translator, and the author most recently of *Blizzard: Poems*. CLAIRE MALROUX is a French poet and translator and the author of *Daybreak: New and Selected Poems* translated by Marilyn Hacker.

JONATHAN BASKIN is the Associate Director of the Creative Publishing and Critical Journalism program at the New School for Social Research, and a founding editor of *The Point*.

ISAIAH BERLIN, the British philosopher, died in 1997. ADAM MICHNIK is the founding editor of *Gazeta Wyborcza* in Warsaw and the author of many books. This conversation was translated by JOANNA TRZECIAK HUSS.

URI TZVI GREENBERG, who was born in 1896 and died in 1981, was an Israeli writer and political figure, and one of the great Hebrew and Yiddish poets of the twentieth-century. "The Poem of the Beautiful Landscapes" was published in Hebrew in 1950.

DAVID THOMSON is the author of many books on film and culture, most recently *Disaster Mon Amour*.

HELEN VENDLER is the A Kingsley Porter University Professor Emerita at Harvard University.

DEVIN JOHNSTON's most recent book of poems is *Mosses and Lichens: Poems*.

CELESTE MARCUS is the managing editor of *Liberties*.

LEON WIESELTIER is the editor of *Liberties*.

*Liberties — A Journal of Culture and Politics* is available by annual subscription and by individual purchase from bookstores and online booksellers.

Annual subscriptions provide a discount from the individual cover price and include complete digital access to current and previous issues along with the printed version. Subscriptions can be ordered from libertiesjournal.com. Professional discounts for active military; faculty, students, and education administrators; government employees; those working in the not-for-profit sector. Gift subscriptions are also available at libertiesjournal.com.

*Liberties — A Journal of Culture and Politics* is distributed to booksellers in the United States by Publishers Group West; in Canada by Publishers Group Canada; and, internationally by Ingram Publisher Services International.

LIBERTIES, LIBERTIES: A JOURNAL OF CULTURE AND POLITICS, is published quarterly in Fall, Winter, Spring, and Summer by Liberties Journal Foundation.

ISBN 978-1-7357187-7-4
ISSN 2692-3904

Printed in Canada.

The insignia that appears throughout *Liberties* is derived from details in Botticelli's drawings for Dante's *Divine Comedy*, which were executed between 1480 and 1495.

As a matter of principle, *Liberties Journal* does not accept advertising or other funding sources that might influence our independence. We look to our readers and those individuals and institutions that believe in our mission for contributions — large and small — to support this not-for-profit publication.

If you are interested in making a donation to *Liberties*, please contact Bill Reichblum, publisher, by email at bill@libertiesjournal.com or by phone: 202-891-7159.